POP ART BOOK

black dog
publishing

CONTENTS

INTRODUCTION

RO

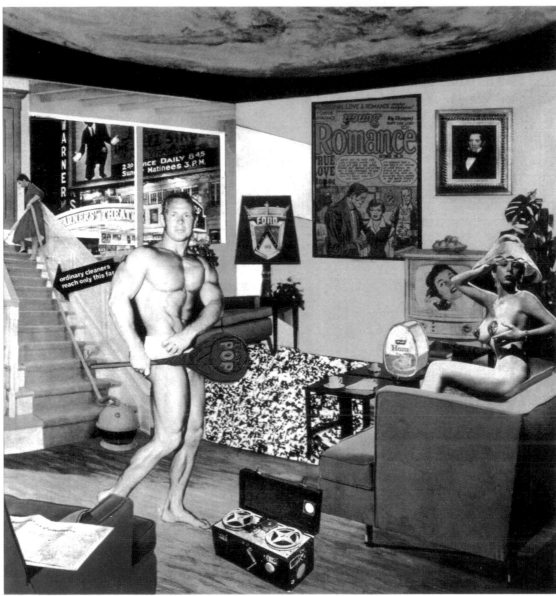

3/25 R Hamilton

Amidst the austerity of post-war Britain, a small group of artists and designers were beginning to analyse and experiment with the saturated images of mass culture newly available through films, comics and advertising. As Britain struggled to recover from the Second World War, inspiration poured in from American popular culture with its rock 'n' roll music and booming industry. This new age brought with it a new kind of popular image, carefully crafted by designers and widely appealing, representing a huge advancement in the commercial aesthetic. While this new visual material was not widely considered to be art proper, there were a few artists in Britain and America that recognised the potential for high artistic innovation in this 'low-brow' material.

One such set of individuals comprised the Independent Group, a collective of artists, architects, journalists, writers and historians who met regularly at the Institute of Contemporary Arts (ICA) between 1952 and 1957. Members included artists Richard Hamilton, John McHale, Eduardo Paolozzi, Nigel Henderson and William Turnbull, critics Lawrence Alloway and Reyner Banham and architects Colin St John Wilson and Peter and Alison Smithson. One of their frequent debates was the impact of post-war popular culture and technology on art, design and culture. Alloway described their interest in: "movies, advertising, science fiction, pop music. We felt none of the dislike of commercial culture standard among most intellectuals, but accepted it as fact, discussed it in detail, and consumed it enthusiastically."[1]

This is Tomorrow was an exhibition held at London's Whitechapel Art Gallery by the Independent Group and consisted of a series of environments, designed by 12 different groups of members. The installation devised by Richard Hamilton, John Voelcker and John McHale was amongst the most memorable. It included an oversized image of Marilyn Monroe from the cinemascope film Seven Year Itch and a 16 foot 'Robbie the Robot' from the film The Forbidden Planet. There was also a wall of billboard-sized film posters and a giant three-dimensional model of a Guinness bottle, all set to the tune of a continually playing jukebox.

Richard Hamilton's collage, Just what is it that makes Today's Homes so Different, so Appealing? appears to foretell the subject matter of Pop Art. The piece was created especially for the exhibition, it was initially devised as an illustration for the catalogue and later became the basis for a black and white poster for the show.

Richard Hamilton
Just what was it that made
Yesterday's Homes so Different,
so Appealing?
26 x 25 cm
Collage electronically restored,
colour laser jet print on paper,
revised 1992 from original 1956
Tate Gallery, London, UK
© Richard Hamilton
All Rights Reserved, DACS 2007

1 Alloway, Lawrence in Pop Art, Lippard, Lucy, London: Thames and Hudson, 1966 revised edition 1988, p. 28.

Hamilton drew up a list of categories to be included in this collage: man, woman, humanity, history, food, newspapers, cinema, TV, the telephone, comics (picture information), words (textual information), tape recording (aural information), cars, domestic appliances and space. Once he had his brief, he selected the relevant images. In describing his aim Hamilton said:

> **The objective here was to throw into the cramped space of a living room some representation of all the objects and ideas crowding into our post-war consciousness. The collage had a didactic role in the context of a didactic exhibition, *This is Tomorrow*; in that it attempted to summarise the various influences that were beginning to shape post-war Britain.[2]**

Not only were the categories to become the subject matter of Pop, but also some of the visual vocabulary—such as the muscleman, the pin-up woman, comics, cars, consumer packaging and advertisements. Indeed, the work actually included the word 'Pop' itself.

This is Tomorrow played a key role in promoting acceptance of a broader definition of culture, one that included popular material and mass media, and it opened up a wider range of opportunities for fine artists and those involved in cultural theory. The experience prompted Richard Hamilton to write his (now famous) letter to the architects Peter and Alison Smithson, defining Pop Art.

2 Hamilton, Richard, "An Inside View", quoted in Hamilton, Richard, *Prints and Multiples 1939–2002*, Dusseldorf: Richard Verlag, 2002, p. 44.

My view is that another show should
be as highly disciplined and unified
in conception as this one was chaotic.
Is it possible that the participants
could relinquish their existing
personal solutions and try to bring
about some new formal conception
complying with a strict, mutually
agreed programme?

Suppose we were to start with the
objective of providing a unique
solution to the specific requirement
of a domestic environment eg some kind
of shelter, some kind of equipment,
some kind of art. This solution could
then be formulated and rated on the
basis of compliance with a table of
characteristics of Pop Art.

Pop Art is:
Popular (designed for a mass audience)
Transient (short-term solution)
Expendable (easily-forgotten)
Low cost
Mass produced
Young (aimed at youth)
Witty
Sexy
Gimmicky
Glamorous
Big Business

Letter to Peter
and Alison Smithson
from Richard Hamilton
16 January 1957
© Richard Hamilton
All Rights Reserved DACS 2007

CPS/100

Richard Hamilton
*Just what is it that makes today's
homes so different?*, 1993
17.6 x 26.7 cm
Print on paper
Tate Gallery, London, UK
© Richard Hamilton
All Rights Reserved DACS 2007

HOW
TO
USE
THIS
BOOK

This book is intended as a playful introduction into the major themes of Pop Art and how they came to influence one of the most important movements in art history. Each section of the book reflects a topic that was significant to artists working at the time Pop Art emerged: the use of popular culture, the influence of politics and the impact of a consumer society on art and design. Within each of the three sections a variety of Pop Art 'sources' are arranged alphabetically, interspersed with various interactive elements arising from the themes explored.

PC
CULTURE

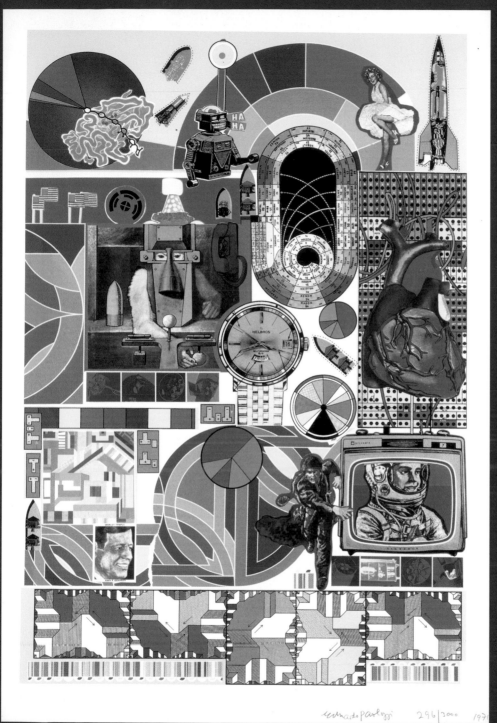

 950 — The Impossible Dream; It's All The Same; 16 in all.

 537 — La Bostella; St. James Infirmary; Jerkin' Around; etc.

 1061 — Dr. Dogood; It's Not Fair; Wind Up Toys; Others.

 156 — A Summer Place; Maria; Tonight; Exodus Song.

 1091—Brilliant harmonica sounds by the Harmonicats.

 1040—Star studded cast sings popular opera selections.

 1070 — Something Stupid; This Is My Song; others.

 1007—Ginger Bread Boy; Circle jazz record, a gas!

 1065—With informative commen... for young and old...

 1156 — Even The Bad Times Are Good; My Town.

 1063 — Gay, festive music which is a delight to the ear.

 770—A Hard Day's Night; I Feel Fine; Glad All Over. More

 1009 — He Was Alone; An Evening Prayer; many more.

 1088—Strangers in the Night; Sweet Maria; many others.

 1078—Green, Green Grass of Home; Bus Stop; Cara Mia; etc.

983—A superb performance from great musicians.

 678* —One O'Clock Jump; Bugle Call Rag; Swing Classic.

684—The Red Hills of Utah; The Fastest Gun Around; etc.

 1092—Fiddler on the Roof; From Russia With Love; others.

 1124 — Take My Love; Hands Across The Sea; etc.

1062 — Big Man In Town; Save It For Me; Ronnie; etc.

433—What Kind Of Fool Am I? This is All I Ask; others.

 801 — I Could Cry; Blue Blue Day; Any Time; 12 in All.

598 — Spanish Harlem Incident; All I Really Want To Do.

 1071—The Boy Next Door; Stouthearted Men; Lover Man.

1153 — A magnificent performance with artistry.

 1077—Beyond the Reef; The Hukilau Song; Blue Hawaii.

 1155—Somewhere, My Love; My Foolish Heart; Smile; etc.

601-Sonata No. 14; (Moonlight); No. 8 Pathetique & No. 23

 1087— Mozart's greatest hits in Jazz vocals! So hot!

1025 — End of The Road; Break-Up; Down The Line; etc.

 1094 — Pussy Cat; Prenatal Twins; Topless Club; others.

436 — Features 14 masterpieces by Debussy. Classic must.

 1090 — Guantanamera; A Man and A Woman; and others.

699 — When Sunny Gets Blue; Teacher Teacher; Manymore.

 1008 — Malaguena; All My Love; one; and other...

BOOTS
NANCY SINATRA
These Boots Are Made For Walking
As Tears Go By - 3 More

771 — Day Tripper; As Tears Go By; In My Room; Others.

566 — My Prayer; Greensleeves; Hungarian Dance No. 5.

1182—Willow Weep For Me; The Blue Scimitar; 10 in all.

444—For tone there is simply no comparison.

1075—Camp Sunny Sunshine, Males Inc., Funniest pair.

191-One Note Samba; Almost Like Being in Love; others.

966 — Sunrise Sunset; This Is My Song; many more.

1082 — Brailowsky plays the popular Chopin Waltzes.

221—Besame Mucho; La Ultima Noche; Amor; other hits.

 1129 — Yesterday; Till; Somewhere My Love; Maria; others.

343 — Ah Dearest Jesus: A Mighty Fortress Is Our God.

 1067 — A perfect recording of excerpts with fine cast.

1057 — Since I Fell For You; Felicidade; Come Sunday; more

328 — Tremendous performance with NY Philharmonic.

986—Love For Sale; Ballade Irlandaise; The Man I Love; etc.

 1001—Reach for the Sun; Good ... Baby; Baby Blue...

 1128 — La Guajira; Don't Think Twice; Shtematy; Others.

523 — Take Care of Yourself; Three Quarter Blues; etc.

 672/673—A Powerhouse performance, Once in a Lifetime; Falling In Love Again; Talk; Meeting the President; (counts as 2 records).

66—Dark Eyes; Surfer's Paradise; Free Fall; Glassy Walls.

5 — Our Day Will Come; Days of Wine & Roses; 12 in all.

160—A triumphant performance filled with romance.

 591 — Anniversary Waltz; Love Letters; I Believe; others.

 348-And the Angels Sing; Oh Mein Papa; 12 favourites.

1125—I'll Go Crazy; Gotta Get Away; Tobacco Road; etc.

724 — 12 dancing numbers in range of modern tempos.

119*—Sands of Time; Bangles and Beads; Fate; etc.

 7 — That Old Gang of Mine; Till We Meet Again; more.

 1157—The Shadow Of Your Smile; A Taste of Honey.

470—Mah Lindy Lou; I Still Suits Me; 15 songs in all.

751* — I'm Always Chasing Rainbows; Moonbeams; etc.

 1154 — Unchained Melody; If I Were a Rich Man; others.

 129-Most celebrated living composer. 1st class conductor.

958—A collection of her greatest songs on one disc.

 162—Study in E Mj. No. 14; Study in A Min. No. 17 (Sor)

 924 — The Second Time Around; My Funny Valentine.

 1020—Grandfather; She Comes & Goes; Grey City Day; etc.

 897 — A masterful performance by brilliant artists.

 800 — On a Clear Day; Downtown; All or Nothing at All.

1018—My Yiddishe Momma; Do... Serenade; oth...

Dada elevated the vulgar and the ordinary to the status of art object and in so doing questioned the whole concept of art and paved the way for Pop's development.

One of the key aspects of Pop Art was that it reflected popular culture, not just fine art, classical literature and music. Colin Self described it as the first truly popularist, democratic art movement. "Pop Art was the first art movement for goodness knows how long, to accept and reflect the world in which it lives. Before POP all ART hid behind being 'ARTY'. Art had reached such a state of insincerity and pretentiousness, POP was a real revelation."

Pop Art evolved out of a surge in (and a heightened appreciation for) popular culture and consumerism after the hardships of the Second World War. It celebrated pop and rock music, films and film stars, and genres of fantastical entertainment like sci-fi, indirectly reflecting the bolder patterns, youthful dynamism and more colourful world of post-war popular culture.

For many artists popular culture provided the visual aesthetic to reflect their artistic concerns: for some this might be the saturated contemporary media found in magazines or films, for others it was almost a nostalgic documentation of their personal lives and referred to older forms of popular culture like fairgrounds or pinball machines. Regardless of the source, Pop Art succeeded in giving future generations of artists the liberty to choose from a wider range of sources in the world around them, and in doing so challenged the distinctions between 'high' and 'low' art.

Nigel Henderson
(b. 1917, London, UK, d. 1985)
Screen, 1949–1952
Four panels, each 152 x 57 cm
Collage, oil paint and photographic processes on wood panel
Pallant House Gallery, Chichester, UK (Wilson Loan)
© Nigel Henderson

Eduardo Paolozzi
(b. 1924, Edinburgh, UK,
d. 2005)
*883, Whipped Cream, A Taste
of Honey, Peanuts, Lemon
Tree, Others. Part of Universal
Electric Vacuum*, 1967
Screenprint
Wolverhampton Art Gallery,
Wolverhampton, UK
© Trustees of the Paolozzi
Foundation
Licensed by DACS 2007

A-Z
BOX OF FRIENDS
AND FAMILY

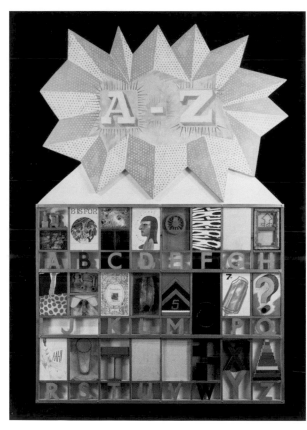

Joe Tilson
(b. 1928, London, UK)
A-Z Box of Friends and Family,
1963
233 x 153 cm
Mixed media
Private Collection
© DACS 2007
Image courtesy of
The Bridgeman Art Library

Although the *A-Z Box of Friends and Family* was initially intended as a personal record of Joe Tilson's private life, it also stands as an extraordinary testament to the British art scene in the early 1960s. Tilson had a wide array of artist friends; he was a part of the older generation of Pop artists, but he knew and admired younger practitioners such as Peter Phillips, Allen Jones, Clive Barker, Richard Smith, Richard Hamilton, Eduardo Paolozzi and Peter Blake. While he largely worked with Pop artists, Tilson was also familiar with artists working in different circles, such as sculptor Anthony Caro, painters Bernard Cohen and Frank Auerbach and photographer Robert Freeman. These artists, along with Tilson's wife and small children, were each allocated a letter and asked to fill a wooden box. The resulting artwork emerged as a unified whole, created out of a truly collaborative concept. The diversity of the contents, ranging from the work of small children to abstract artists, sculptural objects to small paintings, made with a great mixture of materials, were harmoniously combined in Tilson's basic structure and celebratory painted sign above.

American Connections

In America, there was no equivalent to the Independent Group, or any pivotal institution or art college where artists met during the period of Pop Art's emergence. In contrast to the comparative unity of the British art scene at the time, American artists tended to develop their ideas in isolation, though there was a general awareness among practitioners in the late 1950s of the themes other artists were exploring. Dealers and curators began to organise group exhibitions in order to examine and extend the development of this new direction in art, and it was these exhibitions across America, between 1960 and 1963, which brought together key artists for the first time and ultimately brought Pop Art into the public consciousness. Initially, the shows were variously described as New Realist, Neo-Dada, le Nouveau Realisme, The New Vulgarians or Common Object Painting. It was only between 1962 and 1963 that the term Pop Art emerged, referring to the work featured in these extraordinary exhibitions.

In 1950s America, the early seeds of Pop were sown by artists Jasper Johns and Robert Rauschenberg, who were reacting against the dominance of Abstract Expressionism in contemporary art: the work of Jackson Pollock and William de Kooning, for example, whose spontaneous, gestural paintings sought to express the innermost emotions of the artist. Alternatively Johns and Rauschenberg endeavoured to pull art out from the mind of the artist and ground it in the real world. Johns stated he wanted to paint "things that are seen and not looked at" and therefore focused on everyday, recognisable subjects, such as

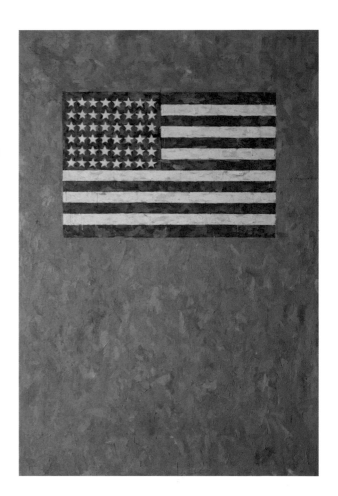

Jasper Johns
(b. 1930, Augusta, USA)
Flag on Orange Field, 1957
167.6 x 124.5 cm
Oil on canvas
Ludwig Museum,
Cologne, Germany
© Jasper Johns/VAGA
New York/DACS
London 2007
Image courtesy of
The Bridgeman Art Library

targets, flags, and numbers. Though he deliberately restricted his range of subjects, Johns was able to produce a wide variety of works, exploring the possibilities of the picture plane, paint texture and colour through the language of everyday objects and themes. For example, Johns' extensive work with flags explored their painterly quality as both artistic material and subject. However, when Johns first exhibited these flag paintings in New York during 1958, they were perceived as an offensive desecration of the national symbol, rather than an artistic experiment.

White Flag, 1955, was simply an American flag painted white, but this simple concept gave rise to an altogether complex emotional response, where the familiar characteristics of a proud national symbol was let of its blood and left in an almost sinister state. *Flag above White with Collage*, 1955, depicts an American flag above a white plane with newspapers and photographs barely visible through the paint, insinuating a narrative beyond the limits of the flag itself. In a different direction, *Flag on Orange Field*, 1957, referred to the theories of the colour-field painters such as Mark Rothko (whose work was characterised by large areas of a single colour) though Johns deliberately flattened the canvas to produce a more immediate response to the material. *Three Flags*, 1958, was unique in that Johns attempted to explore both illusionist and physical depth by mounting three different sized flags on top of one another, interrupting the usual symbolism of the American flag and emphasising its role as artistic material. Johns tried to explain the work: "Say, the painting of a flag is always about a flag, but it is no more about a flag than it is about a brushstroke or about a colour or about the physicality of the paint."[1]

Johns was also known for creating small sculptures of everyday things like flashlights, light bulbs, paint brushes and beer cans, seeking to draw attention to the ambient objects and images that permeated post-war culture.

The now famous story about his beer cans perfectly illustrates Johns' reaction to Abstract Expressionism, the leading proponent of which was Willem de Kooning. "Then I heard a story about Willem de Kooning. He was annoyed with my dealer, Leo Castelli, for some reason and said something like, 'That son-of-a-bitch; you could give him two beer cans and he could sell them.' I heard this and thought 'What a sculpture—two beer cans.' It seemed to me to fit in perfectly with what I was doing, so I did them—and Leo sold them."[2]

Jasper Johns
(b. 1930 Augusta USA)
Three Flags, 1958
78.4 x 115.6 x 12.7cm
Encaustic on canvas
Whitney Museum of American Art, New York, USA; 50th Anniversary Gift of the Gilman Foundation, Inc., The Lauder Foundation, A. Alfred Taubman.
© Jasper Johns/VAGA New York/DACS London 2007
Image courtesy of The Bridgeman Art Library

1 Jasper Johns quoted in *Pop Art*, London: Royal Academy of Arts, 1991, p. 48.
2 Jasper Johns quoted in *Pop Art*, London: Royal Academy of Arts, 1991, p. 47.

Say, the painting of a flag is always about a flag, but it is no more about a flag than it is about a brushstroke or about a colour or about the physicality of the paint. – Jasper Johns

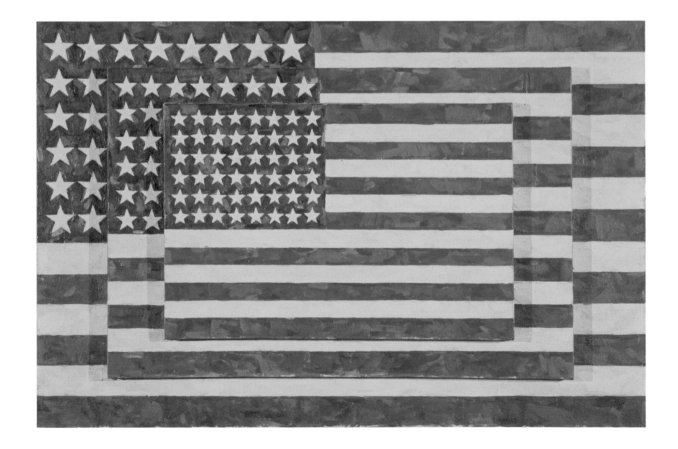

Jasper Johns had a long artistic and personal relationship with another influential American Pop artist, Robert Rauschenberg. Like Johns, Rauschenberg appropriated ordinary objects to create his 'combine paintings'—works that incorporated found objects and everyday 'urban debris'. He played on the confusion of sensations and imagery reflected in the mass media bombardment of modern street life, describing how he wanted to work in the gap between art and life. Rauschenberg went to Black Mountain College—a hotbed of literary, musical and visual art innovation. Here he came into contact with John Cage, the revolutionary composer who investigated the music in everyday noises and silences. The two artists found a resonance with one another. While Cage used ordinary noises and sounds as the material for his extraordinary 'chance music', Rauschenberg transformed commonplace objects and 'urban debris' into something altogether unexpected through his 'combine art' compositions. Both artists were working from the same guiding principle, to take up something wholly usual, and through the application of new methods and concepts, produce something completely different to what had gone before.

Both Johns and Rauschenberg exhibited in New York's Castelli Gallery during the late 1950s, and these shows had a profound influence on a fledgling Pop Art scene. The impact of the exhibited work stemmed from an uncommon choice of subject and media, as well as an emphasis on the flatness of the canvas rather than any attempt to create spatial illusion. It was for these and other reasons that their work represented a significant step for Pop Art in America, remaining influential well into the 1960s.

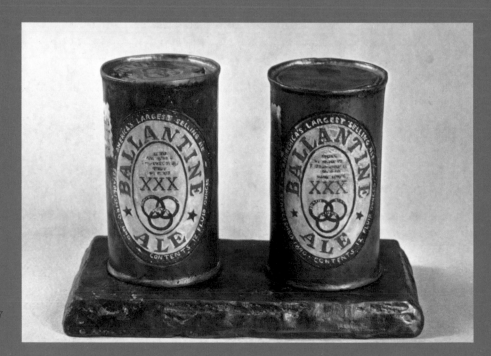

Jasper Johns
(b. 1930, Augusta, USA)
Painted Bronze II: Ale Cans,
1964
13 x 20 x 11 cm
Painted bronze
Private Collection
© Jasper Johns/VAGA
New York/DACS London 2007
Image courtesy of
The Bridgeman Art Library

Robert Rauschenberg
(b. 1925, Port Arthur, USA)
Trophy I
(for Merce Cunningham), 1959
167.7 x 111.7 x 5.1 cm
Oil and collage on canvas
Collection Kunthaus, Zurich
© DACS London/VAGA
New York 2007
Image courtesy of
The Bridgeman Art Library

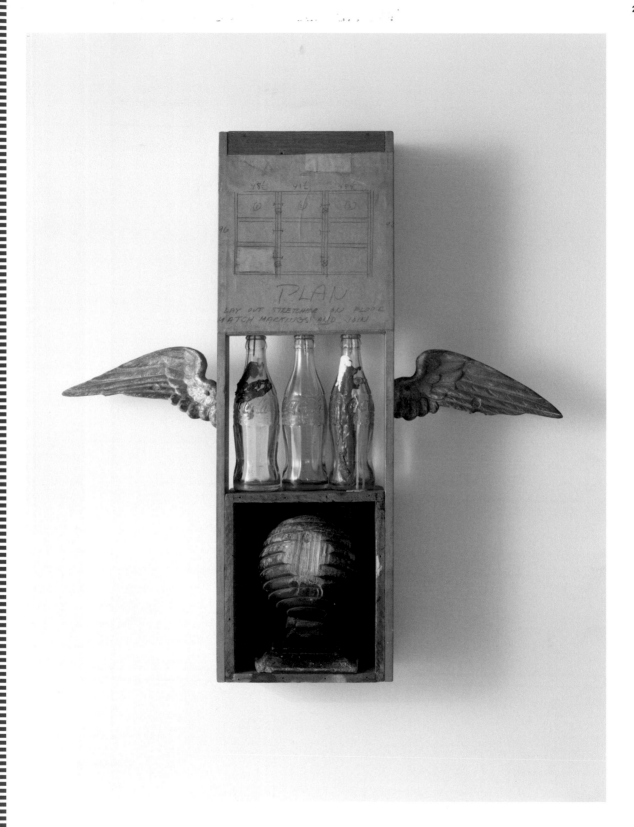

Some of the younger artists who were impressed by those early exhibitions later became key figures in Pop Art, for example Roy Lichtenstein, Andy Warhol, James Rosenquist, Tom Wesselmann, Claes Oldenburg, Jim Dine, Larry Rivers, Ed Ruscha, Robert Indiana, and Allan D'Arcangelo. Richard Hamilton was surprised to find Pop Art flourishing in America when he first visited in 1963: "My other enterprise; that of expressing the interests of a consumer society in fine art terms was a named movement—Pop Art. This, with its masters and camp followers, was a band wagon which had overrun me; I picked myself up and prepared to jump on it."[3] What Hamilton and the American Pop artists had in common was a desire to appropriate material from their surroundings and investigate themes from their own lives, using these things as a mechanism to explore and express new artistic concepts. Their sources were very similar to the British artists—the media, advertising and packaging, various aspects of consumerist imagery and different facets of popular culture. Warhol said "The Pop artists did images that anybody walking down Broadway could recognise in a split second—comics, picnic tables, men's trousers, celebrities, shower curtains, refrigerators, Coke bottles—all the great modern things that the Abstract Expressionists tried so hard not to notice at all."[4]

> **The Pop artists did images that anybody walking down Broadway could recognise in a split second. – Andy Warhol**

Robert Rauschenberg
(b. 1925, Port Arthur, USA)
Coca-Cola Plan, 1958
67 x 64 x 11.4 cm
Mixed media
The Museum of Contemporary Art,
Los Angeles, The Panza Collection
© DACS London/VAGA
New York 2007
Image courtesy of Paula Goldman

3 Hamilton, Richard, *Collected Words*, London: Thames and Hudson, 2001, p. 55.
4 Warhol, Andy, quoted in *Pop Art*, London: Royal Academy of Arts, 1991, p. 60.

B

BRIGITTE BARDOT

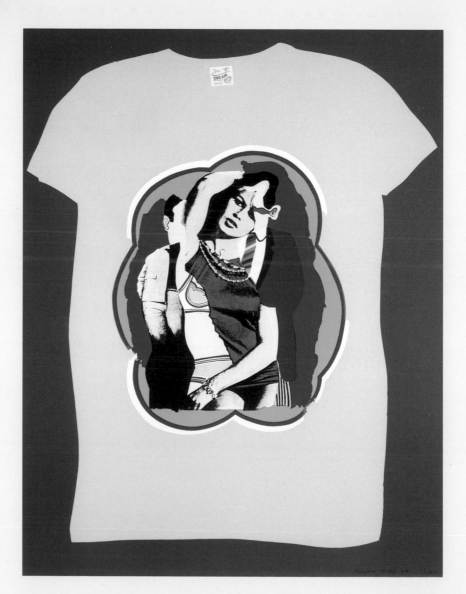

Allen Jones
(b. 1937, Southampton, UK)
Dream T-Shirt, 1964
73.7 x 55.2 cm
Screenprint
Wolverhampton Art Gallery,
Wolverhampton, UK
© The artist

The French actress, Brigitte Bardot, was *the* sex idol of European film in the 1950s and 60s. Beautiful, voluptuous and dangerous; she embodied the 1950s 'sex kitten' and remains one of the few European actresses to receive media attention in the United States, though she never worked in Hollywood. Her distinctive accent and her modern lifestyle gave her image a racier edge than some of her American counterparts, like Marilyn Monroe. It was this mysterious (and highly sexual) quality that made her so popular with artists at the time, indeed, British Pop artists Allen Jones, Gerald Laing and Peter Phillips all depicted her in their work. Peter Blake also included Bardot's image in a number of his collage works, for example, *Knife Board*, used a full size pin-up of Bardot from *Reveille* magazine as the base of the collage.

Inspired by the new trend for T-shirts with printed logos, Allen Jones spent the summer of 1963 experimenting with printing an image of Brigitte Bardot on his own T-shirts. Jones was not alone in considering Bardot to be the height of female beauty, and when he was offered the chance to create a screenprint for the ICA, he decided to include the star's image. Bardot is now combined with other images, some from magazines and others illustrated by the artist. Two male figures are placed behind the starlet, one of them the familiar hand-drawn image of the artist with its signature striped tie, used in several of Jones' previous work. The label on the T-shirt, 'Dream Company', foretold the appearance of a cloud-shaped lens through which the viewer is introduced to a complex array of different images. The collage reflects the artist's preoccupation with the works of philosophers Carl Jung and Friedrich Nietzsche, whose writings inspired him to investigate the relationship between the masculine and feminine sides of the human psyche. The notion that within oneself the marriage of masculine and feminine elements is the source of self-knowledge was important for Jones, indeed he felt that this kind of mental equilibrium would lead to artistic works of lasting importance. As far as Jones was concerned, the epitome of the female term was Bardot, and she therefore featured large in his painterly investigations into his own relationship with the feminine. For example, *Self-Portrait* shows the artist in a reflective pose, accompanied by an image fragment of Bardot, and a characteristic fusion of male and female figures in the background.

In 1963, Allen Jones said: "If pin-ups make you want to paint more than the life model upstairs, then rush round to the magazine store. If your stimulations come from inartistic or untasteful sources and not from Bach, don't worry; if as a result you produce work, then it is justified."[5]

5 Jones, Allen, *Some Statements*, edited by Marco Livingstone, *Aspects 6*, Spring 1979, quoted in *Pop Art*, London: Royal Academy of Arts, p. 158.

Gerald Laing was also among those that found inspiration in the French star, creating a painting and several screenprints based on Bardot's image. Using his dot technique, he chose a close-up view of a newspaper image as his working subject: "I chose photographs that appealed to me, ones that I wished to make more permanent than the essentially ephemeral nature of the daily press would allow, and which were also absolutely of the moment."[6] The impact of these works was heightened by their enlarged scale. By manipulating popular press imagery of the stars, Laing was able to raise their status to icons of a new age, whilst at the same time questioning their validity.

6 Gerald Laing quoted in *British Pop*, exhibition catalogue Bilbao: Musee de Bellas Artes, 2005.

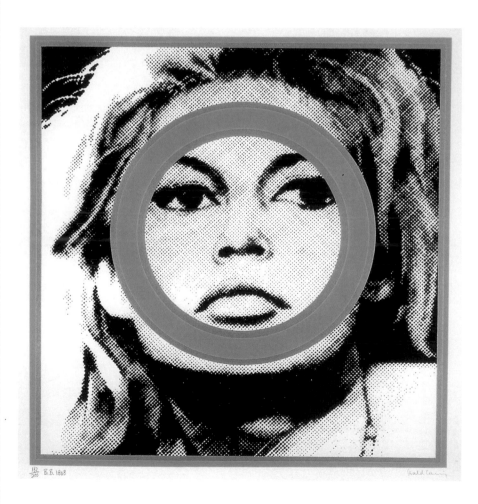

Gerald Laing
(b. 1936, Newcastle Upon Tyne, UK)
Brigitte Bardot, 1962
152.4 x 121.9 cm
Screenprint
Collection of the artist
© The artist
Image courtesy of
Hazlitt Holland-Hibbert Gallery,
London, UK

COMICS

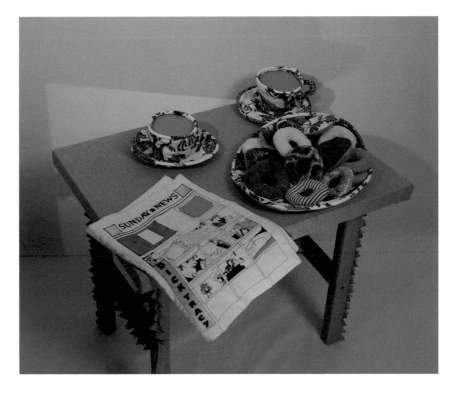

Comics first emerged in the 1930s, and many of the most popular titles continued to be produced well into the 1960s. Many newspapers had a regular comic strip, like the long-time running *Dick Tracy* in the *Los Angeles Times*. There were also a number of cheaply produced illustrated periodicals circulating for children, featuring gender-specific comic strip stories. Titles such as *Eagle*, *Beano*, and *Dandy* were aimed specifically at boys, while *Girl* and *Judy* were aimed at girls. Whatever the gender, and in whatever form the distribution, there was an overwhelming demand for comic books in post-war America, and Pop Art responded to its popularity by experimenting with its characteristic aesthetic.

While Peter Blake made several paintings of children reading comics, the vast majority of Pop artists' work directly referred to the content of American comic genres like wartime narratives, adventure stories and science fiction. Jess Collins (known professionally as 'Jess') made a series of works entitled *Tricky Cad* (an inversion of the name *Dick Tracy*) depicting full pages of original comic strips. Jann Haworth made soft sculpture pieces, such as *Comics, Doughnuts and Coffee*, 1962, and *LA Times Bedspread*, 1965, illustrated with the same *Dick Tracy* comic strip series. Ed Ruscha took up similar images in *The Flash, LA Times*, 1963, and *Noise, Pencil, Broken Pencil, Cheap Western*, 1963.

Jann Haworth
(b. 1942, Los Angeles, USA)
Donuts, Coffee and Comics,
1962
57.2 x 69 x 53.8 cm
Fabric, thread and kapok
Collection of the artist
© The artist
Image courtesy of
The Mayor Gallery, London, UK

No other Pop artist is more closely associated with the comic strip aesthetic than Roy Lichtenstein. From 1961, he began exploring the visual language of comics, selecting parts of a frame from a strip and reproducing it at a much larger scale. Working within the comics' stylistic framework of the Benday dot four-colour printing process, Lichtenstein could subtly adapt and change his source material in order to emphasise his visual and aesthetic concerns. *In the Car*, for example, depicted the original comic strip from *Girls' Romances*, but Lichtenstein drastically increased the scale of the image, and removed the thought bubble and text so that we are forced to rely on image alone in order to understand the relationship between the two characters depicted. He also simplified the lines and colour further, separating the pigment dots and emphasising areas of abstract colour. For example, the man is blue-haired and blue-suited while the woman has yellow hair and a yellow coat. In this way the couple's psychological separation, indicated by their body language, is further emphasised, and the artist's particular interest in form, shape and colour are made evident. Playing with some of the graphic conventions of the cartoon draughtsman, Lichtenstein turns the lines used to indicate glass windows and movement into simple abstract borders, highlighting the image's geometric forms. We are therefore drawn less towards the narrative and more towards the graphic techniques used in the comic strip.

It was hard enough to get a painting that was despicable enough so that no one would hang it—everybody was hanging everything.
– Roy Lichtenstein

Roy Lichtenstein
(b. 1923, New York, USA, d. 1997)
In the Car, 1963
172.7 x 203.2 cm
Oil and magna on canvas
© The Estate of Roy Lichtenstein/DACS 2007
Image courtesy of the Estate of Roy Lichtenstein
Collection of the National Galleries of Scotland

Lichtenstein commonly used themes from romantic melodrama and war comics, being particularly attracted to comics that expressed "violent emotion and passion in a completely mechanical and removed style".[7] However, Lichtenstein repeatedly states that he was not interested in the subject matter of the sources he chose, but rather the visual language of comics in general. Referring to the common themes prevalent in his work, Lichtenstein made his famed remark: "It was hard enough to get a painting that was despicable enough so that no one would hang it— everybody was hanging everything. It was almost acceptable to hang a dripping rag, everybody was accustomed to this. The one thing everyone hated was commercial art; apparently they didn't hate that enough either."[8] While Lichtenstein was creating his earliest paintings *Popeye* and *Look Mickey*, 1961, Andy Warhol was using comic strips as the subject matter of his initial paintings such as *Saturday's Popeye*, 1960, and *Superman*, 1960.

After having seen Lichtenstein's work, Warhol decided to turn his focus elsewhere, and began to make the kind of work for which he later became famous. In Pop Art, both painting and sculpture often had a strong visual link with the bright colours and simplified expressive forms of comics. Mel Ramos, working on the west coast of America, also made use of the comic strip aesthetic in his early paintings: *Batmobile*, 1962, and *Superman*, 1961. Nicholas Monro's sculpture *Par Avion*, 1967–1968, is reminiscent of both Surrealist paintings and the visual language of comic books. His use of a restricted colour range to emphasise sculptural forms seems to consistently result in a range of subtly uplifting shapes or angles, setting the stage for his playful sense of humour.

The enthusiasm for comics continued among artists well into the 1960s. The second generation of British Pop artists frequently refer to the influence of comics that inspired characteristic features such as narrative compositional formats and an almost brutally flat canvas.

7 Lichtenstein, Roy, quoted in *Roy Lichtenstein*, London: Hayward Gallery, 2004.
8 Lichtenstein, Roy, quoted in Gene R Swenson, "What is Pop Art? Part I", *Art News,* 62, no. 7, November 1963, p. 25.

Nicholas Monro
(b. 1936, London, UK)
Par Avion, 1967–1968
102 x 88 x 47 cm
Painted fibreglass
Collection of the artist
© The artist
Image courtesy of
The Mayor Gallery, London, UK

COWBOYS

Although Westerns were popular films during the time Pop Art emerged, there were few direct representations of scenes from this genre in the art being made at the time. A notable exception is Jann Haworth's *Cowboy*, 1963–1964, a life-sized fabric sculpture depicting the artist's impression of life in the southern states of America.

> **The image of the cowboy came from the rodeo in Lubbock, Texas (Buddy Holly's town). I spent one summer there with my stepmother (1954, I think), reading about Elvis and watching the cowboys. Every detail was grabbed from the lazy guys hanging around that hick town.... It's a conflicted Adonis... on the one hand a gorgeous seductive image, on the other an utterly stupid, prejudiced jerk. (I was appalled on this visit to see the rest rooms and the water fountains in Texas were segregated: 'White Ladies' on one and 'Black Women' on the other.) The whiteness of the cowboy was partly about this.**[9]

Haworth's work was also partly in reference to the film studio workshops, where they made the life-size latex figures to act as stand-ins for actors for stunt action sequences of cowboys being shot off cliffs, for example. Her father was a Hollywood production designer, so Haworth had no shortage of experience with these kinds of formats, though she worked in fabric rather than latex. Haworth wanted viewers to instantly recognise and relate directly with the figures, acutely aware of their physical presence in the room, thereby provoking an immediate reaction to the material. In the very male-dominated environment of the Slade School of Art, Jann Haworth felt creating fabric sculpture not only allowed her to use a more sensuous medium that related more to life than more traditional materials, but also provided her with a particularly female means of expression. She had begun sewing at an early age and had a good knowledge of the technical aspects of the craft. Fabric as medium: "Soft, Warm, Changeable, Flexible. This was the main turning point for 'why?' on fabric. I wanted not so much realism, but sculpture that felt right. It was quite repulsive to me to think of bronze as a representation. When Paolozzi saw my work for the first time at the Slade, he said: "Cast it in bronze". I told him that I had cast it in cloth and that was the point." This characteristically patronising attitude to female students provoked her: "I was determined to be better than them, and that's one of the reasons for the partly sarcastic choice of cloth, latex and sequins as media. It was a female language to which the male students didn't have access."[10]

Jann Haworth
(b. 1942, Los Angeles, USA)
Cowboy, 1963–1964
180 cm high
Kapok and unbleached calico
Pallant House Gallery,
Chichester, UK
(Wilson Gift
through The Art Fund)
© The artist

9 Haworth, Jann, quoted in *British Pop*, Bilbao: Musee de Bellas Artes, 2005, p. 422.
10 Haworth, Jann, interview published in *tate etc*, Issue 1, online.

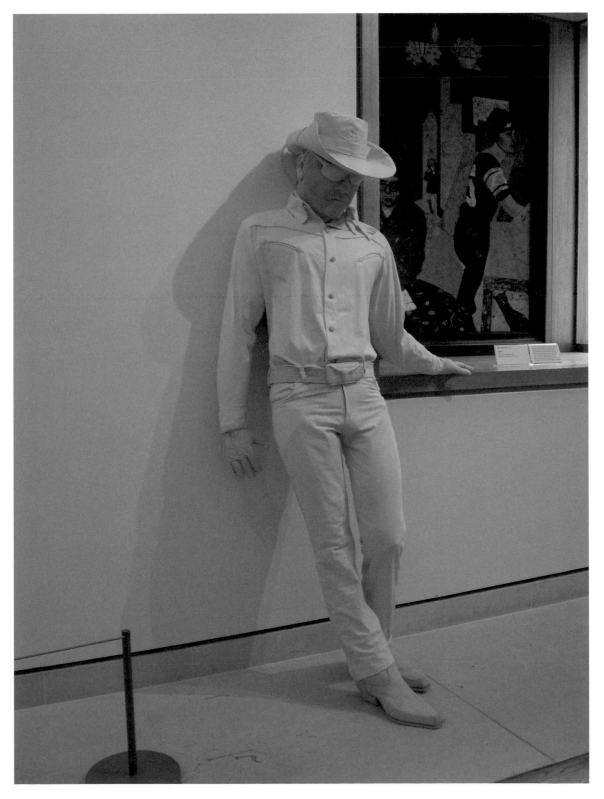

F

FAIRGROUND

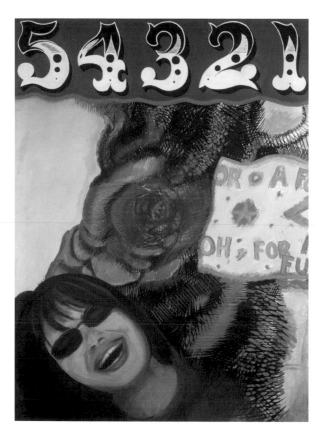

Pauline Boty
(b. 1938, Surrey, UK, d. 1966)
5 4 3 2 1, 1963
125 x 100 cm
Oil on canvas
Estate of Pauline Boty
© Estate of Pauline Boty
Image Courtesy of Whitford Fine Art

Before Pop Art, fairs had been an important part of British culture for centuries, satisfying both economic and entertainment needs. With the development of mechanical attractions in the twentieth century they began to exist as forms of amusement in their own right. And as prosperity increased for working people during the 1950s and 60s the concept of daytrips and holidays became more widespread. Most holiday resorts provided funfairs and amusement arcades as diversions for visitors. Helter-skelters, ferris wheels and slot machines mingled with the hum of popular illuminations and the taste of candyfloss—making the fair a truly multi-sensory experience, a place of escapism and nostalgia.

The significance of the fairground for British Pop artists was explored in the BBC programme *Pop Goes the Easel*. One of the opening scenes shows Derek Boshier, Pauline Boty, Peter Blake and Peter Phillips at a typical British fair, shooting at targets, images of which were a common feature in Pop Art. Much of the typography and colour use prevalent in Pop Art at the time was a direct influence of the saturated, hyperbolic images and environments offered by both fairgrounds and circuses in the 1950s and 60s, with their amusement arcades, pinball machines, mechanical entertainments and colourful lights. Peter Blake had collected traditional fairground

and circus signboards since childhood, and the aesthetic of these folk objects was to heavily influence his work throughout his life. The fairground lettering on Pauline Boty's *5 4 3 2 1* is combined with the pictorial suggestion of the physical thrills of the fair: depicting a long-haired female throwing her head back in laughter, surrounded by the implied imagery of the fairground. Peter Phillips was also interested in the painted boards of traditional fairground games, and took up the aesthetic of jukeboxes, slot machines and pinball games, with their flattened pictorial qualities and bright colours. The grid-like compositions of these common diversions inspired Phillips to divide the canvas into tiers and use cut-out sections and wooden compartments within the main structure to separate his illustrative devices. He completed a number of paintings using this methodology, including *The Entertainment Machine*, 1961, *For Men Only—Starring MM and BB*, 1961, and *War/Game*, 1961. In the 1960s Phillips described his interest in the aesthetic of popular diversions; "I was very interested then in what I called 'game formats'... a big image subdivided into little pictures... I had a lot of comic strips, but I wasn't self-conscious that this was anything particularly important. To me, nobody had done it, so I thought I'd just stick it in, paint a comic strip."[11]

In American painting the most prominent example of fairground influence was Jasper Johns' target paintings. He selected the target board because it was a commonplace object with a simple geometric form which, in a similar way to his flag paintings, would allow him the freedom to concentrate on painting itself rather than the subject he painted. *Target with Plaster Casts* however, includes a third dimension, a row of boxes containing plaster casts of body parts, across the top part of the canvas. This combination of canvas and three-dimensional elements influenced a number of Pop artists including Peter Blake, Joe Tilson and Peter Phillips.

11 *Retrovision: Peter Phillips Paintings 1960–1982*, Liverpool: Walker Art Gallery, 1982, pp. 19–22.

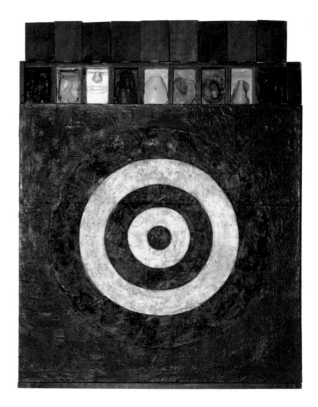

Jasper Johns
(b. 1930, Augusta, USA)
Target with Plaster Casts, 1955
107.3 x 153.8 cm
Encaustic and collage
Private Collection
© Jasper Johns/VAGA
New York/DACS London 2007
Image courtesy of
The Bridgeman Art Library

A comment on the superficiality of American life; its images are taken from pinball machines and the neon glare and the road signs of America. When I did that painting, I had no idea its theme would occupy most of my life. – Robert Indiana

Robert Indiana's *The American Dream 1* was described as being "like a cosmic pinball machine" when it was first exhibited in 1961.[12] Indiana, when filling out an artist's questionnaire for the Museum of Modern Art in New York, gave a detailed description behind this work.[13] He explains 'TILT' as a reference to "all the millions of pinball machines and jukeboxes in all those hundreds of thousands of grubby bars and roadside cafes, alternative spiritual homes of the American". '40-29-66-37' refers to the numbers of highways that stretch across America, most of which he had travelled during national service. 'Take All', he described as "the well-established American ethic in all realms". While 'The American Dream' was a phrase widely used to express the scope of opportunity in a new land of freedom and relative wealth. Much of Indiana's work had an autobiographical element, and referred particularly to his own childhood experience, describing his parents' affection for automobiles, pinball and slot machines during the economically depressed 1930s. Indiana liked stencilled letters, the lowly sign-painter's craft, using different colour typography which seemed to imitate the flickering lights of the fairground. The messages contained in his work were deliberately universal, common and accessible, describing it as "... a comment on the superficiality of American life; its images are taken from pinball machines and the neon glare and the road signs of America. When I did that painting, I had no idea its theme would occupy most of my life."[14]

12 Swenson, Gene. Exhibition review *Art News*, May 1961, p. 20.
13 Museum of Modern Art Artists' questionnaire 11 December 1961 quoted in S E Ryan, *Robert Indiana: Figures of Speech*, London: Yale University Press, 2000, p. 91.
14 Farnsworth Library and Art Museum, *Indiana's Indiana 5*, quoted in S E Ryan Robert *Robert Indiana: Figures of Speech*, London: Yale University Press, 2000, p. 95.

Robert Indiana
(b. 1928, New Castle, USA,
as Robert Clark)
The American Dream 1, 1961
182.9 x 154.4 cm
Oil on canvas
Museum of Modern Art,
New York, USA,
Lady Aldrich Foundation Fund
© ARS New York/DACS
London 2007

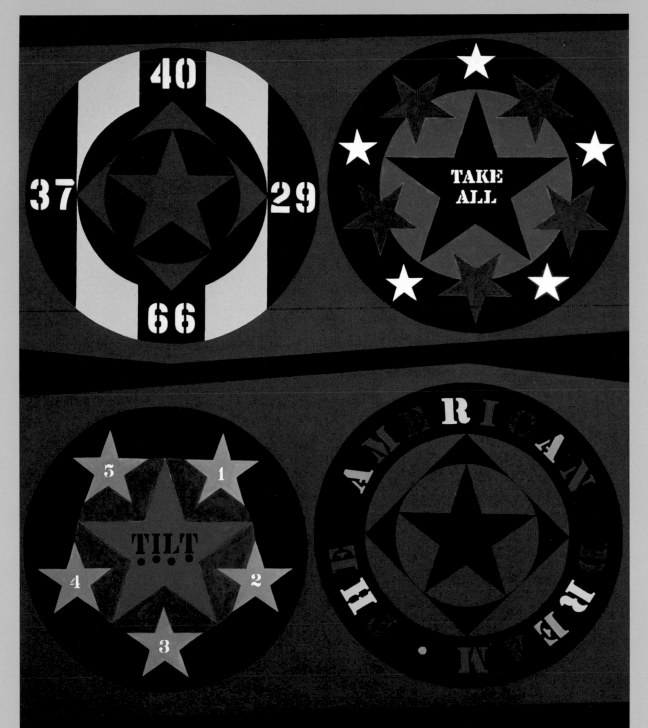

FAMOUS FOR 15 MINUTES

Andy Warhol famously stated in 1968, that in the future, everyone would be famous for 15 minutes. Warhol himself was to become the most famous of all the Pop artists, and his paintings of packaging and celebrity portraits are widely recognised today. Andy Warhol called his studio in New York 'The Factory', a site humming with a diverse range of people: some working, others socialising, the young, the glamorous, eccentrics, transvestites, society women, artists, dealers, musicians and celebrities. Many of these people were involved in Warhol's projects during the 1960s, for example, Gerard Malanga—poet, photographer and filmmaker—helped with screenprinting from 1963, and performed at the *Exploding Plastic Inevitable*. Others were simply involved in the film projects, which Warhol began in 1963. Warhol preferred to film 'real' people as opposed to actors, and as a result many of his own entourage became his 'superstars' including the likes of Ultra Violet, Edie Sedgewick and Nico.

Warhol was responding to the boom in mass communication (television, popular magazines and newspapers) in America at the time. He was interested in the role played by the media in creating celebrities, and opted to provide unknown people with 15 minutes of fame through works such as the *Disaster Series*. Warhol began the series in 1962, depicting macabre subjects like aircraft crashes, car accidents, fire and fatal food poisoning. The images were taken from original press photographs, which were then overlaid with a half-tone screen to create the dot effect present in printed newspaper imagery. Although technically paintings, the images were silk-screened onto the painted canvases to create an unusual effect. The deliberate crudeness of Warhol's printing techniques (usually printed onto unstretched canvas on the floor) often resulted in smudged, heavily contrasted images with little shading or detail, emphasising their mass produced source.

Jacqueline, 1964, is a silkscreened oil painting of Jackie Kennedy, at the funeral of her husband, President John F Kennedy (JFK), following his assassination on 22 November 1963. It was an event that shook the American nation. Apart from being admired as the youngest American President in history, and applauded for his forward-looking policies, Kennedy and his stylish wife were also perceived as a golden couple: glamorous, cultured and progressive. Media coverage followed the Kennedy family closely over the days succeeding JFK's death, in particular scrutinising

Andy Warhol
(b. 1931, Pittsburgh, USA, d. 1987)
Jacqueline, 1964
50.8 x 40.6 cm
Silkscreen oil paint on canvas
Wolverhampton Art Gallery, Wolverhampton, UK
Victoria & Albert Museum Purchase Grant Fund
© Licensed by the Andy Warhol Foundation for the Visual Arts, Inc/ARS New York/DACS London 2007
Image courtesy of Wolverhampton Art Gallery, Wolverhampton, UK

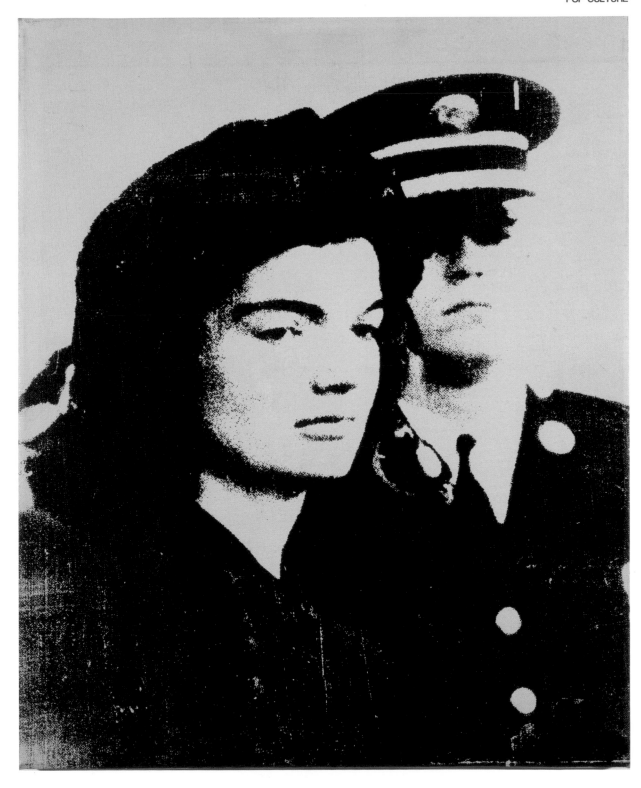

the funeral where his widow's dignified bearing greatly impressed the public. These were the early days of ordinary households possessing televisions, and for many viewers, their first experience of watching such an event in their own home. It was certainly one of the first times so private an event was made so public.

Warhol created *Jacqueline* a representation of a celebrity icon. The lack of detail in the image conceals her emotions and fragility, preserving only her elegance and decorum. At the same time it reflects the fact that the media had managed to transform a personal tragedy into a moment of national mourning, thereby substituting the intimacy of a wife losing her husband, for the significance of a country losing its leader. By creating such memorable images as *Marilyn* and *Jacqueline*, Warhol further confirmed their iconic status, extending the longevity of their celebrity well beyond their years. Indeed, Warhol's paintings on the themes of celebrity earned him such fame that during the following decades, the rich and powerful attempted to commission Warhol portraits in a bid to raise themselves to that same iconic status.

The idea that fame is something available to everyone, if only for a short time, might be seen as an egalitarian notion, however these early works by Warhol seem to suggest that fame has a price, and interrogates the impact of that price. Questions surrounding the cost of fame are still very much relevant today, and Warhol would not be the last artist to produce work on this theme.

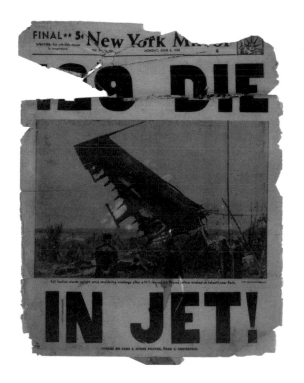

Andy Warhol
(b. 1931, Pittsburgh, USA, d. 1987)
Newspaper, source material for 129 Die in Jet!, 1963
38.1 x 28.6 cm
Printed ink on newsprint
The Andy Warhol Museum, Pittsburgh, USA,
Founding collection
Contribution The Andy Warhol Foundation for the Visual Arts, Inc
© Licensed by The Andy Warhol Foundation for the Visual Arts, Inc/ARS New York and DACS London 2007

opposite
Andy Warhol
(b. 1931, Pittsburgh, USA, d. 1987)
Self-Portrait, 1966–1967
55 x 55.9 cm
Oil on canvas
The Andy Warhol Museum, Pittsburgh, USA,
Founding collection
Contribution The Andy Warhol Foundation for the Visual Arts, Inc
© Licensed by The Andy Warhol Foundation for the Visual Arts, Inc/ARS New York and DACS London 2007

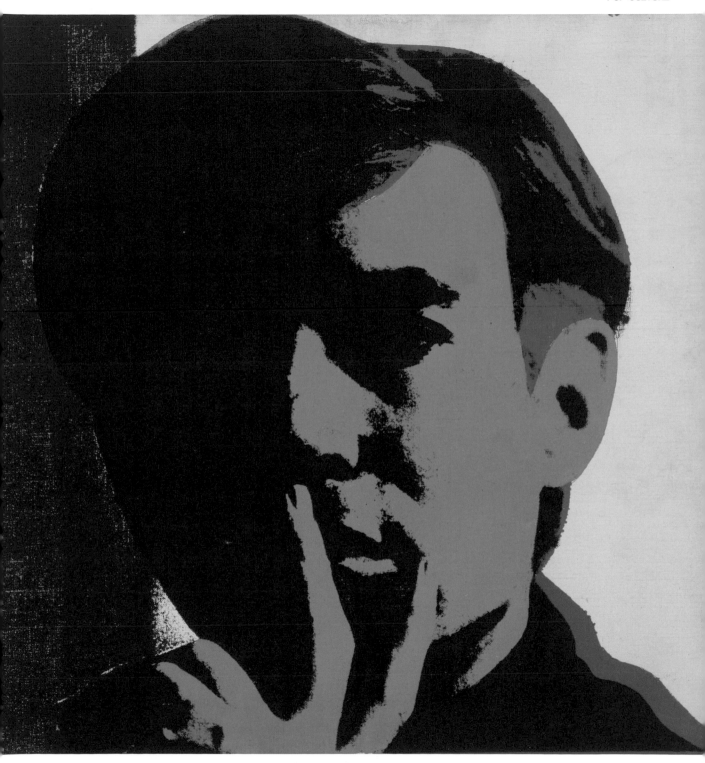

HEROES AND HEROINES

Artists have always celebrated popular heroes and heroines, but Pop artists took a unique approach to the theme. Rather than painting or sculpting works in honour of real or imagined heroes, Pop artists investigated the nature of the hero itself; how they come to be and what effect they have on the lives of the people who revere them.

During the 1940s and 50s, artists linked with the Independent Group celebrated stars of the silver screen. The Hollywood celebrity machine had successfully produced and promoted stars since the 1930s. Glamorous photographs were made available for the press and fans, stoking the flames of celebrity. However, the Independent Group artists tended to be more interested in the less polished images available through promotional film posters and magazines, and the various celebrity images used on sweet wrappers and collectable cards found inside cigarette and tea packaging. These cheaply printed images were collected by artists such as Richard Hamilton, Nigel Henderson and Eduardo Paolozzi and included in their collage works.

In *Self-Portrait With Badges*, Peter Blake depicts himself holding an Elvis Presley fan magazine, wearing denim jeans and a jacket covered in badges. One need only cast an eye over the list of badges portrayed to gain an understanding of the issues and themes that interested the artist at the time: a First World War medal, a badge with the head of Yvonne de Carlo, a badge featuring Max Wall, another with the phrase 'I like Fiorello' (a reference to a show in New York), an American Flag and 'Diana Crack Shot' (a reference to 'Diana' air guns) badge, a French General, Road Safety and Pepsi-Cola badges, a large Elvis Presley badge, 'Temperance 7' (a pop group) and Red Cross Day badges, a Lodge Plug badge, an American Boy Scout badge, an Adlai Stevenson campaign badge and another of the Union Jack, a portrait of an American football player and a Dan Dare badge. The stars and stripes at the lower left of the jacket indicates Blake's interest in America, though at the time he had never been there. Blake uses the badges and the Elvis magazine in much the same way that historical portrait painters did in their full-length formal

Peter Blake
(b. 1932 Dartford UK)
Self-Portrait with Badges, 1961
172.7 x 120.6 cm
Oil on hardboard
Tate Gallery, London UK.
© DACS 2007

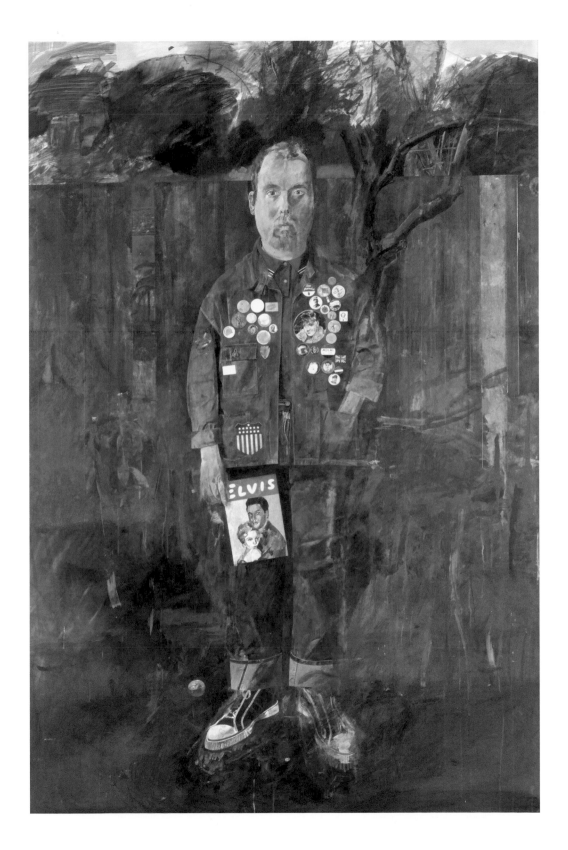

portraits, to tell us something about his own identity and interests. In the late 1950s, Peter Blake depicted Hollywood stars and celebrities of popular music—rock 'n' roll, pop and jazz—indeed Blake was often described as a 'fan' himself, and his interest in music was the driving force behind works like *Beach Boys* and *Bo Diddly*.

In other works, however, Blake explores the fan's role in the creation of celebrity, and the subsequent role these popular idols play in the lives of the people that made them famous through their very devotion.

In reference to his painting *Girls with their Hero*, 1960, Blake said: "This is a straight presentation of 60 comments on Presley. I've never actually seen him in the flesh and don't particularly go for his type of music... but I'm a fan of the legend rather than the person." Blake in fact made a number of works paying homage to Elvis, he was enthusiastic about American popular culture and would have been in a position to witness Elvis' rapid rise to international fame during the 1950s. Some of Elvis' most popular songs, such as "Hound Dog" and "Blue Suede Shoes" hit the charts in 1956, and the press was rife with reports of the thousands of hysterical fans that followed the performer's every movement. In *Girls with their Hero*, a small group of screaming teenage fans are sketchily depicted, obviously shouting, crying or holding their heads, while on the right a girl stares out towards us frowning intensely with concentration. The figures are surrounded by the ephemera of fandom—images of Elvis from magazines, posters and advertisements.

> I've never actually seen him in the flesh and don't particularly go for his type of music... but I'm a fan of the legend rather than the person. – Peter Blake

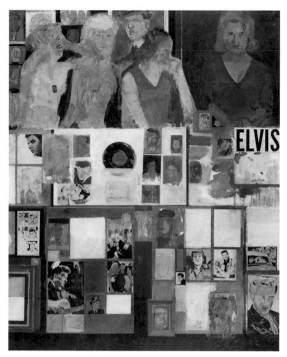

Pauline Boty painted *Celia Birtwell and her Heroes* in 1963. Celia Birtwell is now a well-known textile designer who first made her name as the partner of fashion designer Ossie Clarke, creating clothing for the 1960s swinging set. At first glance, the painting seems to be an intimate portrait of the designer in front of a wall adorned with pictures reflecting her interests and idols. Immediately obvious is the press cutting from *The Sunday Times Magazine* of David Hockney with his painting *The Hypnotist*, 1963. Hockney's close friendship with Birtwell lead to several of his works featuring her image, including *Mr and Mrs Clark and Percy*, 1970, now on display at Tate Modern. Other images depicted behind Celia seem to show black and white images of young male film stars or pop musicians: a full-length portrait of Elvis, possibly the Everly Brothers and a male figure in a leather jacket. Some of the pictures belong to Boty's own sitting room wall—Blake's *6d* from the back cover of the magazine *Motif*, Blake's 'clowns' sketch, the suspended heart, and the paper target, brought back from the fairground shooting range where they were filmed for the television programme *Pop Goes the Easel*. The painting, therefore, is as much a reflection of Boty's own domestic life in Addison Road as it is an investigation in to the personal life of Celia Birtwell. The majority of Boty's paintings were not of friends, but of her own heroes—film stars of the contemporary French 'Nouveau Realism' cinema or older Hollywood films that captured her interest, including Jean-Paul Belmondo (a film star whose looks she admired) Monica Vitti, Kim Novak and Marilyn Monroe. While the majority of her work focused on characters in popular culture, some of Boty's other paintings depicted her political heroes, such as Fidel Castro.

left
Peter Blake
(b. 1932, Dartford, UK)
Girls with their Hero,
1959–1962
152.4 x 121.9 cm
Oil on hardboard
Pallant House Gallery,
Chichester, UK
(Wilson Gift
through The Art Fund)
© DACS 2007

right
Pauline Boty
(b. 1938, Surrey, UK, d. 1966)
Celia Birtwell and her Heroes,
1963
152.4 x 121.9 cm
Oil on canvas
The Women's Art Library
Collection, London, UK
© Estate of Pauline Boty

In *I Wonder what my Heroes Think of the Space Race*, Derek Boshier was also principally interested in his personal heroes, set within a painted vision of the modern world. Boshier was familiar with the writing of Daniel J Boorstin who, in 1962 published the popular *The Image or What Happened to the American Dream*. In the book Boorstin examines the difference between hero and celebrity; the hero was distinguished by his achievement, the celebrity by his image or trademark. The hero creates himself; the celebrity is created by the media and the fan: "The hero was a big man; the celebrity is a big name."[15] Boshier was suspicious of the workings of the world of mass media, and would have consciously selected heroes as opposed to celebrities. In *Pop Goes the Easel* he describes three of his heroes, Lord Nelson (the eighteenth century Admiral of the Fleet), President Lincoln (US president from 1861 to 1865) and Buddy Holly (the then contemporary rock 'n' roll star). Boshier describes Nelson as a childhood hero, brought up, as he was, in a naval family. Lincoln and Buddy Holly are chosen because of "something to do with their background: they were both born in a small town in the Southern States and both in their own way, rose from that to effect the people who lived in the same generation as them. One thing they all had in common was that they died a hero's death: Nelson at sea, Abraham Lincoln assassinated and Buddy Holly in an air crash on his way to making a debut in this country."[16]

In terms of contemporary popular culture Boshier remarks: "Buddy Holly really personifies everything I like about Pop singing, Pop heroes and I suppose heroes in general." Although Holly was a celebrity, he also made a significant contribution to Pop music which, for Boshier, elevated the star from the status of celebrity to the rank of hero.

Kitaj's heroes were largely culled from literature and history, but he also made paintings that referred to characters from popular culture such as film directors and baseball players. *Poets Series, First Series: Some Poets* was made up of ten screenprints, which were largely portraits of writers influenced by Ezra Pound and linked with the Black Mountain College in Carolina. Kitaj considered Robert Duncan to be one of America's greatest poet-scholars. While in some senses he idolised Duncan, Kitaj also befriended him while teaching at the University of California in 1967. Unlike other Pop artists such as Tilson and Warhol, Kitaj's heroes were from the world of literature and philosophy, rather than more mainstream popular culture. His interest in the scholarship behind the study of iconography enabled him to conceive of the picture plane as the site for a complex personal amalgamation of different figurative elements or symbolic images. His personal interest in literature and his own Jewish heritage led him to incorporate (often obscure) references that only bore a personal

15 Boorstin, Daniel J, *The Image or What Happened to the American Dream*, Salt Lake City: Athenaeum Press, 1962, p. 70.
16 Derek Boshier in *Pop Goes the Easel*, BBC Monitor series, directed by Ken Russell, BBC Archives, London, UK © Ken Russell, 1962.

Derek Boshier
(b. 1937, Portsmouth, UK)
*I Wonder What My Heroes
Think of the Space Race*, 1962
241 x 174 cm
Oil on canvas
Government Art Collection,
London, UK
© The artist

meaning, but Kitaj hoped that the multi-layered nature of his works would allow people with a diverse range of interests to relate to his art. Kitaj shared a method with other Pop artists through the practice of incorporating photographs, texts, drawings and collage into his screenprints. These images included both visual material from the media as well as personal ephemera, indeed the photograph at the top of *Star Betelgeuse, Robert Duncan* was of his lifelong companion, Jess Collins.

Like Blake, Warhol was a fan of Elvis and chose to depict him in his first music-themed painting in 1963. Warhol's time capsules (boxes full of the ephemera collected throughout his life) reflect his own enthusiasm for popular culture, and his long-held conviction that this material was of cultural and artistic importance. His early boxes contain fan memorabilia, such as celebrity photos and film magazines; even the marked up photographs and collages which he used for some of his most famous celebrity portraits, such as *Marilyn* and *Jacqueline*.

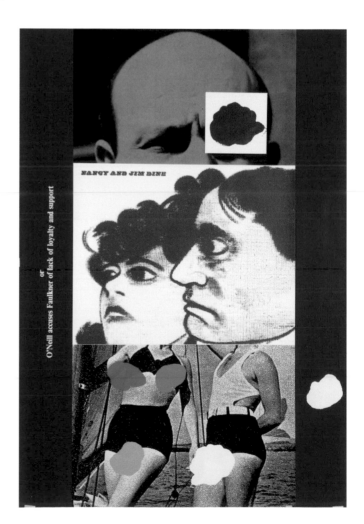

R B Kitaj
(b. 1932, Cleveland, USA)
Star Betelgeuse Robert Duncan, 1967
72 x 51 cm
Screenprint
Wolverhampton Art Gallery,
Wolverhampton, UK
© DACS London/VAGA
New York 2007

R B Kitaj
(b. 1932, Cleveland, USA)
Nancy and Jim Dine,
1969–1970
84.8 x 58.4 cm
Screenprint
Wolverhampton Art Gallery,
Wolverhampton, UK
© DACS London/VAGA
New York 2007

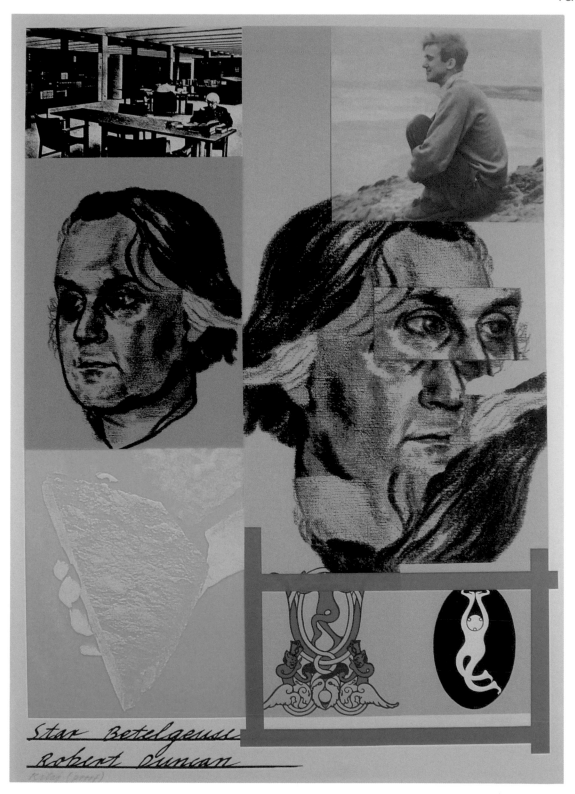

Star Betelgeuse
Robert Duncan

Marilyn Monroe

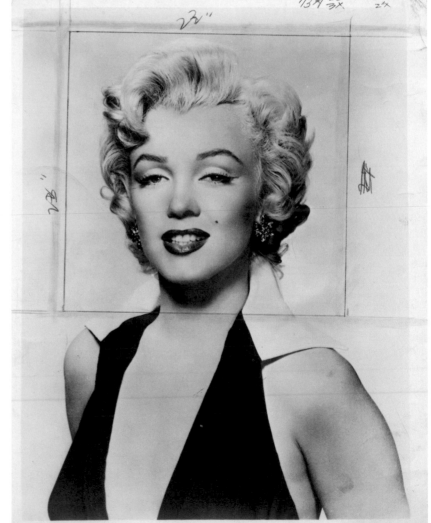

Andy Warhol
(b. 1931, Pittsburgh, USA,
d. 1987)
Mechanical (Marilyn Monroe),
c. 1953, source for Warhol's 1962
Marilyn series
25.9 x 20.3 cm
Gelatin silver print with ink
The Andy Warhol Museum,
Pittsburgh, USA
Founding collection
Contribution The Andy Warhol
Foundation for the Visual Arts, Inc.
© Licensed by The Andy Warhol
Foundation for the Visual Arts,
Inc/ARS New York and DACS
London 2007
© TM 2006 Marilyn Monroe,
LLC by CMG Worldwide Inv.,
Indianapolis, Indiana,
46256 USA
www.MarilynMonroe.com

A career in film had launched a number of women to iconic status in the 1950s and 60s, but probably the most famous of these was Norma Jean Baker, or as she is generally known, Marilyn Monroe. Andy Warhol began his first portrait of her soon after the announcement of her death in August 1962. He based the work on Gene Korman's publicity still from the film that launched her into stardom in 1953; *Niagara*—an image showing her flush in her prime nine years earlier, with her characteristic mix of vulnerable, childish innocence and sexual allure.

In the same year Warhol had begun screenprinting images onto canvas—using what at the time was considered a commercial process, normally associated with printing packaging. Silkscreen however, enabled him to use found photographic sources—as the photographic image could be easily transferred on to the screen photo-mechanically. His fairly crude handling of the technique created a grainy, strongly contrasted effect, reminiscent of newspaper images. No matter how distorted, the image of Marilyn was instantly recognisable. Warhol also used bold, naive strokes of colour to further emphasise the blonde hair and glamour make-up so often associated with her public image. He worked on over 30 different versions of this portrait in the two years after the star's death, all based on the same publicity still by Gene Korman. The floating use of colour denotes the superficiality of her Hollywood image, the mask that concealed the sadness which led to her suspected suicide. Marilyn herself was unhappy with her public persona, stating that: "A sex symbol becomes a thing. I just hate being a thing."[17]

Warhol was not the only artist in the 1960s who was moved by her death. Such was her iconic status that nearly 20 artists painted her portrait during this period.

A sex symbol becomes a thing. I just hate being a thing. – Marilyn Monroe

Allan D'Arcangelo
(b. 1930, Buffalo, USA, d. 1998)
Marilyn, 1962
152.4 x 139.7 cm
Acrylic on canvas with scissors
University of Buffalo Art Galleries, Buffalo, USA
© DACS, London/VAGA New York 2007

17 Walker, John A, *Art and Celebrity*, London: Pluto Press, 2003.

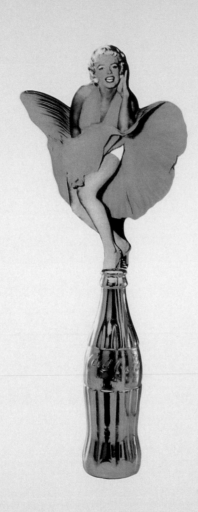

STUDY FOR SCULPTURE
1967 (COKE & MARILYN) 3/8 Clive Barker 1997

Pauline Boty celebrated the femininity of Monroe, she depicted the female icon walking down the street wearing a fur stole and flanked on either side by large blocks of abstract colour, as if to suggest her vulnerability in an increasingly closed-in world. Clive Barker used one of the most iconic images of Marilyn from the film *Seven Year Itch*—and put her on a Coke bottle, emphasising the similarity between the marketing of product and person in post-war culture. This compares with Ray Johnson's *Hand Marilyn Monroe*, 1958, a collage of a hand the same size as a figure of Marilyn Monroe posing seductively, suggesting the Hollywood star was seen and used as a consumable sex toy. Richard Hamilton used a contact sheet by the photographer George Barres as the basis for his *My Marilyn*, where Monroe had scratched out the images she did not like—the aggressive nature of the 'X' over her own image implies the self-loathing that eventually led to her premature death, and the star's futile attempt to control her public persona. Hamilton further highlights the complex and mysterious relationship Monroe had with her celebrity status by painting out her features and parts of her body.

In depicting the characteristics of fame, Allan D'Archangelo uses the image of a child's toy where the facial features can be added and arranged as a basis for his *Marilyn*—a symbol which neatly suggests both the vacuous nature of celebrity beauty, with a blank face, and the artificiality of the Hollywood publicity machine which creates the look of each actress.

opposite
Clive Barker
(b. 1940, Luton, UK)
*Study for Sculpture
(Coke and Marilyn)*, 1969
55 x 80 cm
Screenprint
Wolverhampton Art Gallery,
Wolverhampton, UK
© Clive Barker

Richard Hamilton
(b. 1922, London, UK)
My Marilyn, 1965
55 x 80 cm
Screenprint
Tate Gallery, London, UK
© Richard Hamilton
All Rights Reserved
DACS 2007

Music

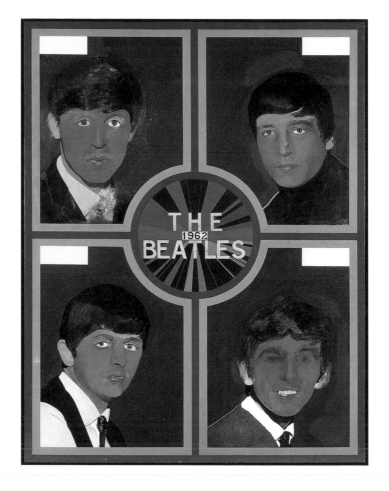

Just as Hollywood directly inspired Pop artists, so did music. The impact of the arrival of rock 'n' roll in the late 1950s, and in particular Elvis Presley's succession of hits, starting with *Heartbreak Hotel* in 1956, had an enormous impact on popular youth culture. It was perceived as a sharp deviation from past traditions, a breaking down of hierarchies and the beginning of a new era in music and politics. Elvis was a new kind of sex icon, a style leader and all-around American. For the British youth, including the young Pop artists at the time, the release of American records and the subsequent UK tours of bands such as Bill Hayley and the Comets, introduced the world to American culture as something exciting, young and desirable. Such was the allure that Peter Blake, Richard Smith, and Clive Barker all saw musicians like Bill Hayley perform. Jazz and rhythm and blues were equally popular, and again inspiration poured in from America, flooding popular culture with the likes of John Coltrane and Ornette Coleman. Peter Blake was a member of the Dartford Rhythm Club in his youth, indeed in the early 1960s his main ambition as a Pop artist had been for his work to achieve the directness and distribution of Pop music.

Peter Blake
(b. 1932, Dartford, UK)
The Beatles 1962, 1963–1968
122 x 91.6 cm
Acrylic emulsion on hard board
Pallant House Gallery,
Chichester, UK
(Wilson Gift
through The Art Fund)
© DACS 2007

From 1963–1968 Blake worked on a portrait of The Beatles, though he never finished it. Rather than collage publicity shots, Blake painted portraits of the four members of the band, using a magazine image as his working source. The painted framework echoes a graphic design layout while the different colour auras around each figure refers to a misregistration of colour printing. Besides being a fan, Blake was interested in the almost universal appeal of the band, indeed such was his fascination that he was later to design the cover for The Beatles' *Sgt. Pepper's Lonely Hearts Club Band* album in 1967.

In other music portraits by Blake, the imagery is derived directly from record sleeve designs, driven by the artist's personal enthusiasm for the music, for example, *Bo Diddley* and *The Beach Boys*. Indeed he made two portraits of Bo Diddley, but one was lost when the artist left it in a hotel reception as a gift for the musician.

In 1963, Peter Blake married Jann Haworth, and in the same year a family trip took him to Los Angeles. Blake finally visited the country that, for many young people living through Britain's post-war depression, provided colour, excitement and exposure to a new kind of a youth and a new kind of freedom. Blake returned with many subjects for his work but one of his most poignant memories was cruising down Venice Beach in a Corvette Stingray, while listening to The Beach Boys for the first time. Blake was so affected by the excitement and promise of that experience that he sought to replicate it through *Beach Boys*, 1964, by combining an image from the LP sleeve *Shut Down Volume 2*, with decorative lettering in a bright striped framework of primary colours, reminiscent of the fairground art and decorative poster typefaces that were so influential at the time.

In *Pop Goes the Easel* the artists are all depicted working to music. Derek Boshier and Pauline Boty were even chosen to dance on *Ready Steady Go*; a live music television programme presented by Cathy McGowan, that had its audience dancing to the popular music of the day, both in the studio and at home.

Both the title and the subject of Pauline Boty's *My Colouring Book*, 1963, is based on the song on Dusty Springfield's first solo album in 1963. In the painting Boty quotes the lyrics almost entirely, dividing them up amongst six images arranged in two rows. The lyrics are in Letraset transfers but the painted images are a mixture of expressionistic abstracts and reproductions of magazine images. Through the language of colour, Boty tells the story of a girl rejected by her lover, using painterly materials as a starting point from which to tell the story of young, unrequited love.

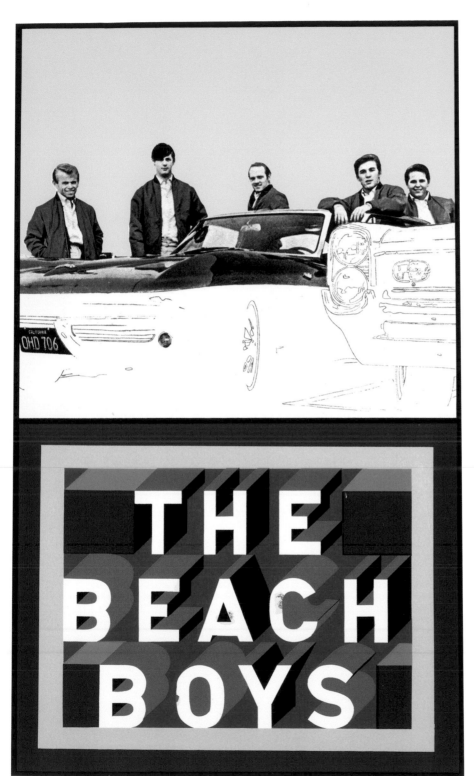

Peter Blake
(b. 1932, Dartford, UK)
The Beach Boys, 1964
53 x 30.5 cm
Screenprint
Wolverhampton Art Gallery,
Wolverhampton, UK
© DACS 2007

Warhol was also an avid popular music fan, his contemporaries often commented on the way the artist played music when he was working. In the early 1960s, visitors such as art dealer, Ivan Karp and curator, Henry Geldzahler, would find Warhol working with the same single record endlessly repeating. He often had the television, radio and record player going at the same time, reportedly in an attempt to make his mind as empty as possible.

Between 1965 and 1967 Warhol became directly involved with pop music by befriending the rock band The Velvet Underground. Attracted to the raw energy and experimental nature of their music, Warhol initially used them to provide the backing tracks for his films. He designed the record sleeve for the album *Velvet Underground and Nico* in 1967, with an innovative sticker of a silk-screened banana which, when peeled, revealed flesh coloured fruit. The German singer, Nico, who was part of the band at the time, was eventually the star of Warhol's film *Chelsea Girls*, 1965. In April 1966, Warhol launched *Exploding Plastic Inevitable* at the Dom (Polsky Dom Narodny Hall) in New York's East Village, which was a multi-sensory event including music, dancing, light shows and performances by his resident Factory cohorts (for example, Gerard Melanga and his whip dance). The events were designed to overload the senses, particularly with the loudness of the music and use of feedback, in order to achieve an almost drug-like trance. *The Exploding Plastic Inevitable* reached such popularity that it (and its cast of artists and musicians) eventually travelled to different venues across America.

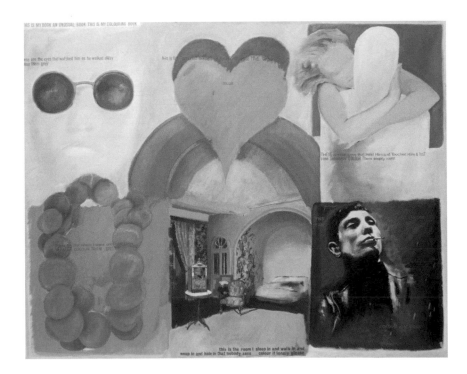

Pauline Boty
(b. 1938, Surrey, UK,
d. 1966)
My Colouring Book, 1963
121.9 x 152.4 cm
Oil on canvas
The Women's Art Library,
London, UK
© Estate of Pauline Boty

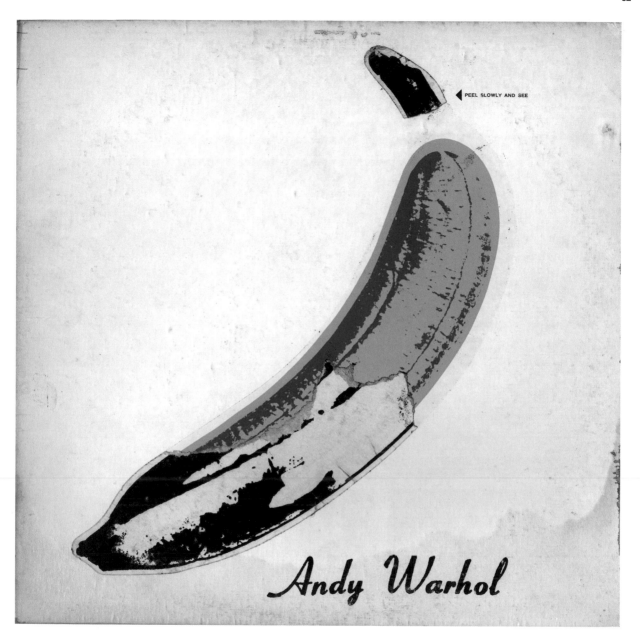

PEEL SLOWLY AND SEE

Andy Warhol
(b. 1931, Pittsburgh USA, d. 1987)
The Velvet Underground and Nico, 1967
31.1 x 31.4 cm
Record cover (on Verve Records; produced by Andy Warhol;
cover design by Andy Warhol; photographs by Nat Finkelstein,
Billy Name, and Paul Morrissey)
The Andy Warhol Museum, Pittsburgh, USA,
Gift of Charles Pounds
© Licensed by the Andy Warhol Foundation for the Visual Arts,
Inc/ARS New York/DACS London 2007

record cover

Other artists also had special affinities with particular musicians. Richard Hamilton's subject of choice was Mick Jagger of The Rolling Stones. The band represented a contemporary youth suppressed by draconian, old-fashioned laws and institutions. Hamilton's fascination with them was spurred when members (along with art dealer Robert Fraser) were arrested for the possession of drugs. *The Times* editorial: "Who Breaks a Butterfly on a Wheel", questioned the justice of serving a disproportionately punitive sentence to Jagger because he was a pop celebrity. Richard Hamilton was also shocked, particularly as Robert Fraser was his dealer at the time. "I had felt a strong personal indignation at the insanity of legal institutions which could jail anyone for the offence of self-abuse with drugs." It was when he saw Robert Fraser's collection of press cuttings that he decided to make a print.

Hamilton's collage of newspaper cuttings relating to the event highlight the extreme language and manipulative power the media could wield. The work, with the artist's emphasis on blobs of paint and collaged elements, was printed as a photo-offset lithograph. Hamilton particularly picked up on the judge's declaration: "There are times when a swingeing sentence

Richard Hamilton
(b. 1922, London, UK)
Swingeing London 67
1968–1969
67 x 85 cm
Oil and screenprint on canvas
Tate Gallery, London, UK
© Richard Hamilton
All Rights Reserved
DACS 2007

can act as a deterrent." Only a year before, *Time* magazine had coined the phrase 'Swinging London' and included Fraser's gallery as one of the lively art spaces in London. This led to the title of the work, *Swingeing 67,* which was published in an edition of 1,000 in 1968. Art dealer, Robert Fraser, persuaded The Beatles to use an artist for another album cover in 1968. Richard Hamilton's concept was to flout the conventions for record sleeve design and keep the exterior of the sleeve completely white, with only 'The Beatles' embossed in small letters, and numbering each sleeve like you might a limited edition book. Though the album was meant to be named after the band, it is a testament to the impact of the design that it came to be generally known as 'The White Album'. The poster inside was a collage work Hamilton generated from photographic material supplied by members of the group.

Pop artists also created more generic images of pop singers and music. *Pop Singer,* 1970, was created by American artist Larry Rivers, who had trained as a musician in New York and worked as a professional jazz saxophonist during the 1940s. Toward the end of that decade, he began studying art and was principally known as a painter by the 1950s. Rivers became associated with Pop Art when he began using 'found' subjects, painting reproductions of famous works such as *Washington Crossing the Delaware,* 1953, as well as various elements of packaging and commercial graphics; playing cards, menus, cigarette packets, bank notes and magazine photos of US Civil War veterans. His paintings of everyday themes were, however, executed in an expressive, gestural style. This combination particularly influenced the young British Pop artists, Allen Jones and David Hockney, who came into contact with his work through art magazines and, eventually, during his sojourn in London and Paris from 1961 to 1962.

Pop Singer is a simple construction. The image (probably derived from a magazine image or record sleeve) is built from three acrylic sheets assembled much like a three-dimensional collage or pop-up illustration. Yet this simplicity is set off by the delicate draughtsmanship of the artist's drawn lines. In his characteristic style, Rivers has refrained from flooding the image with detail, but rather uses a minimal amount of form to give rise to a certain intensity of expression without eclipsing the viewer's imagination. This enigmatic work has, therefore, a more haunting personal quality, in addition to the obvious interpretation of a mass produced pop star as a cardboard puppet packaged in a box. With the advent of affordable portable record payers and radios, record-collecting became a popular hobby. The phenomenon of rock and pop was of great interest to young artists, who experimented with everything from the titles and content of songs, to the spectacle of live and recorded performance. Art and music shared a close relationship in the 1960s, a number of key musicians attended art schools, including John Lennon and Pete Townsend, and such colleges were regular venues for upstart pop musicians and jazz bands. More established musicians were taking up elements of new

Larry Rivers
(b. 1923, New York, USA,
d. 2002 as Yitzhok
Loi Za Grossberg)
Pop Singer, 1970
35.5 x 43.2 cm
Mixed media, paper, perspex
Wolverhampton Art Gallery,
Wolverhampton, UK
© DACS, London/VAGA
New York 2007

art forms in performance around this time too. Bands such as Pink Floyd began incorporating light shows into their sets to provide a total multi-sensory environment. In America, The Velvet Underground attempted similar effects when they developed sophisticated light shows for Warhol's *Exploding Plastic Inevitable*, the West Coast dance halls, the Fillmore and the Avalon.

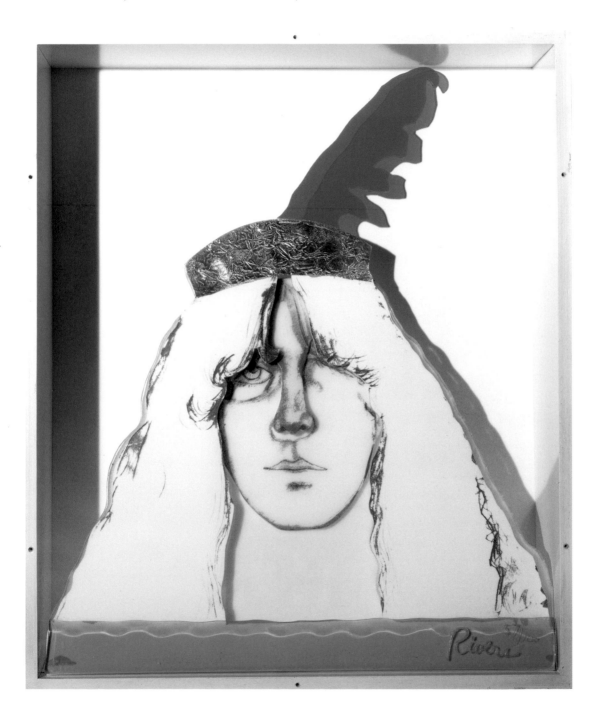

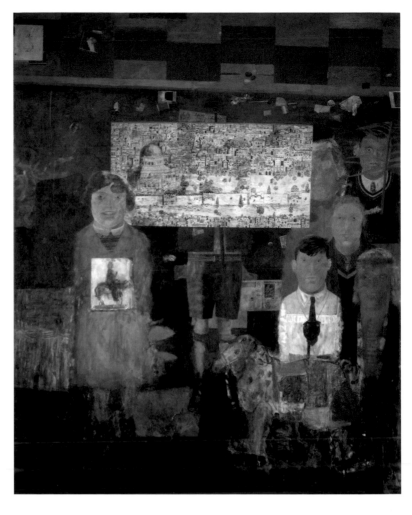

Nostalgia

Pop Art is often thought of as a younger generation's reaction to the concrete aesthetic relationship the art establishment had with post-war society. While the subject matter in many artists' work was dominated by popular culture, it was not necessarily contemporary popular culture. Pop artists are generally divided into two generations. In the UK, the older generation were born in the 1920s and grew up during the Depression of the 1930s and reached maturity during the Second World War. The younger generation were born in the 1940s, and were more experientially linked with the changes in society following the war. There was a strong element of nostalgia amongst both generations of Pop artists—often resulting in references to the 1930s and 1940s in their work. In addition, there were references to traditional popular culture, which stemmed back to the early nineteenth century—whether it be fairground lettering, popular illustration or images from the pioneering settler days in America Peter Blake said: "For me, Pop Art is often rooted in nostalgia: the nostalgia of old, popular things... and although I'm also continually trying to establish

Peter Blake
(b. 1932, Dartford, UK)
*Preparation for the Entry
into Jerusalem*, 1955–1956
125 x 101.5 cm
Oil on hardboard
Royal College of Art,
London, UK
© DACS 2007

a new Pop Art, one which stems directly from our own time, I'm always looking back at the sources of the idiom and trying to find the technical forms that will best recapture the authentic feel of folk pop."[18] Blake acknowledges the place of the Independent Group and the direct influence of American painters Jasper Johns and Rauschenberg, but said that he mainly just took himself as the primary source for his work, ultimately drawing on his interests and experiences.

18 Blake, Peter and Mervyn Leyy Peter, "Blake a: Pop Art for the admas" in *Studio International*, November 1963, p. 184.

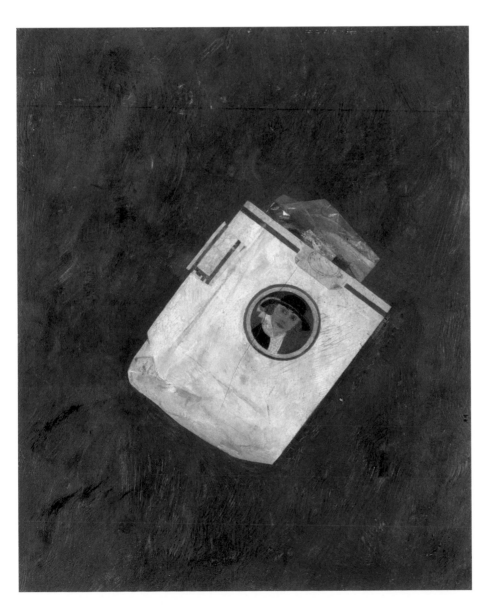

Peter Blake
Cigarette Packet, 1955
22.8 x 22.8 cm
Oil on board
Wolverhampton Art Gallery,
Wolverhampton, UK
© DACS, 2007

> **Pop Art is often rooted in nostalgia: the nostalgia of old, popular things. – Peter Blake**

Blake has a very personal enthusiasm for popular graphics, which he has collected since childhood. As one of the earliest Pop Art painters in Britain, Blake made pioneering use of themes from his everyday experience, ranging from images of wrestlers to political statements. Topics of particular personal significance for the artist are worked into the detail—badges, magazines, packaging and other ambient graphic material. At times, Blake painted pictures of children surrounded by nostalgic ephemera, performing typical childhood activities like reading comics, staging nativity plays or standing on chairs, often surrounded by discarded packaging, photographs or postcards that provided the details necessary to create a context for the subjects depicted.

This fascination with nostalgia (and the popular material that would be the nostalgic content of the future) was further developed during and after his travel scholarship in 1956. Blake received a first class diploma from the Royal College of Art, and won the Leverhulme Research Award, enabling him to study art in Europe for one year. When he returned to Britain, Blake brought back a large collection of bus tickets, wrestling programmes, circus posters, packaging, postcards, advertising and numerous sketches and small oil paintings of pebbles on a beach, a lost shoe and a matchstick.

On the Balcony is a complex composition of things such as postcards, reproductions of famous paintings and newspaper images of the royal family mingling with the common detritus of post-war commercial culture. In fact, it has been observed that On the Balcony is almost like a "small encyclopedia of themes that were later taken up by both English and American Pop".[19]

19 Russell, J and S Gablik, *Pop Art Redefined*, London: Thames and Hudson, 1969, p. 40.

Peter Blake
(b. 1932, Dartford, UK)
On the Balcony, 1955–1957
121.3 x 90.8 cm
Oil on canvas
Tate Gallery, London, UK
© DACS 2007
Image courtesy of the artist

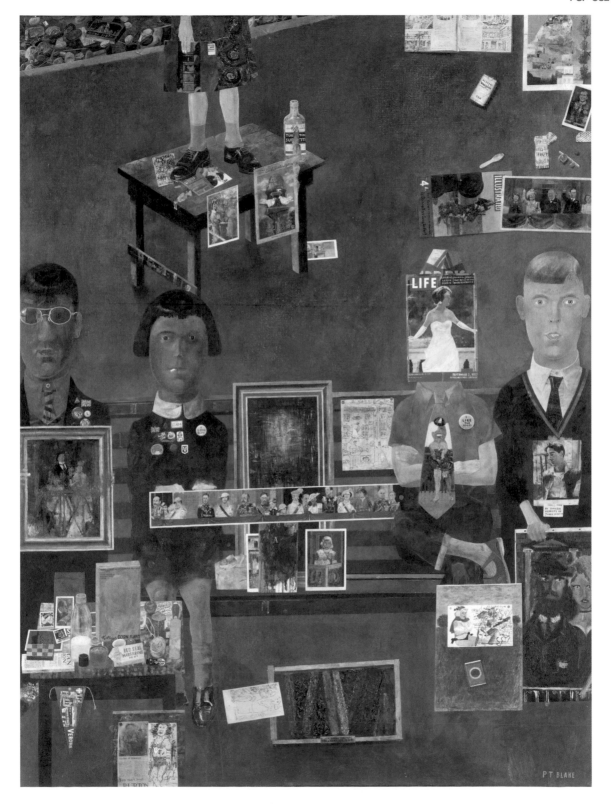

On the Road

The concept of the 'open road' deeply appealed to artists who associated the American highway with ideals of individual liberty and the freedom to roam the 'land of opportunity'. US highways that spanned thousands of miles were elevated to an almost mythic status as symbolic of the youth and promise of a new America. Literature and film began to take up themes of the open road and infuse them with the danger and excitement of a younger, less fettered, popular culture; a prime example being Jack Kerouac's cult novel *On the Road*, 1957. Films arising from these concepts famously include *The Wild One*, 1953, starring Marlon Brando (which was banned in many cinemas in both Britain and America), and *Rebel without a Cause*, 1955, with James Dean. Both films personified the youthful rebel and his quest for freedom—a theme that was linked to the rise of a clearly recognisable youth culture in the 1950s. These film characters inspired no shortage of Pop artists to make works in their image.

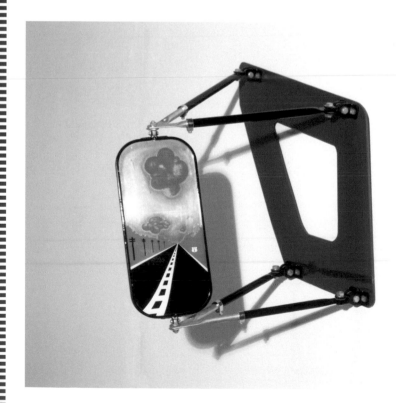

Allan D'Arcangelo
(b. 1930, Buffalo, USA
d. 1998)
Yankee 290, 1970
49.5 x 30 x 16.8 cm
Perspex and steel
Wolverhampton Art Gallery,
Wolverhampton, UK
© DACS 2007

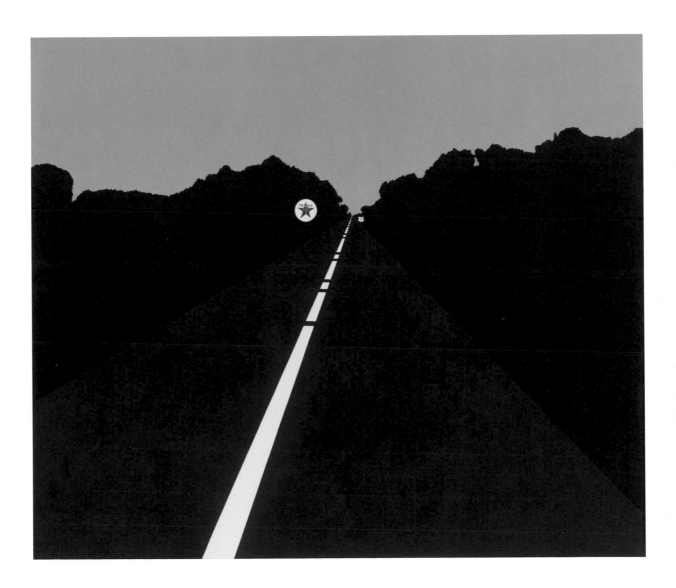

Allan D'Arcangelo
(b. 1930, Buffalo, USA, d. 1998)
U S Highway 1, No. 5, 1963
177.6 x 207 cm
Synthetic polymer paint on canvas
The Museum of Modern Art, New York, USA
© DACS London/VAGA New York 2007
Image courtesy of The Museum of Modern Art,
New York/SCALA, Florence

In 1956 the American Congress dedicated enormous sums of its defence budget to the development of a nationwide, interstate highway spanning over 40,000 miles. Though they appealed to national pride and the pioneering tradition, these new freeways did not often deviate from a standardised aesthetic—extremely long roads bissecting undeveloped landscapes, the monotony of which was only interrupted by the occasional gasoline station, chain restaurant or motel. These uniquely American amenities were themselves franchised, and had a reliable look and feel that varied little from place to place, giving rise to a sort of disembodied Americana that people from all over the country could relate to. Robert Indiana, Allan D'Archangelo and Ed Ruscha all alluded to the main routes across America in their work—simply quoting their numbers would make them instantly recognisable to Americans.

Allan D'Arcangelo was fascinated by these highways. *Yankee 290* was a sculpture made out of a lorry's wing mirror, protruding from the wall, as it would on such a vehicle. On the back of the mirror are black and yellow hazard stripes, but on the mirror itself, D'Arcangelo has painted a distant view of the highway receding into the distance. This view would be recognisable to any highway driver—the endless road stretching out in front and behind, made more surreal by the childish depiction of the clouds and stick-like telegraph poles disappearing into the horizon.

Most of D'Arcangelo's early paintings focus on themes of the open road, which are often depicted in twilight or with a night sky. In *June Moon*, 1969, there are four views of the road with the moon in the distance combined onto one canvas. As the moon rises, it reveals itself as the logo of the Gulf gasoline company. As in commercial graphics the design is simplified: the flat colour planes emphasise the geometric pattern of the asphalt and the dynamic diagonals receding into the distance. Nature is condensed into a simple black silhouette. In D'Arcangelo's representation the modern traveller is no longer guided by stars and moon. Instead, the hum of gasoline stations and motels become the modern landmark.

Alongside representations of the American freeway, were themes of the American car, celebrating the individual, the all-American male and the drive of consumer culture. Owning a large American car was an essential component of realising the American dream, and completed a package that included a family, a white-collar job and a home in a pleasant suburban neighbourhood.

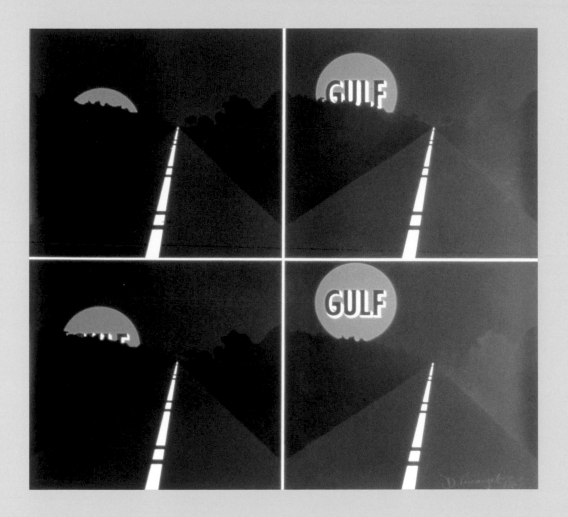

Allan D'Arcangelo
(b. 1930, Buffalo, USA,
d. 1998)
June Moon, 1969
59.7 x 64.9 cm
Screenprint
University of Buffalo Art
Galleries, Buffalo, USA
© DACS London/VAGA
New York 2007

POP GOES THE EASEL

In 1962, the British film director, Ken Russell, made a film for the BBC Monitor Series, based on the lives and work of four emerging young artists: Peter Blake, Derek Boshier, Pauline Boty and Peter Phillips. All of the artists featured made a significant contribution to Pop Art, even Pauline Boty—who died a few years after the film was made—was subsequently recognised as one of the most important female artists of the time. The title *Pop Goes the Easel* was a reference to the Pop Art movement itself, to which these four artists were making a significant contribution at the time.

The film is formally introduced by presenter Huw Weldon, but proceeds from a rather stiff beginning to become a snappily-edited, at times surreal, representation of Pop Art. The artists are shown going about their daily lives, referencing the influences on their artistic practice and talking directly about their work. Peter Blake muses about Brigitte Bardot, Peter Phillips plays pinball and practices target shooting, Derek Boshier eats his breakfast and contemplates cereal packaging and Pauline Boty is filmed back-combing her hair in preparation for a night out. Many of the scenes are designed to give a personal context to the rise of Pop Art, and an account of the everyday experiences and influences behind the movement. The film ends with a shot of the artists 'twisting' at a party with various other art students, including David Hockney.

Peter Blake in his studio
Still from *Pop Goes the Easel*
BBC Monitor Series, 1962
Directed by Ken Russell
(b. 1937, Southampton, UK)
BBC Archives, London, UK
© Ken Russell

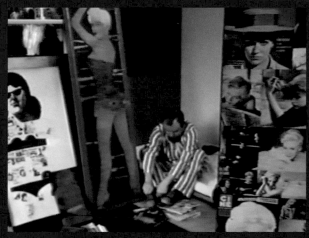

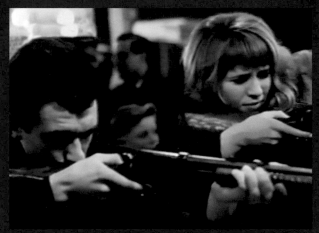

clockwise from top left
Peter Blake in his studio
Derek Boshier eating his breakfast
Pauline Boty and Peter Phillips (from left to right)
at the fairground
Peter Phillips reading a horror magazine
Stills from *Pop Goes the Easel*
BBC Monitor Series, 1962
Directed by Ken Russell
(b. 1937, Southampton, UK)
BBC Archives, London, UK
© Ken Russell

S

SCI-FI AND HORROR MOVIES

Many Pop artists made reference to characters from classic films of the 1920s and 30s, including *King Kong*, *Dracula* and other science fiction titles. These references might be the inclusion of a detail, like Tilson's use of contact strips of images of King Kong and a Laurel and Hardy film in *Cut Out and Send*. Some artists, such as Nicholas Monro, created whole works based on subjects from sci-fi and horror movies. Indeed *King Kong* was his model for a 23 foot high sculpture, commissioned by the Peter Stuyvesant City Sculpture Project, for a site in Birmingham surrounded by tower blocks. In a playful interaction with the physical and cultural environment, Monro exhibits his characteristic sense of humour by planting this giant ape in the middle of an urban area. Other sculptures included *Coco the Clown* 1977, *Grimaldi*, 1979, and TV comedians *Morecambe and Wise*, 1977, and music hall comedian *Max Wall*, 1978.

Horror films also inspired Pop artists, particularly Bela Lugosi, the actor who became permanently identified with the horror films of the 1930s and 40s after his role as the Vampire Count in *Dracula*, 1930. He was depicted in Warhol's 1963 screenprint, *The Kiss (Bela Lugosi)*, which was based on a still from the 1932 film *Dracula*, depicting the actor kissing the neck of his co-star Helen Chandler. Lugosi's fan club newsletter provided the framework for Joe Tilson's political work *Bela Lugosi*, where he presented contemporary media images of horror and fantasy.

Nicholas Monro
(b. 1936, London, UK)
King Kong, 1971
135 x 119 x 42 cm
Painted fibreglass sculpture
Wolverhampton Art Gallery,
Wolverhampton, UK
© The artist

Jim Dine depicts the 'wolf man' (a popular American movie theme) in
The Wall, made during the four years that he spent in London from 1967 to
1971. During this time he became very involved in writing poetry, particularly
in exploring the relationship between pictorial and literary themes. In
The Wall, words are arranged like concrete poetry, so that their physical
arrangement both echoes the outline of the image but also controls how
the words are said, creating a slow moving staccato tempo reminiscent of
horror movies themselves. The image is etched, imprinted into the thick
deckle-edged paper, in the manner of a traditional fine art print. As in
many of his works, although Dine draws images from popular culture and
everyday objects, *The Wall* is a personal expression rather than a comment
on mass culture.

Jim Dine
(b. 1935, Cincinnati, USA)
The Wall, 1967
76 x 54 cm
Etching, letterpress,
rubber stamp
Wolverhampton Art Gallery,
Wolverhampton, UK
© ARS New York/DACS
London 2007

TICS

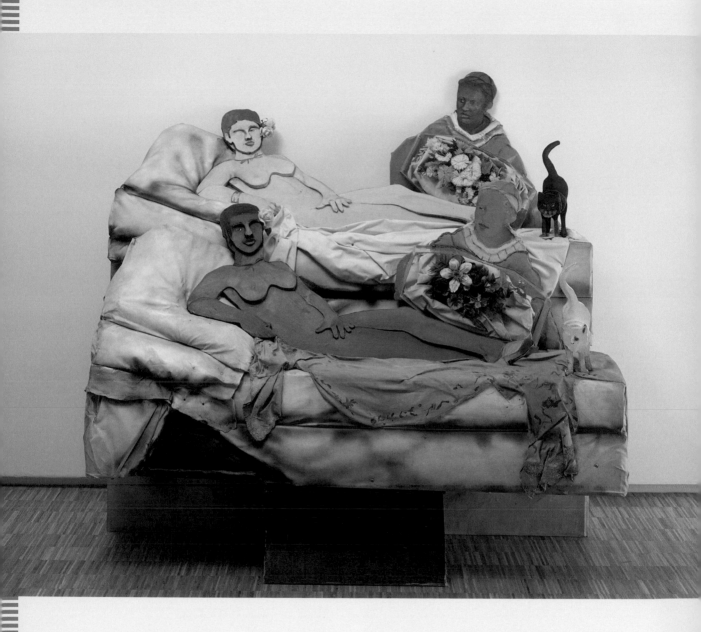

Larry Rivers
(b. 1928, New York, USA)
I Like Olympia with a Black Face, 1970
182 x 194 x 100 cm
Oil on wood, canvas with plaster, plastic and plexiglas
Musée d'Art Moderne, Centre Georges Pompidou, Paris, France
© DACS London/VAGA New York 2007
Image courtesy of Photo CNAC–MNAM Dist. RMN/Philipe Migeat

POP AND POLITICS: REDS, BLACKS, PURPLE HEARTS AND MOON DUST

The late 1950s and early 60s were dominated by the growth of a young, international popular culture. Whilst the previous generation had been bound together by the barren years of the 1920s and 30s, the war and the shortages of the 40s, the focus of this new generation was dominated by the concept of the individual. Young writers, musicians and poets spun tales of individual freedom, of travel and drugs, of sexual freedom and new Eastern religions. The concept of the hero, though alive and well, had changed; it was no longer Jimmy Stewart but rather it was Marlon Brando and James Dean. Theirs were characters that captured the popular imagination; dependant only upon themselves, carving their own path through the post-war landscape. Great emphasis was placed on the power of the individual to create his or her own freedom and future. This was manifest throughout the 1960s not only in movies, literature and music, but also in protests, demonstrations and marches. Participants were drawn from across the social spectrum, some motivated by their belief in political ideologies, others by the conflict in Vietnam and the rising spectre of nuclear war. Young people who felt excluded by the existing political system and buoyed up by a new youth-focused culture, were presented with a dynamic arena and an opportunity for political participation, a chance to shape the world they were due to inherit. The key issues occupying this new political activism, all intrinsically linked, were civil rights, racial equality and the nuclear threat. Consequently, these are some of the dominant issues reflected in the work of Pop artists.

The Civil Rights Movement brought Americans onto the streets in their thousands, influenced by a number of charismatic leaders. Foremost among them was Martin Luther King Jr The Movement brought the level of racism existing in modern America (the supposedly progressive leader of the Western World) to worldwide attention. Ralph Ellison's novel *The Invisible Man* published in 1952, was for many the opening gambit in civil rights activism:

> I am an invisible man. No, I am not a spook like those who haunted Edgar Allen Poe; nor am I one of your Hollywood movie ectoplasms. I am a man of substance, of flesh and bone, fibre and liquids —and I might even be said to possess a mind. I am invisible, understand, simply because people refuse to see me.

Ellison weaves a story of the black experience both in regard to white privilege and the black Civil Rights Movement in Harlem. This subject matter was new to American audiences, and combined with extensive coverage in the media, exposed the racial segregation ubiquitous in the southern states, where public services and amenities had designated black only and white only areas. The work of American artists such as Larry Rivers, Robert Indiana and Allan D'Arcangelo deals with these unspeakable aspects of American society and the resistance faced by civil rights

activists, some of whom paid for their activism with their lives. Despite this unrest, the 1960s began with a spirit of optimism marked by the election of the young war hero John F Kennedy as the 35th president of the United States in 1961. His promise of social reform and a bright technological future was seductive, and the media fuelled his rapid rise to power. He was young, good looking and offered a fresh vision of the future, especially when contrasted with the incumbent Richard Nixon. This was seized upon by Pop artists in both America and Britain, such as James Rosenquist, Andy Warhol and Richard Hamilton, who used images from his campaign in their work. When he was assassinated in Dallas in 1963, his death was mourned across continents. If in life, Kennedy was a symbol of a new America, in death his image became an icon of the age.

This era in international politics was also characterised by the looming spectre of the Cold War. This was a war largely fought in the imagination of the public with nationalistic strategic threats and displays of strength. Whilst international espionage filtered secrets from East to West and vice-versa, the spy was given life in the popular imagination through the daring escapades of film characters such as James Bond. The technological advances fuelled by war led to great leaps in space exploration; the Russians sending the first man into space, cosmonaut Yuri Gagarin, in 1961, and the US with astronaut Neil Armstrong taking the first steps on the moon eight years later in 1969. This propaganda and muscle flexing gently ratcheted up the levels of fear and paranoia amongst the general public. In 1962, this anxiety was brought to life with the Cuban Missile Crisis. The Soviet Union had secretly deployed nuclear weapons in Cuba, bringing North American cities within range of Russian ballistic missiles. While the public held its breath, the world teetered on the edge of all-out nuclear war. In this battle of wills, the Soviet leader, Nikolai Khrushchev, blinked first, dismantling the missiles and averting a nuclear catastrophe. It would have seemed only a matter of time before this brinkmanship burst into wholesale war. Wherever communism and

capitalism came into contact, whether physically or ideologically, it generated conflict. The defining arena of the Cold War in the 1960s was Vietnam. As the decade wore on, largely due to relentless and often negative television and press coverage, the Vietnam War was increasingly seen as a pointless massacre of young American troops and innocent Vietnamese civilians. This resulted in (often violent) anti-war demonstrations all over the world.

From the political ferment emerged heroes who became household names through global media coverage. Martin Luther King Jr, for example, was awarded the Nobel Prize for Peace in 1964. At 35 he was the youngest ever Nobel laureate, donating his prize money to further the work of the Civil Rights Movement. Che Guevara, the Argentinean guerrilla leader who fought first

in Cuba and then in Bolivia, became a cult hero to young people the world over, not only for his exploits as a revolutionary, but also as an icon —Alberto Kordas' image plastered onto T-shirts and posters, becoming a shorthand political statement for the consumerist age. Muhammad Ali, by renouncing his 'slave name' of Cassius Clay and refusing to fight in Vietnam, elevated himself above the status of mere heavyweight champion to the rank of hero, his image coming to represent something more than the man himself.

Pop artists created a modern iconography through the language of these images, addressing political issues through an examination of a multitude of charged visual material, engaging not in an emotive, personal response but in a more objective examination, a looser sort of social enquiry, viewed through the prism of the media. The coverage of political affairs across the world, in the press, on the radio and the new television channels, brought individuals from across the social spectrum; politicians, movie stars, musicians and sportsmen into the living room and provided an abundance of material for Pop artists. They treated the news in much the same way as they did consumer culture, examining how mass media was able to manipulate politics and emotions as well as consumer preference, whether it be Kennedy or Kentucky Fried Chicken.

Larry Rivers
(b. 1928, New York, USA)
Boston Massacre (1 of 13 images), 1970
Dimensions variable
Screenprint
Wolverhampton Art Gallery, Wolverhampton, UK
© DACS London/VAGA New York 2007

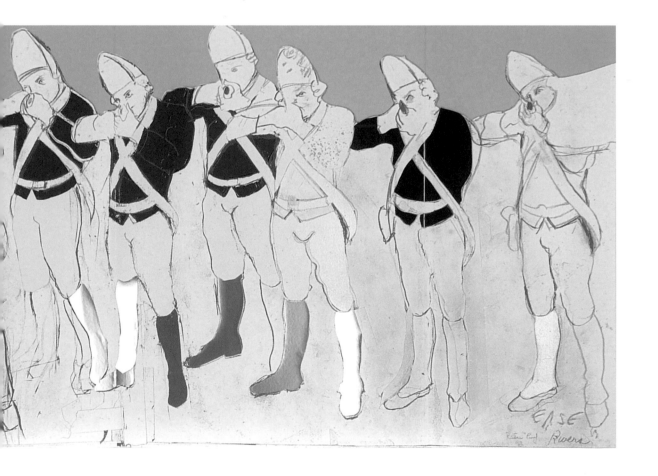

Boston Massacre

Perhaps influenced by the two-hundredth anniversary of the so-called Boston Massacre of 1770, Larry Rivers uses a historical subject to draw parallels between contemporary America and the oppressive rule of the British in the eighteenth century.

The people of Boston deeply resented the garrisoning of British troops in their city, and this resentment boiled over into conflict between the British grenadiers and American civilians, resulting in the British opening fire on unarmed protesters in 1770. The event triggered further protests and eventually led to the American War of Independence from 1775 to 1783, which brought British rule in America to an end. Rivers drew comparisons between the revolutionary spirit of America during the eighteenth century and the occupying force it had become by 1970, interfering in the governing of countries such as Vietnam and Korea. Furthermore the peaceful protests against racial discrimination and international foreign policy within America itself had met with violent rebuke from the police and military forces during the 1960s, leading many to believe that America had forgotten the lessons learnt from her own colonial past.

Larry Rivers' *Boston Massacre* mimics an artist's folder with a collection of collaged scraps and sketches organised into a deceptive informality. Upon closer inspection it is in fact a complex series of screenprints, produced in London by Kelpra Press. The format allowed Rivers to include images derived from eighteenth century depictions of Boston, cut from newspapers, and sensitively drawn figure sketches, giving rise to a uniquely personal response to the political climate assembled almost entirely from publicly available material.

A reproduction of Pelham's eighteenth century engraving *The Bloody Massacre Perpetrated in King Street* is instantly recognisable, pasted alongside the *40th Regiment* which was an image copied and circulated by Paul Revere in order to generate anti-British sentiment preceding

the American Revolution. The image of a neat row of soldiers is essentially a fiction and the scene was probably more like the representation included in another print in the set, *Black Revue,* as it was the taunting of a British sentry by a few Americans that provoked the armed response from the British. Of the five people killed in the massacre the first was Crispus Attucks, a black man and possibly the runaway slave referred to in the literature as 'Mr A'. "For Crispus A" in *Black Revue* can be seen as a reference to the first black man to become a victim of the Revolution, and highlighted the fact that black Americans fought for a free nation, only to be imprisoned by the very country they helped to create. Alongside these historical images of heroism and wartime glory were more contemporary depictions of Native and Black Americans bearing the weight of their own struggle for liberty, including a fragment of a *Daily Mail* piece featuring an injured protester from a civil rights demonstration. In including images of this kind, along with those of Vietnamese fighters, Rivers alludes to the extent of America's aggression both at home and abroad, contextualised within the stark background of British imperial oppression and the lofty aspirations of the American Revolution.

Larry Rivers
(b. 1928, New York, USA)
Boston Massacre (1 of 13 images), 1970
Dimensions variable
Screenprint
Wolverhampton Art Gallery, Wolverhampton, UK
© DACS London/VAGA New York 2007

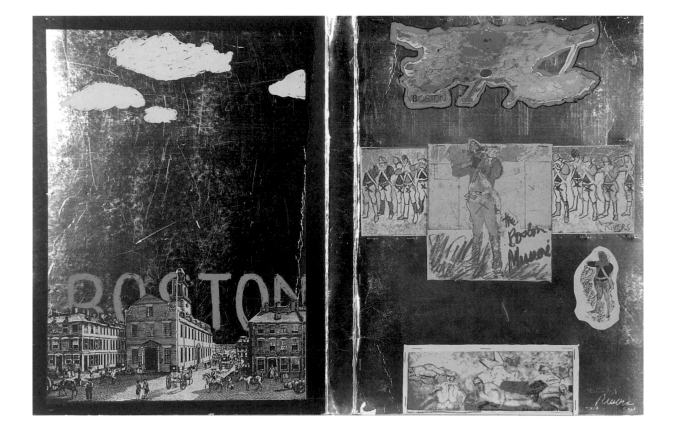

CAPITAL PUNISHMENT

Capital punishment was widely debated during the 1960s in both America and Britain. The first bill abolishing the death penalty in Britain was passed in 1965, and in 1969 a second vote cemented the conviction that the state should not have the power to take the lives of its citizens under any circumstances. Meanwhile, in America, the debate continues with large numbers for and against capital punishment. The electric chair has become a symbol for what is often seen as America's archaic commitment to medieval punitive practice, and as such functioned as prime artistic fodder for a critical generation of Pop artists.

Again, the media helped to bring the growing dissent to the forefront through publicising often gruesome depictions of the death penalty being carried out in America. One of the most famous and inflammatory examples of this was the media broadcast of Caryl Chessman's execution in 1960. Chessman, a convicted thief and rapist, was executed in 1960 after 12 years of remission. The public outcry that ensued from the details of the case, and the manner in which it was handled, inspired Pop artists such as Derek Boshier and Bruce Conner to explore the human rights issue of capital punishment through works such as *Caryl Chessman*, 1961, and *Homage to Chessman*, 1960.

Andy Warhol's *Electric Chair* paintings, created between 1963 and 1964, were part of his *Death and Disaster* series, starting in 1962 with *129 Die in Jet*, which focuses on media reports of tragedy. The *Electric Chair Series* began in 1963, the year of the last execution in New York, which showed that although other states continued to enforce the death penalty, the critical debate about its place in civilised society was well underway.

Warhol always used the same newspaper image of the electric chair. The bleak, empty execution chamber of the infamous Sing Sing Gaol in New York was the basis for all of his works on this theme, which only varied in cropping and background colours. The chilling starkness of the image suggests the lingering presence of the chair's last occupant and was one of the first times Warhol juxtaposed an image of this kind with a blank canvas—the aesthetic of which emphasised a sense of void; a narrative of life and death. The later prints of the series—which were made from 1971

Andy Warhol
(b. 1931, Pittsburgh, USA,
d. 1987)
Little Electric Chair, 1964–1965
59.9 x 71.1 cm
Acrylic and silkscreen ink
on linen
The Andy Warhol Museum,
Pittsburgh, USA,
Founding collection
Contribution The Andy Warhol
Foundation for the Visual
Arts, Inc.
© Licensed by The Andy
Warhol Foundation for
the Visual Arts, Inc/ARS
New York and DACS
London 2007

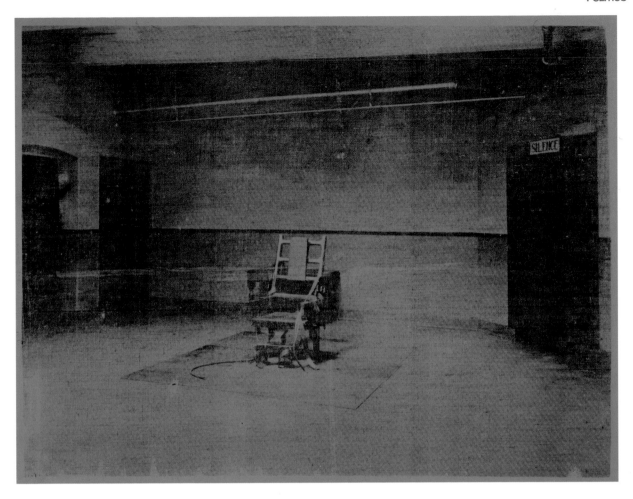

onwards—were printed in two colours. The image gradually faded into the background, sometimes with an illuminated sign reading 'SILENCE'—a shocking reminder that most of these executions were carried out in front of a live audience. The *Electric Chair* paintings are strangely evocative of Warhol's own statements on death:

> When I die I don't want to leave any leftovers. I'd like to disappear, People wouldn't say he died today, they'd say he disappeared.... I never understood why when you died, you didn't just vanish, and everything would just keep going the way it was only you just wouldn't be there. I always thought I'd like my own tombstone blank. No epitaph and no name. Well, actually, I'd like it to say "figment".[1]

1 Warhol, Andy, quoted in *Andy Warhol/Retrospective*, exhibition catalogue, New York: Museum of Modern Art, 1989, p. 466.

CHE GUEVARA

The image of a young Che Guevara with tousled hair and beret endures as a familiar symbol of honour, rebellion, and a fearless commitment to the ideals of equality and justice. Ernesto Guevara de la Serna, 1928–1967, came to fame during Castro's revolution in Cuba when against all odds Castro's rebels (including Guevara) overthrew the existing Cuban government and established a socialist regime in 1959. Although promoted to senior political positions, and having published works on the theory of guerrilla warfare, Guevara left Cuba in 1965 in order to lead revolutions in other countries, first in Congo-Kinshasa and then in Bolivia. During this period his whereabouts were kept secret, although regular letters home were proof that he was still alive and politically active.

In 1967 Guevara was captured by the Bolivian army and executed. A photograph of the dead body was immediately sent to press agencies around the world, shocking many people. It was this press image that Tilson used as the source for his print, alongside fragments of the Bolivian flag and sections of a map depicting the spot where Guevara was finally ambushed and seized. The photograph taken by the Bolivian authorities showed Guevara's stripped, laid out body with his head propped up, such that the world might recognise his face and complete the triumph of the Bolivian army over rebellion forces. Despite the attempt by the armed forces to cement their victory, many refused to believe that Guevara had died, especially as his family were not allowed to see the body. Tilson therefore asks the same question that was on everyone's lips, "Is this Che Guevara?" and through a compilation of evidence from press photographs and documents, creates a dark memorial to the quintessential people's hero. Tilson's use of cropping serves to focus simply on Guevara's head and, in isolation, his eyes seem strangely alive, creating an interesting dialogue with the printed material around the image pronouncing his death. The image is repeated in successive rows, but with each reproduction Tilson manipulates the dots that define the form, beginning with a crudely reproduced newspaper picture and turning it into something quite abstract, almost ethereal. All this is in sharp contrast to the playful, ordinary, snapshot of Guevara's girlfriend paper-clipped to the upper right-hand corner of the work.

Joe Tilson
(b. 1928, London, UK)
Is This Che Guevara?, 1969
99 x 66 cm
Screenprint collage
© DACS London 2007
Wolverhampton Art Gallery,
Wolverhampton, UK

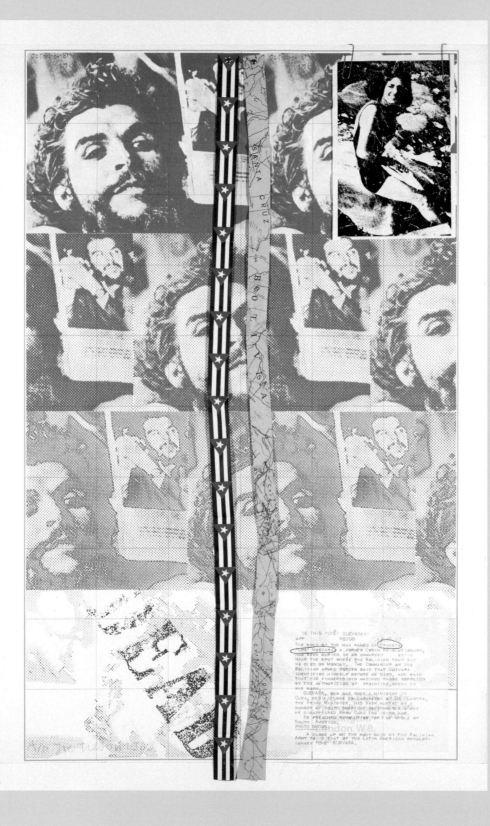

I say to you today, my friends, so even though we face the difficulties of today and tomorrow, I still have a dream. It is a dream deeply rooted in the American dream.

I have a dream that one day this nation will rise up and live out the true meaning of its creed: We hold these truths to be self-evident: that all men are created equal.

I have a dream that one day on the red hills of Georgia the sons of former slaves and the sons of former slave owners will be able to sit down together at the table of brotherhood....

I have a dream that one day, down in Alabama, with its vicious racists, with its governor having his lips dripping with the words of interposition and nullification; one day right there in Alabama, little black boys and black girls will be able to join hands with little white boys and white girls as sisters and brothers.

I have a dream today.

– Martin Luther King Jr

CIVIL RIGHTS

The Civil Rights Movement began in 1954 with the aim of enforcing the Fifteenth Amendment of the United States Constitution which declared that "the right of all citizens of the United States to vote shall not be denied or abridged by the United States or by any State on account of race, colour, or previous condition of servitude" and therefore promised equality to Americans of all colours and creeds. However, the letter of the law did not translate into fair treatment and despite the Emancipation Act of 1863 and the amendments to the Constitution, inequality and segregation was rife in America's southern states well into the 1960s.

Perhaps the most famous civil rights activist was Martin Luther King Jr of the Southern Christian Leadership Conference, who initiated a campaign to end segregation in public spaces (including schools, public transport, restaurants, cafes and housing schemes) and to ensure the universal right of all citizens to vote and hold public office. Upholding President Lincoln's exhortation in the Emancipation Proclamation that "the people so declared free to abstain from all violence" the Civil Rights Movement pursued a path of peaceful, non-violent protest. The campaign was successful in universally highlighting that the American dream of equality, freedom and justice was a battle still to be won, but it provoked a violent and aggressive response from the authorities and some white community members in the South. One such incident is probably remembered more than any other, when in May 1963 police responded to the non-violent action of the Birmingham campaign in Alabama with disproportionate aggression, shocking the American people as they saw it broadcast into their homes. Dogs were released to attack protesters, fire hoses were let loose on defenceless schoolchildren and batons were used to 'subdue' those who were neither armed nor aggressive.

Spurred to action over 230,000 people marched on Washington on 28 August 1963 outraged by this and other incidents of civil injustice. It was in front of this immense crowd that Martin Luther King Jr made one of the most famous speeches in history, known today as "I have a dream". These memorable words were delivered in front of one of the most recognisable symbols of American freedom—the Lincoln Memorial with its mural of the angel of truth giving freedom and liberty to the black slave, flanked by text from the Gettysburg address declaring "this nation, under god, shall have a new birth of freedom; and that government of the people, by the people, for the people, shall not perish from the earth". King's speech and the Washington demonstration were instrumental in mobilising support for the Civil Rights Act of 1964, and in that year King was awarded the Nobel Prize for Peace.

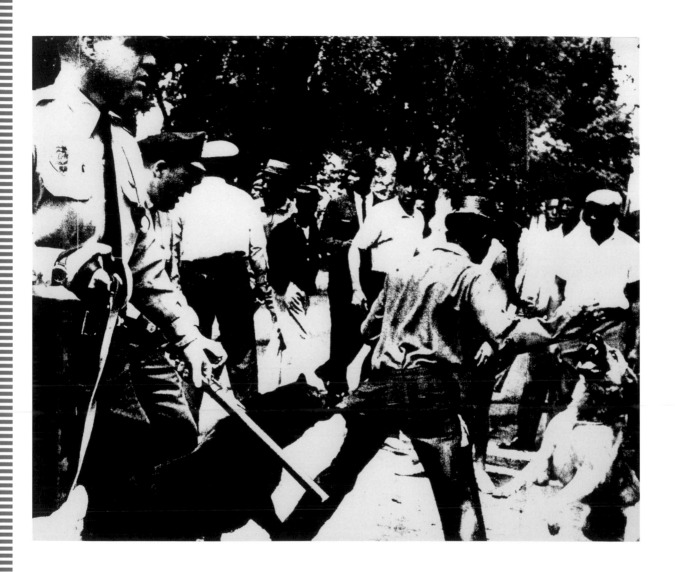

Andy Warhol
(b. 1931, Pittsburgh, USA, d. 1987)
Birmingham Race Riot, 1964
50.8 x 61 cm
Screenprint on paper
The Andy Warhol Museum, Pittsburgh, USA
Founding collection
Contribution The Andy Warhol Foundation for the Visual Arts, Inc.
© Licensed by T he Andy Warhol Foundation for the Visual Arts,
Inc/ARS New York/DACS London 2007

Warhol famously avoided making political statements or even acknowledging emotional reasons behind his work. Yet he often betrays his political inclination through choice of subject. In *Birmingham Race Riot* he chose to focus on one of the most emotive political events of the day, the civil rights protest in Birmingham, Alabama, during May 1963. His *Race Riot* images were based on three different photographs from *Life* magazine depicting police dogs savaging protesters. As was common for the artist, Warhol worked with a commercial printer, in this case George Townsend. The image was screen-printed in paint onto a canvas, using a variety of colours and sequences of repeated images. In a rare political statement, Warhol described the riots as a blot on the American conscience and asked Townsend for a muddier printing, to make the image dark and foreboding in keeping with the spirit he sought to represent.

In March 1965 civil rights protesters planned to march from Selma, Alabama to Montgomery, but their plans were thwarted when over 2,000 supporters were arrested and a black youth murdered by a state trooper. The protesters persisted, but as they attempted to march police advanced on them armed with clubs, whips, tear gas and electric prods. The media coverage once again provoked nationwide outrage and President Johnson was forced to intervene, enabling the march to take place with Martin Luther King Jr at its head. The sense of victory, however, was short lived. After the marches one of the protesters, Viola Liuzzo, a white woman from Detroit, was giving a young black man a lift when her car was attacked and she was shot dead. Allan D'Arcangelo refers to this incident in *US 80 (In Memory of Mrs Liuzzo)*, 1965.

D'Arcangelo was among those who used art as a political tool, drawing attention to issues he took to be important. A political activist on and off the canvas, D'Arcangelo rallied against the war in Vietnam, nuclear arms, and in this instance particularly, the infringement of civil rights. In his characteristically simplified style, D'Arcangelo depicts the horror of the event by creating a sinister memorial of Liuzzo's death in the form of a simple US Highway 80 road sign, splattered with protesters' blood and riddled with bullet holes. The worm's eye perspective, setting the sign against the blue sky, conjures up feelings of a memorial tablet or burial marker.

As part of his *Confederacy* series, Robert Indiana plots the town of Selma on a map and places it in the middle of one of his characteristic targets, reflecting the protests that have occurred there. The series refers to attacks on non-violent civil rights demonstrations, not only in Selma, but also in Alabama, Philadelphia, Mississippi, Bogalusa, Louisiana and Florida. In each case Indiana stencils the same phrase: "Just as in the anatomy of men, every nation must have its hind part." The statement is difficult to read as a continuous sentence, so certain words are isolated from their original meaning within the phrase and resonate with each other and the picture plane to produce a more poetic effect. "Must have" is no longer contained in the sentence, but is free to refer to things like the campaign for voting rights; "nation" suggests the imminent threat to the American dream resulting from the violent suppression of civil rights, while "every man" suggests an essential equality of all people. The lettering in each painting of the series is positioned differently, so that when hung together the works appear to be spinning round in an endless motion. Indiana called these 'history paintings' in reference (and contrast) to the traditional form of the genre, where a narrative is represented by figures at a moment of dramatic intensity, similar to a staged performance.

As a poet, Indiana took text to be an integral part of painterly practice. Indeed he often referred to himself as a "painter of signs", adopting a style reminiscent of commercial artists. Even Indiana's methods are associated with the sign-makers craft, using stencilling and planes of flat colour rather than modelled and shaded forms, producing a directness that allowed him to emphasise the subject matter of the work rather than its painterly qualities. Technological advances during the 1950s and 60s bolstered a new kind of media, one that could broadcast stories, images and footage worldwide and with an unprecedented speed. These developments meant that domestic affairs could no longer remain domestic, and events associated with (among other things) the Civil Rights Movement were made publicly available for scrutiny. In Britain, the coverage raised concerns for a growing number of people who questioned Britain's close alliance with America, including Joe Tilson who made several works investigating British perceptions of American current affairs.

Allan D'Arcangelo
(b. 1930, Buffalo, USA, d. 1998)
U.S. 80 (In Memory of Mrs Liuzzo), 1965
61 x 61 cm
Acrylic on canvas
University of Buffalo Art Galleries, Buffalo, USA
© DACS, London/VAGA New York 2007

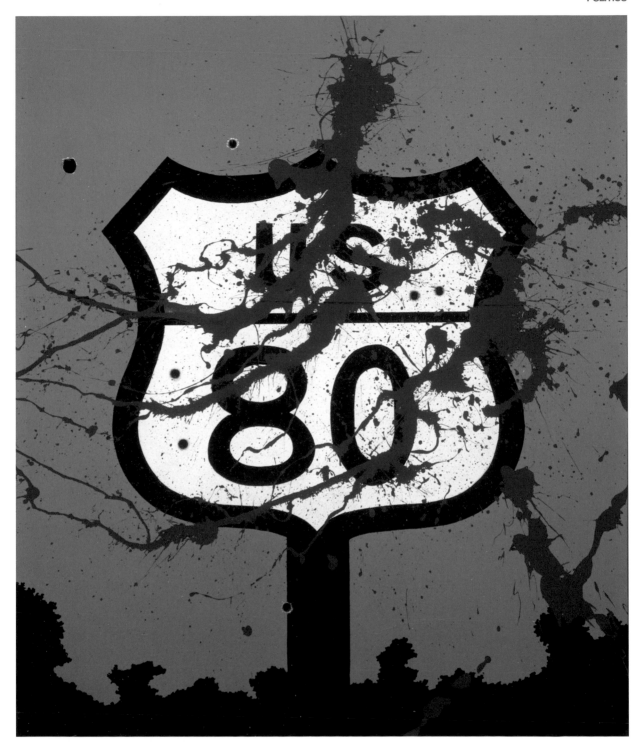

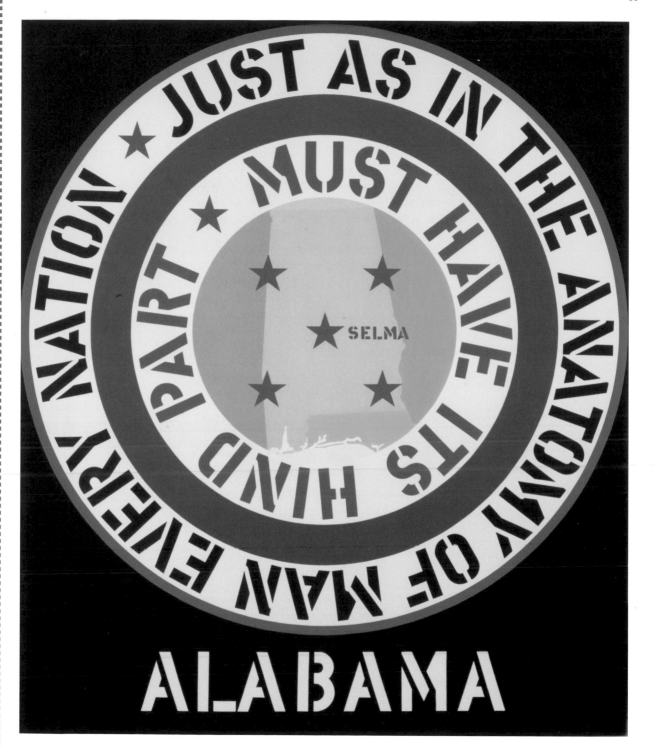

The Bela Lugosi Journal is a screenprint of the front page from a fictitious newspaper, featuring real press images of police brutality against a black demonstrator. Interestingly, using the familiar format of a newspaper allowed Tilson to use his famous columnar structure (often found in his geometric work and wooden constructions) without drawing attention to its presence.

Contained within this structure are Tilson's investigations into a range of topical issues of the day, forming a surreal combination of social, political and artistic items. A grimacing laboratory monkey is set off by an image of police brutality during civil rights protests, while Miss Police World beams triumphantly next to an image of a wounded child victim of the Vietnam War. Tilson uses text to disrupt the meaning of some of these images, for example a photograph of Missouri farmer Buck Nelson (complete with denim dungarees) is flanked by a text describing him as a "contactee", who had been taken by spaceship to meet the Venusians, as an ambassador of Earth. To add to the dizzying array of symbols, images and texts, Tilson overlays the work with a wash of red, white and blue in reference to both the American Flag, and the spilled blood of innocent people at home and abroad. The presence of gestural marks on the screenprint reveals the hand of the artist in collecting these otherwise anonymous images, emphasising the personal statement made through the appropriation of mass produced material.

However serious the content, *The Bela Lugosi Journal* is not a serious political title but rather a fanzine for the legendary actor of Vampire films, drawing a tongue-in-cheek association between the fantastical nature of horror films and the very real horror of contemporary American politics.

opposite
Robert Indiana
(b. 1928, New Castle, USA,
as Robert Clark)
*The Confederacy:
Alabama*, 1965
152.4 x 177.8 cm
Oil on canvas
Miami University Art Museum,
Miami, USA
Gift of Walter A and
Dawn Clark Netsch
© ARS, NY and DACS
London 2007

Joe Tilson
(b. 1928, London, UK)
The Bela Lugosi Journal, 1969
78 x 59 cm
Screenprint
Wolverhampton Art Gallery,
Wolverhampton, UK
© DACS 2007

#

In 1959, Fidel Castro, First Secretary of the Communist Party of Cuba led his revolutionary forces to oust General Batista from power, declaring Cuba a socialist state. Situated off the coast of Florida, the island of Cuba (represented through a map in the centre of Pauline Boty's *Cuba Si*) became one of the main sites on which confrontation played out between America and the Soviet Union during the Cold War.

Boty references Cuba's historic struggle against foreign imperialism with a black and white portrait of José Marti, the leader of the Cuban Revolutionary Party, set against the colourful and patterned targets so popular in Pop Art.

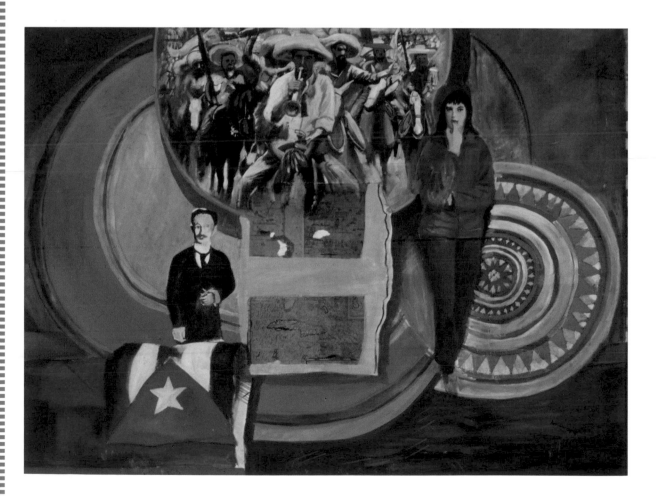

Marti died at the Battle of Dos Rios in 1895 in the fight to win independence from Spain, but not before authoring one of Cuba's most infamous freedom songs: *Guantanamera*, which has come to be associated with nationalist politics in Cuba generally, particularly with supporters of Fidel Castro's communist insurgence. The title literally translates as 'a country girl from Guantanemo' and refers to the American attempt to exert influence over the Cuban government, beginning with the end of Spanish rule in 1903 when the US forced Cuba to rent Guantanemo Bay for use as an American naval base.

Following Castro's rise to power the Cuban government increasingly looked to the Soviet Union for support, and a trade agreement for the sale of Cuban sugar in return for crude oil was signed in 1960. When American companies refused to refine the oil, Castro nationalised Texaco, Shell and Esso. Thwarted in undermining the trade agreement with the Soviets, America began a propaganda campaign to stir up revolt. Kennedy sanctioned Operation Pedro Pan which was launched on Radio Swan (an unlicensed radio transmission broadcast from nearby Swan Island) with the exhortation: "Cuban Mothers, don't let them take your children away!" The operation saw the US refuse entry to Cuban immigrants under the age of five and over the age of 18, persuading many parents to send their unaccompanied children to America in the belief that there they would avoid the strictures of communism and have a wider range of opportunities. Through this initiative, the US government hoped that the parents left behind in Cuba would form an emotional allegiance with America and American values, eventually forming an active opposition to overthrow Castro. America also provided military support to Cuban exiles trying to invade Cuba, an initiative that ended in an ignominious defeat at the Bay of Pigs in 1961. In a rousing speech made by Castro two weeks later he hailed:

> **The motherland of today where we have won the right to direct our own destiny, where we have learned to decide our destiny, a motherland which will be now and forever—as Marti wanted it—for the well-being of everyone and not a motherland of the few!**

> **What kind of morality and what reason and what right do they have to make a Negro die to defend the monopolies, the factories, and the mines of the dominating classes? The invaders came to fight for free enterprise! As if these people did not know what free enterprise is! It was slums, unemployment, begging. One hundred thousand families working the land to turn over 25 per cent of their production to shareholders who never saw that land. How can one of those who never knew labour say that he came to shed the people's blood to defend free enterprise?**

Pauline Boty
(b. 1938, Surrey, UK,
d. 1966)
Cuba Si, 1963
125 x 96 cm
Oil on canvas and collage
The Women's Art Library,
London, UK
© Estate of Pauline Boty

In 1962, US spy planes photographed a Soviet intermediate-range ballistic missile site under construction in Cuba. Kennedy had to make the incredibly diplomatic decision as to whether or not to take military action and risk provoking the Soviet Union into war, or allow the country to enhance its nuclear capabilities rendering the USSR superior in nuclear power to the United States with a nuclear base some 250 kilometres from American borders. Kennedy demonstrated the strength of his leadership by resisting the advice of many officials and military advisors who were advocating an air assault, and instead blockaded the area with naval ships while he entered into negotiations with Khrushchev. Following concessions from the United States, Russia agreed to dismantle the site. This situation is referred to as the Cuban Missile Crisis, and is probably the closest the world has ever come to wholesale nuclear war.

In a warning against forgetting the lessons of the Cuban Missile Crisis, Gerald Laing depicts the two leaders involved in an event that horrified the international community: Nikita Khrushchev on the right and John F Kennedy on the left, in describing the work, Gerald Laing made the following statement:

The images of Kennedy/Khrushchev are painted on vertical one inch square wood strips set at 45 degrees in the frame, so that when the viewer looks at it diagonally from the left, Khrushchev is visible; from the right, Kennedy; when viewed directly from the front, these two images merge into a two-mouthed monster under a flag composed of confused elements from those of their respective countries. This sums up in visual terms the attitude of many people at the time to the actions of both men, which seemed about to launch the whole world into a nuclear holocaust.

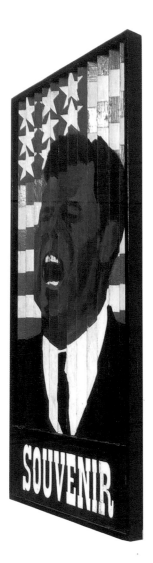
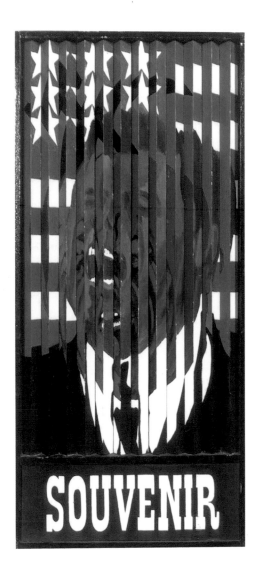
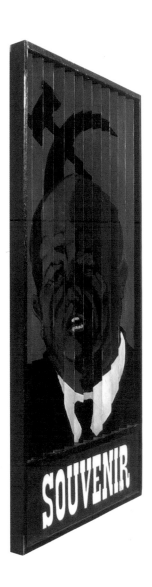

Gerald Laing
(b. 1936, Newcastle
Upon Tyne, UK)
Souvenir, 1962
63.5 x 38.1 cm
Oil paint on wood construction
Collection of the artist
© The artist

F

F1-11

James Rosenquist's painting *F1–11* is a summation of the issues artists faced in this age of growing anxiety. It is a complex composition created out of a synergy between consumer products, space technology and weapons of mass destruction. The atomic mushroom cloud is mimicked in the hood of the hair dryer, on which scenes of space exploration are depicted, jarringly combined with images of a fragmented military fighter plane.

The *F1–11* was, as Rosenquist observed, "the newest, latest fighter-bomber at this time, 1965.... The prime force of this thing has been to keep people working, an economic tool; but behind it, this is a war machine."

Equally imposing, the painting *F1–11* is 26 metres long and designed to wrap around four walls of a gallery, creating an all-consuming installation that works to overwhelm the viewer. Installations were often used by Pop artists such as Rosenquist and Kienholz who were looking for new ways of promoting a social realism in art, without reverting to traditional methods. Favoured by communist and fascist regimes alike, the notion that traditional painting could fill a political role was questioned by Pop artists, who preferred to appropriate images from mass media, developing an assemblage approach. This method, taken to its logical and aesthetic conclusion, naturally progressed into the realms of sculpture and installation work. Rosenquist wanted to create a claustrophobic environment, in which the work could not be seen all at once: a disorientating experience which promoted the viewing of fragmented images in more abstract terms of colour and form. The painting was made up of 51 panels, which Rosenquist had initially intended to sell separately, as they "would... give the idea to people of collecting fragments of a vision". For Rosenquist 'fragments' were both visually more interesting but also conveyed the speed and complexity of twentieth century life.

In 1974 Rosenquist made another version of *F1–11* as a print. Although not as large as the painting, it maintained an impressive scale, extending over seven metres and divided into four sections. The size was novel and for the publisher, Petesburg Press, this print opened the door to other large experimental print projects in America.

In both the print and the painting, the colours were arresting; a combination of fairly acid pigments together with a fluorescent tint to create an ambient, almost haunting, glow. Photographs of Rosenquist's studio show the floor strewn with magazines, and the walls covered in the torn pages and drawings that provided the inspiration for this most impressive work. For example, the helmet hairdryer was derived from a Coca-Cola advertisement published in *Life* magazine. Rosenquist however adapted the hood to give it a more dynamic, hard-edged shape, reminiscent of a futuristic helmet. In one study the tinned spaghetti is given a day-glo tint and annotated as 'radioactive spag', hovering behind a pattern applied with a wallpaper roller signifying atomic fallout.

Articles in *Time*, *Newsweek* and *Business Week* placed the debates around the development of the *F1–11* in the public domain, flagging up the relationship between national defence aims and consumer culture. Government spending on defence and the development of technology promised economic growth, wealth, and an ever-increasing consumerist culture. In some cases, consumer goods and military hardware physically overlapped in a parody of their conceptual closeness indicated by Rosenquist's light bulbs featuring the American military star insignia—indeed industry leaders General Electric and Westinghouse produce[d] both domestic light bulbs and major military instruments.

Rosenquist's commentary extends to the newly available time-saving products like instant foods, promoted as a nutritious alternative for a busy modern consumer. Rosenquist mocks advertisers attempts to seduce the buyer by representing little flags on which the names of vitamins were written: niacin, iron and riboflavin. Irony is also conveyed by the young girl sitting under a salon hair dryer, an innovation only introduced in 1963. Not only is the hood altered to remind the viewer of a military helmet, but the girl sitting underneath it has a burnt face, in a harsh reminder of the nuclear threat so feared by the world at the time. Throughout the work, the artist continues to provide emotional examples illustrating the absurdity of contemporary culture, like the surreal juxtaposition of a colourful umbrella over the atomic mushroom cloud. Rosenquist here illustrates how the products of consumer culture, through their association with military devices, conceal a more sinister and threatening nature lurking underneath attractive packaging.

HO CHI MINH

The Cold War brought to the fore the political ideologies of the East, which caught the fascination for some in the West. Joe Tilson was among those who chose to explore the beliefs and practices of a part of the world now widely accessible to Western culture.

In the Western press Ho Chi Minh was usually depicted as a mysterious and dangerous enemy, but in his print, *Ho Chi Minh,* Tilson portrays him as a man with simple tastes and pleasures. A black and white photographic image shows him as a father figure with two small children, on the left is a rainbow-coloured graph of a bird song to reflect his love of birds; tender qualities for the monster the press generally portrayed. Attached to the print is a string suspending a wooden fish, referencing an excerpt from a biography of Ho Chi Minh. Jean Lacouture, the author, described a folk story of the man from Nghe Tinh, a province in Vietnam so poor it is known as "the land of the wooden fish". The man had so little money that when he travelled he would hide a wooden fish in his rice, pretending he could afford to eat meat. Later, when hungry, he would be able to lick the fish and be reminded of the meal as he trudged along the road.

Ho Chi Minh had similarly modest beginnings, spending his youth in France and England doing menial work. Although brought up with the Confucian tradition in his native Vietnam he turned to Communism while in France and lobbied for Indochina's independence from French control. As leader of the Viet Minh forces he defeated the Japanese and in 1945, Vietnam was declared an independent state. In the following years he led forces against the French and in 1959 supported the National Liberation Front in South Vietnam, which brought North Vietnam and America into direct conflict during the Vietnam War. This tribute to Ho Chi Minh was created after his death in 1969. It provides an almost ethereal effect with the bright yellow and orange colouration, which was achieved through the solarisation of a half-tone image, a technique that was developed for Tilson, by Chris Prater at Kelpra Studio in London.

Joe Tilson
(b. 1928, London, UK)
Ho Chi Minh, 1970
103.2 x 70.2 cm
Screenprint and mixed media
Wolverhampton Art Gallery,
Wolverhampton, UK
© DACS 2007

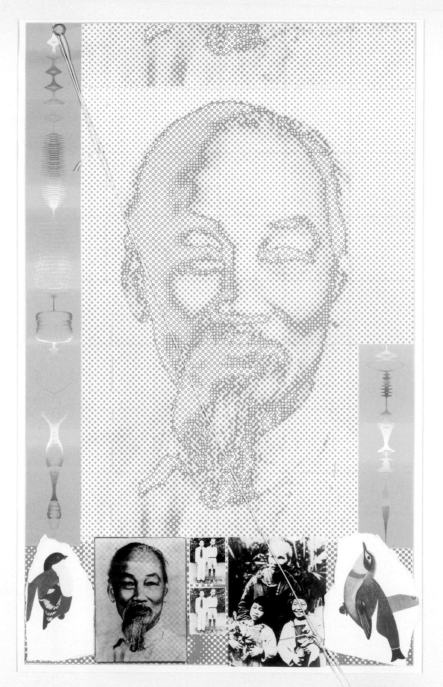

 # JAN PALACH

Anxieties in the West about the encroachment of Communism received a new impetus when Soviet tanks rolled in to Prague in August 1968. This brought the 'Prague Spring'—a period of political liberalisation where increasing freedom of the press and democratisation promised a cultural renaissance in Czechoslovakia—to an abrupt end. Photographs of the tanks invading the seemingly peaceful city exploded on the international media, along with the gruesome scenes of Jan Palach committing suicide in protest against the invasion by setting himself on fire.

Tilson combined these images with the equally disturbing press photos from Biafra, a West African state that sought independence from Nigeria. At the time the print was made Biafra had already been militarily defeated and was suffering a terrible famine. Though Tilson was committed to using his artistic voice to address what he took to be important political issues, by 1970 he was beginning to rethink his initial premise that art was an effective tool for understanding politics, fearing that aesthetic response to his work might trivialise its very serious subject:

If people want to act in areas like politics and social work, it really is much better to go out and help people... than to involve yourself indirectly through art.[3]

Joe Tilson
(b. 1928, London, UK)
Jan Palach, 1970
72.5 x 85 cm
Screenprint and collage
Wolverhampton Art Gallery,
Wolverhampton, UK
© DACS 2007

3 *Joe Tilson/Graphics*, exhibition catalogue, Vancouver: The Vancouver Art Gallery, 1979, p. 5.

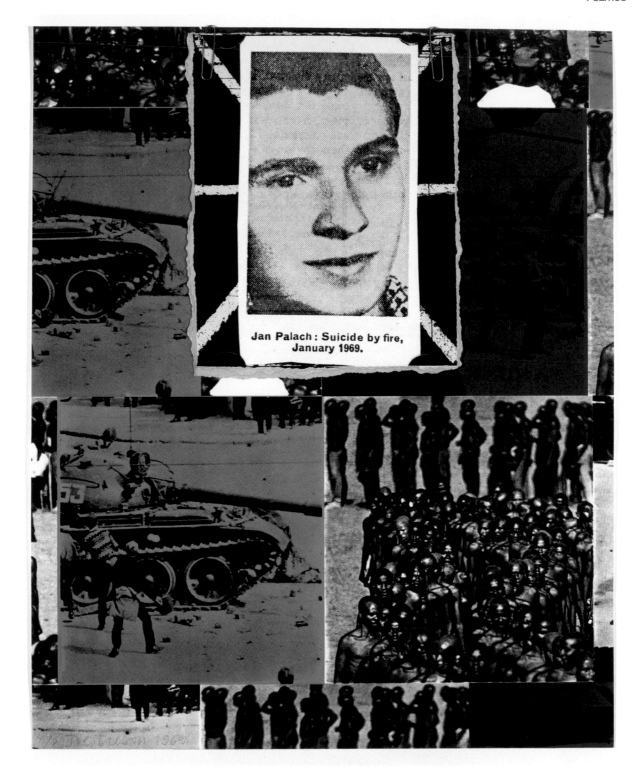

Jan Palach : Suicide by fire,
January 1969.

JOHN F KENNEDY

[I] Was fascinated by how people advertise themselves, whether film stars like Marilyn Monroe or Joan Crawford, or presidential candidates.
– James Rosenquist

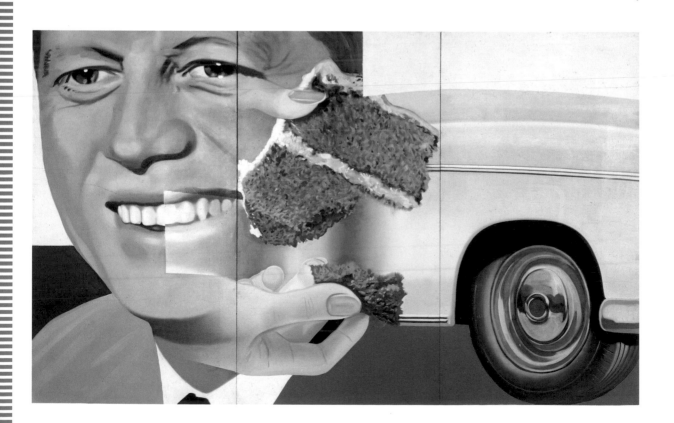

John F Kennedy became president of the United States on 20 January 1961. And even though he was assassinated shortly thereafter (in 1963) his influence was such that the 1960s are often remembered as the 'Kennedy years'. James Rosenquist began painting *President Elect* during Kennedy's presidential campaign, having recognised the politician as the first presidential candidate to fully harness the power of mass media to political ends. He and his glamorous wife, Jackie Lee Bouvier, projected an image of youth, energy, and sophistication, which many saw as a break with drab presidential tradition. Before Kennedy even announced his candidacy for the presidency, 70 per cent of the electorate recognised his face, most likely because he allowed a film documentary, *Primary*, to record his campaign for the Democratic presidential nomination in 1959. Coverage did not stop there; Kennedy's image was a ubiquitous feature of 1960s popular culture. During his televised debates with Richard Nixon, Kennedy emerged triumphant in the eyes of the public and ultimately turned the election to his favour. Never before had a president won an election through the language of mass media, and Pop artists were extremely interested in this altogether 'new world' phenomenon.

As the basis for *President Elect*, Rosenquist uses a beaming portrait of Kennedy derived from an election poster. Rosenquist described how at that time he was fascinated by how people advertise themselves, whether film stars like Marilyn Monroe or Joan Crawford, or presidential candidates. In his election campaign Kennedy deploys a standard advertising technique used for the celebrity endorsement of a product, where the emphasis is on the face. Rosenquist was interested in these and other media practices, alluding to other subliminal techniques, such as the elegant caressing fingertips used in the cake advertisement, or the airbrushed glamour of car styling. Rosenquist was also interested in the positioning of adverts, for advertisements were often incongruously placed within a magazine next to pages reporting important political events or images of human tragedy, and given equal if not more visual prominence.

Rosenquist generally used advertisements from *Life* magazine from the 1940s and 50s because of their large photographic format, stripping out the textual information from the images in an effort to distance the viewer from the original message and concentrate on their subliminal content. In *President Elect* Rosenquist uses ads for Swans Down Devil's Food Mix from 1954 and a Chevrolet car advertisement and juxtaposes them with images from JFK's presidential campaign. The consumer products selected represent American symbols of affluence, technological success and middle class standards of living—the typical promises of politicians — although Rosenquist provided a more cynical explanation: "His promise was half a Chevrolet and a piece of stale cake."[4]

4 Rosenquist, James, quoted in Hopps, Walter and Bancroft, Sarah, *James Rosenquist: a Retrospective*, New York: Harry N Abrams, 2003.

James Rosenquist
(b. 1933, Grand Forks, USA)
President Elect, 1960
228 x 366 cm
Oil on isorel
Musée d'Art Moderne,
Centre Georges Pompidou,
Paris, France
© DACS, London/VAGA
New York 2007
Image courtesy of
CNAC/MNAM Dist RMN
© Droits réservés

Rauschenberg reproduced many images from Kennedy's campaign after watching the 1960 election return on television. The artist even sent the drawing to the newly elected president, and while it was lost as a result, the process had fixed the powerful media images surrounding Kennedy in the artist's mind and he began a series of silk-screened canvases, which were only completed after Kennedy's assassination in 1963.

Rauschenberg began using the silkscreen technique to transfer images to his canvas in 1962. In this way he could combine photographic images with his more gestural marks to build up a multi-layered composition. Like Warhol, the images were not printed in crisp detail, but were linked with television and newspaper sources with a blurred and uneven pigment. In most cases, portraits of Kennedy are part of a layered composition of disparate images: some are barely legible, others appear irrelevant, but all evoke the bombardment of visual material in modern life. One symbol of particular significance to Kennedy's presidency was the astronaut; indeed the president invested heavily in the space programme.

Rauschenberg did not give exact explanations of this work but stated "painting relates to both art and life. Neither can be made. (I try to act in that gap between the two)."[5] It seems his attempts were successful, because in 1964 Rauschenberg received international recognition for his work when awarded the Gold Prize at the Venice Biennale.

Kennedy's assassination in 1963 shook the world, not least because scenes of the assassination were quickly disseminated worldwide by the media. For many it has become a defining moment in television history. Interestingly, the images so familiar today and used by Gerald Laing in *Lincoln Convertable* came from an amateur movie by Abraham Zapruder, as the press were not covering the presidential cavalcade in Dealey Plaza. This colour film was to become crucial evidence for the Dallas police, while the other copy was sold to *Life* magazine, who then published stills from the footage.

Robert Rauschenberg
(b. 1925, Port Arthur, USA)
Untitled, 1964
147.3 x 127 cm
Oil on canvas
Private Collection
© DACS, London/VAGA
New York 2007
Image courtesy of
The Bridgeman Art Library

Laing wrote an account of the day:

> That November the shiny image of America cracked from side to side. I heard the news in my studio on Fournier Street, when radio broadcasts were interrupted to announce the events in Dallas. I detested the treacly talk of 'Camelot' in Washington, and paid little attention to American politics. In spite of the ghastly violence of the twentieth century we had been endowed with a sanitised version of the past, which produced in us a sense of stability, which was as deeply held as it was false. Thus, when the president of the richest and most powerful country in the world proved to be vulnerable to the assassin's bullet, it came as a terrible and fundamental shock, which forced us all to adopt more realistic attitudes towards the world about us.[6]

Gerald Laing
(b. 1936, Newcastle
Upon Tyne, UK)
Lincoln Convertible, 1964
185.4 x 281.9 cm (irregular)
Oil on canvas
Collection of the artist
©The artist

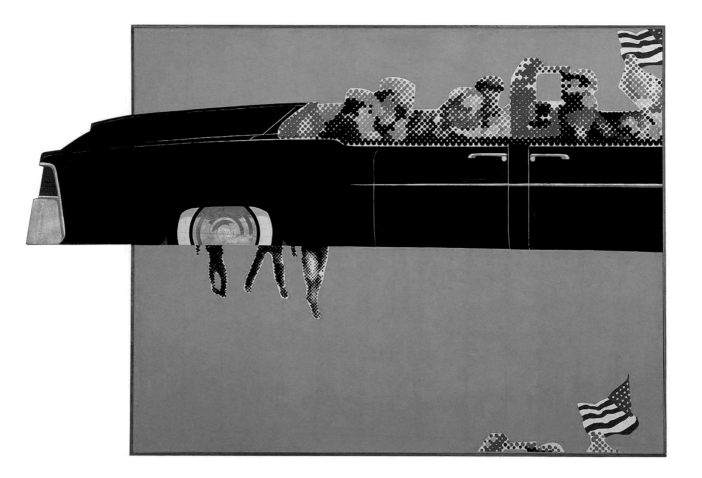

5 Seitz, William C, *The Art of Assemblage*, New York: Museum of Modern Art, 1961, p. 116.
6 Laing, Gerald, extract from unpublished *An Autobiography*, emailed to author 22 February 2006.

Instead of using a single frame from the stills illustrated in *Life* magazine, Laing included the lower half of the frame below as well, which places the main image in a cinematic narrative. He used a series of painted dots to create a sense of form modelled with light and shade, borrowing the technique from commercial printing processes, particularly posters in the underground. He usually used black dots but here chose colour as he "intended to convey a Buddhist meaning where colour rather than black is associated with mourning. It also enables me to clarify two important visual features of the drama—Jackie Kennedy, with pink suit and pill-box hat, and the yellow roses held by Governor Connolly of Texas."[7]

The size and shape of Laing's *Lincoln Convertible* were inspired by the size of the Lincoln Continental convertible itself. The extended canvas emphasised the division between the two frames, but also created a sense of forward movement as the front of the vehicle disappears from view beyond the canvas.

The post-Kennedy era ushered in a period of uncertainty articulated in the works of artists like Pauline Boty, one of the few women Pop artists. She was part of a group of political activists in London, which included the literary agent and TV producer Clive Goodwin, whom she subsequently married.

Countdown to Violence presents a bleak image of the situation in America. Portraits of former US presidents Abraham Lincoln and John F Kennedy appear below the countdown, '3 2-1-ZERO', which suggests the imminent downfall of America. Both presidents were known for their progressive attitudes and policies, and both presidents were assassinated. Under the picture of Kennedy is an image of his coffin as it appeared in his funeral procession. Depicted on the left is one of a Buddhist monk who set himself on fire in protest of the political situation in Vietnam. While on the right, police are depicted brutalising a civil rights protester; the image of the snapping dog echoes the depiction of the Birmingham Riots in *Alabama* by Andy Warhol. The manicured hand cutting the rose with a pair of glinting, hard edged secateurs seems to suggest that despite a veneer of civilisation, the human race is severing its links with nature, and indeed with life itself by the imminent threat of nuclear destruction.

7 Laing, Gerald, extract from unpublished *An Autobiography*, emailed to author 22 February 2006.

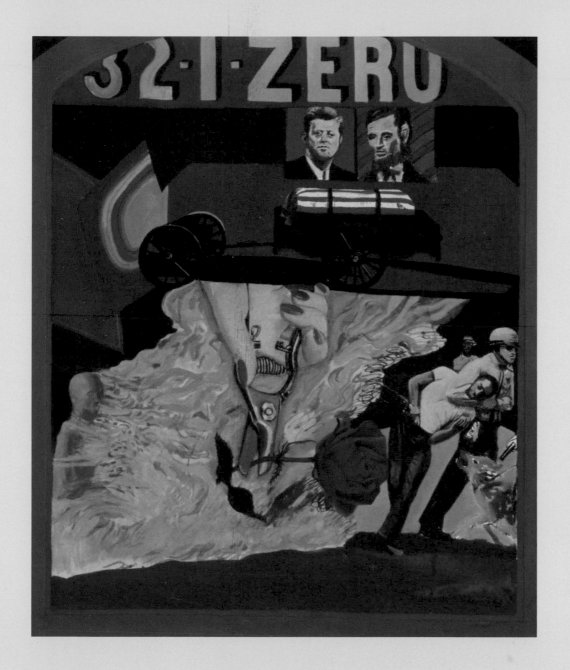

Pauline Boty
(b. 1938, Surrey, UK, d. 1966)
Countdown to Violence, 1964
98 x 83 cm
Oil on canvas
The Women's Art Library, London, UK
© Estate of Pauline Boty

M

MALCOLM X

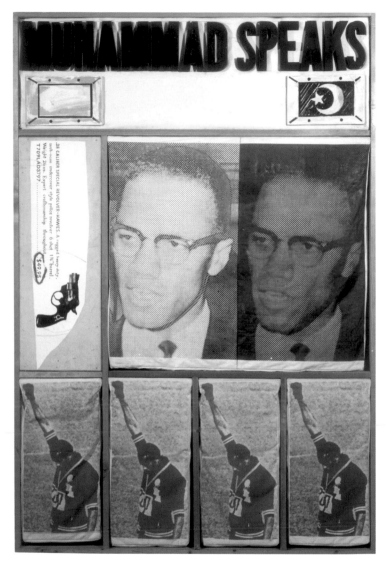

The latter half of the 1960s saw an escalation of violence in America. In the summer of 1967, there were riots in 31 cities, which left 86 dead, 2,056 injured and over 11,000 arrested. Possibly more shocking were the assassinations of two of the Civil Rights Movement's most charismatic leaders, Malcolm X in 1965 and Martin Luther King Jr in 1968.

Joe Tilson took an active role in the fight against racism. In *Page 18: Muhammad Speaks*, 1969, he borrowed the title of a contemporary newspaper published by the American black separatist movement, the Nation of Islam led by Elijah Muhammad. Malcolm X was a key spokesman for this group until he converted to orthodox Islam in the last year of his life. As a statement of his political ideology he dropped his 'slave' name of 'Little', calling himself Malcolm 'X'. Here, below the double image of Malcolm X, are repeated press photographs of the black American Olympic gold medal sprinter, Tommie Smith. During the Mexico City Olympic Games in 1968, Smith brought the Civil Rights Movement into the (officially, but not practically) politically-neutral environment of the Olympic Games when he performed the Black Power salute, an image that was instantly transmitted around the world.

Referencing the murder of Malcolm X in 1965, Tilson includes an advert from a mail-order catalogue listing a .38 calibre for sale at $49.95. The gun culture in America that led to the shootings of John F Kennedy in 1963 and Robert Kennedy, Andy Warhol and Martin Luther King Jr in 1968 horrified Tilson. The artist's particularly American fascination with guns arises from a romantic reading of American history, positioning the settlers in the 'wild west' as brave defenders of a young nation against the colonising power of Britain. The right to carry a firearm was therefore protected in the Constitution and heralded as an American principle, and indeed, duty. The reality of such a commitment to firearms was starkly apparent by the 1960s, through a succession of high-profile assassinations, ending the careers and lives of some of America's most progressive and influential public figures. Malcolm X was one of these figures, killed by those who felt he had betrayed the anti-white tenets of the Nation of Islam. Although three members of the organisation were convicted of his murder, there were a number of conspiracy theories implicating the US government in Malcolm X's assassination.

Both *Page 18: Muhammad Speaks*, and *Page 16: Ecology, Air, Fire, Earth, Water*, 1969–1970, were part of a series of over 20 'pages', dealing with political issues. The *Pages Series*, 1969–1970, consisted of large wooden boxes divided into compartments into which screen-printed soft sacks of canvas were inserted. Instead of conventional canvas stretched on a wooden frame or stretcher, Tilson sewed and stuffed the material, inserting it into a three-dimensional frame, reminiscent of the newspaper printing process. Tilson looked at traditional techniques with a spirit of enquiry and expanded the possibilities of screenprinting while challenging the conventions of traditional painted canvas. The tactile three-dimensional quality and almost homemade feel, was reminiscent of the underground newspapers, newsletters and catalogues of the environmental movement at the time.

Joe Tilson
(b. 1928, London, UK)
Page 18: Muhammad Speaks
1969–1970
187 x 126 cm
Screenprint and oil on canvas
on wood relief
Collection of the artist
© DACS 2007
Image courtesy of
Waddington Galleries,
London, UK

MAO TSE TUNG

One of the most widely read books of the period was *The Little Red Book*, which contained quotations by Chairman Mao, the revered Communist leader of the Chinese people. The book was influential in shaping the politics of youth in the West and contributed to the anxiety surrounding China in the US. The death of thousands of innocent people in the wake of Mao's Cultural Revolution, unleashed in 1966, which denounced intellectuals and forced them to return to the fields and work as manual labourers, was not yet widely known in the West.

Drag – Johnson and Mao depicts American President Lyndon B Johnson, a less prominent subject in Pop Art, who succeeded Kennedy, and Chairman Mao. President Johnson had been responsible for the widely unpopular decision to increase US involvement in Vietnam during the 1960s, and decided not to seek re-election the following year because of his failure to bring the war to an end.

Like *The Wall*, *Drag – Johnson and Mao* was made during the period Jim Dine was living in London, where he concentrated mainly on writing and printmaking. Working with Editions Alecto he completed *The Tool Box*, followed by two prints where he experimented with photo-etching. Joe Studholme, director of Editions Alecto, recalled that Dine was interested in the contrast of the weak, failing leader (Johnson) and the strong, new leader (Mao). But here dolled up with rouged cheeks and eye shadow these bodiless heads float emasculated and ridiculed. Communism and Capitalism meet head to head, but two of the most powerful men in the world are powerless at the hand of the artist who makes them both equally ridiculous.

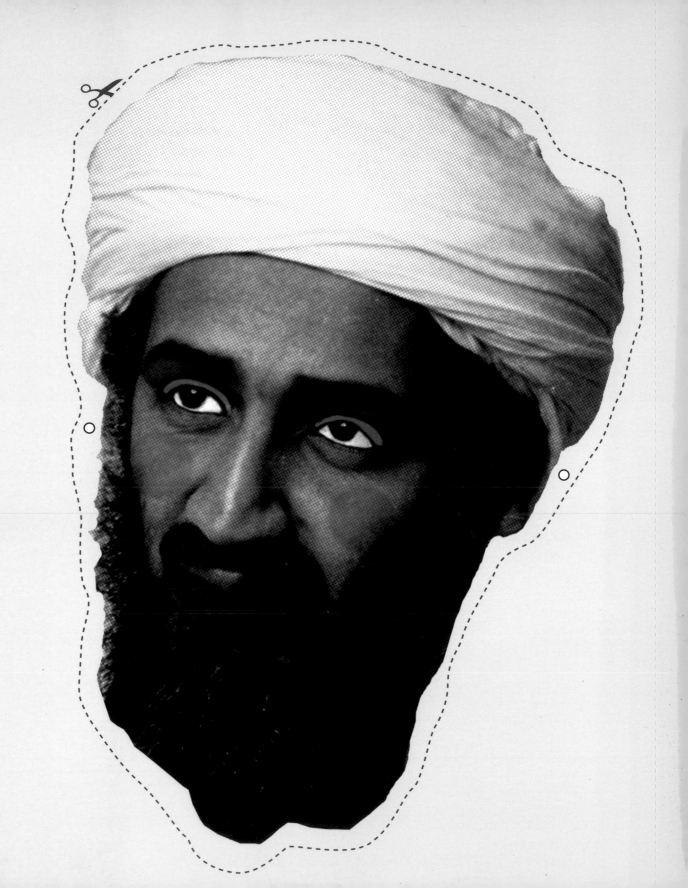

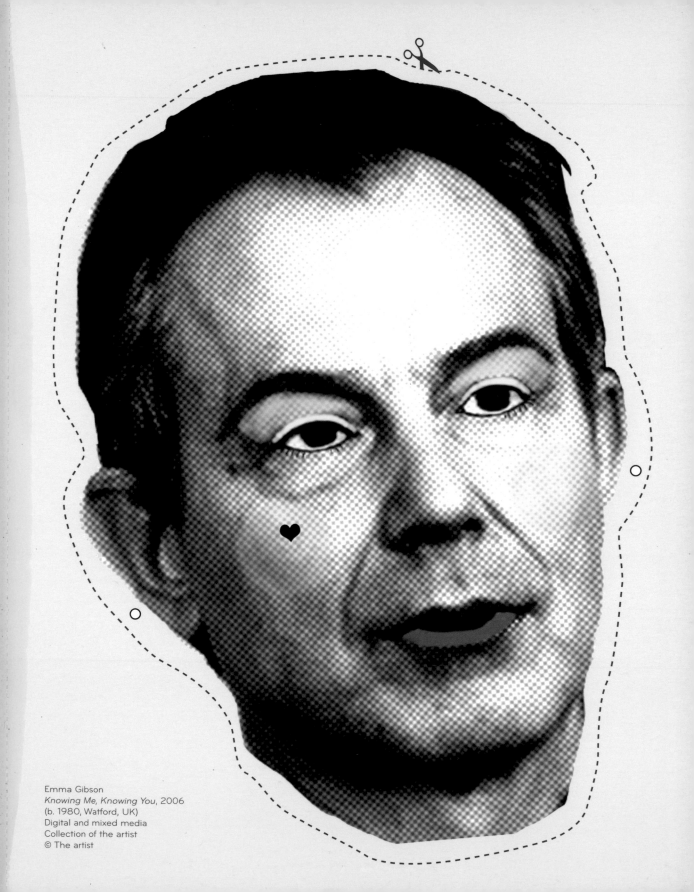

Emma Gibson
Knowing Me, Knowing You, 2006
(b. 1980, Watford, UK)
Digital and mixed media
Collection of the artist
© The artist

N NUCLEAR THREAT

America was the first country to use atomic weapons in an act of aggression, dropping bombs on Hiroshima and Nagasaki at the end of the Second World War, killing over 200,000 people in the process. Since then America and the Soviet Union have both developed substantial nuclear capabilities: bomber planes and missiles that could be aimed at any place in the world with the aid of space satellites. In response to the growing nuclear capacity of other countries, fighter planes and anti-ballistic missiles were also developed, intended to intercept nuclear attack. In the 1960s, pictures of the nuclear mushroom cloud were widely shown in the press, and became an ominous reminder of the destructive power of the nuclear bomb. By 1963 there was greater awareness of the side effects of these tests and a partial Nuclear Test Ban Treaty was signed by the United States, the Soviet Union and the United Kingdom.

In Britain, activists brought the full impact of military developments in nuclear war to public attention with the founding of The Campaign for Nuclear Disarmament (CND) in February 1958. At its first public meeting in London, 5,000 people attended. Every Easter there was a march to the Atomic Weapons Establishment at Aldermaston. In 1960, 100,000 people rallied in Grosvenor Square, London before marching on to Aldermaston in protest of nuclear arms and the growing threat of nuclear warfare. Of the Pop artists, David Hockney and Richard Hamilton were active CND members, while others casually attended marches and meetings. In 1962 the Cuban Missile Crisis brought home how close a reality nuclear confrontation was, contributing to a latent fear throughout the 1960s that the horrors of Hiroshima and Nagasaki would soon be repeated. Colin Self did not participate in anti-nuclear protests but the threat invoked a deep-seated, personal fear that almost paralysed him into inactivity during the early 1960s:

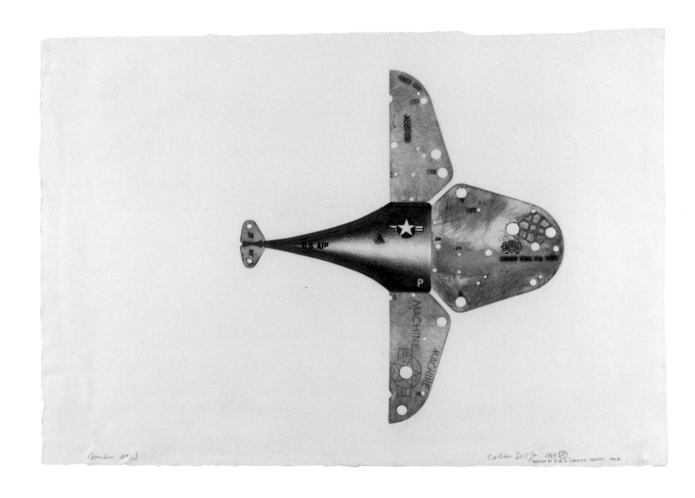

Colin Self
(b. 1941, Norwich, UK)
Bomber No. 1, 1963
39.6 x 57.6 cm
Mixed media on paper
Tate Gallery, London, UK
© DACS 2007

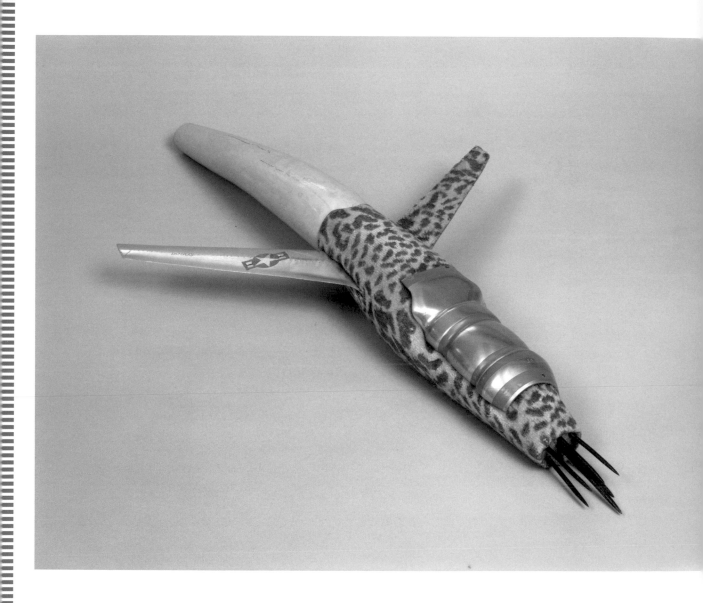

Colin Self
(b. 1941, Norwich, UK)
*Leopard skin Nuclear Bomber
no 2*, 1963
9.5 x 80 x 42 cm
Painted wood, aluminium, steel
and fake leopard skin
Tate Gallery, London, UK
© DACS 2007

As a teenager, I had been devastated by the modern nuclear arms race East/West Cold War Armageddon preaching of the philosopher Bertrand Russell. People seemed still normal but I was raw to it all, day and night. After some five years of inner torment I saw a news photo where Kennedy and Khrushchev, smiling, exchanged a peace document. Hope. The log-jam in my frozen psyche got loosened. My post-nuclear art poured forth from years of deep theorising about a place for art in this changed world.

Art had buried its head in the sand, dominated by bullshitters. No artist painted cars in their street scenes or aeroplanes in the sky. Obscurantism. Art just repeated itself. I got my head around nuclear issues, iconography....[8]

Self's sculptures were often subtly horrifying. His *Leopard skin Nuclear Bombers* were around 60 cm long bomber planes, wrapped in leopard-skin with aluminium wings and menacing sharp metal spikes protruding from their noses. In *Leopard skin Nuclear Bomber No. 2*, the plane's wing bears the American star insignia. The phallic shape and animal fur suggests male aggression and animal ferocity. In an equally jarring image, Self's *Beach Girl, Nuclear Victim*, 1966, is made to represent the charred, disfigured form of a glamorous female model victimised by nuclear warfare.

Pop got its head round being human, inner worries, complexes, sex, 'cool', innocence, base, cynicism, chic, fun, darkness, 'tongue-in-cheek', DIY. Pop went into all the 'no-go' human areas with complete approachability, sincerity and honesty. These iconoclastic revolutionary iconic truths and new aesthetic are the usurped catalyst, the oil of the machine of all modern marketing, packaging, presentation, society, the world of materialism turning. Pop actually revealed The Human Condition like nothing else.[9]

8 Colin Self quoted in *British Pop*, exhibition catalogue, Bilbao: Museu de Bellas Artes, 2005, p. 446.
9 Colin Self quoted in *British Pop*, exhibition catalogue, Bilbao: Museu de Bellas Artes, 2005, p. 450.

Adrian Henri's painting was derived from an image by the German Expressionist, James Ensor, titled *Christ's Entry into Brussels*, 1889. Henri's work however, situates the procession in Liverpool, and identifies the events and observations that drove people to action in the 1960s—emphasised in the embroidered banners and flags peppering the scene; 'Ban the Bomb'; 'Long Live Socialism', 'Colman's Mustard', 'Keep Britain White' and 'Freemasons'. Looking at the poem "The Entry of Christ into Liverpool" the artist's political attitudes become obvious.

> **Crushing surging carrying me along**
> **Down the hill past the Philharmonic The Labour Exchange**
> **Excited feet crushing the geraniums in St Luke's Gardens**
> **Placards banners posters**
> **Keep Britain White**
> **End the War in Vietnam**
> **God Bless our Pope**
> **Billboards hoardings drawing on pavements**

Although written some time ago Henri maintains that the poem's cautions echo through to present day events: "It is about Vietnam, but it is still relevant. It's about sitting faithfully in England while thousands of miles away terrible atrocities are being committed in our name."

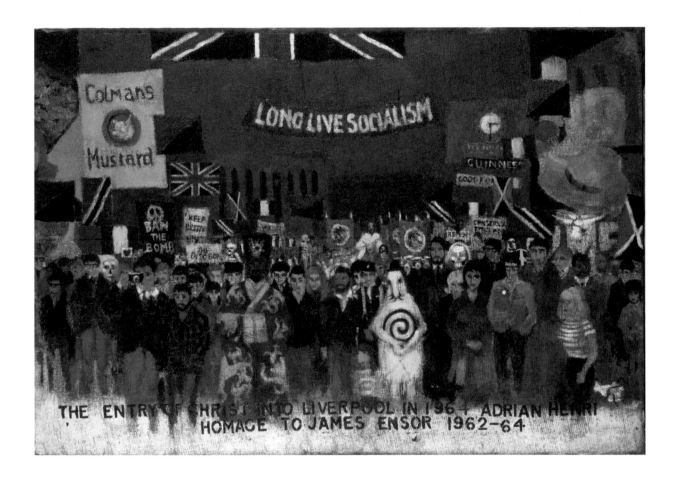

opposite
Colin Self
(b. 1941, Norwich, UK)
Beach Girl, Nuclear Victim,
1966
28 x 170 x 58 cm
Fibreglass, hair, cinders,
polyurethane paint
Imperial War Museum,
London, UK
© DACS 2007

Adrian Henri
(b. 1932, Liverpool, UK,
d. 2000, Liverpool, UK)
*The Entry of Christ
into Liverpool*, 1962–1964
172.7 x 241.3 cm
Oil on canvas
Private Collection
© Private collection
Image courtesy of Whitford
Fine Art, London, UK

P The Profumo Affair

While much Pop Art in Britain was a critique of American politics and culture, the Profumo affair in the UK provided a subject for Pauline Boty to reflect on British politics and the place of women in the era of the 'dolly bird secretary' and the mini skirt.

Scandal 63, as the press labelled it, refers to the affair between John Profumo, a British cabinet minister and Secretary of State for War and Christine Keeler, a model and showgirl. Keeler was portrayed as a high society prostitute who also had personal relations with Yevgeny Ivanov, the Soviet naval attaché at the Russian embassy in London, and represented a potential threat to national security. For many, Keeler was the scapegoat for a political intrigue for which there was no clear evidence. Having lied to the House of Commons over the affair, Profumo was forced to resign and his downfall exposed the hypocrisy of the British Establishment.

In Boty's work Keeler is given the most prominence while the faces of Profumo and Ivanov are arranged on the upper edge of the painting alongside two black men falsely accused of assault—presenting a rare critique of the underlying racial tension and negative attitudes towards women in Britain.

Boty based her image of Christine Keeler on a semi-pornographic photograph by Lewis Morley, which depicts a naked Keeler sitting on a backwards-facing chair; an image that later came to sum up the Profumo affair. Boty poses questions about the representation of women in art and media that were to be taken up by feminists a decade later.

Michael Ward
(b. 1929, Streatham, UK)
Pauline Boty, 1964
Photograph of Pauline Boty
holding *Scandal 63* (now lost)
with her collaged wall in
the background
National Portrait Gallery
© The artist

THE SPACE RACE

The Cold War spurred the race into space during the 1950s and 60s, as the Soviet Union and America competed to lead the field in space exploration. Kennedy summed up the necessity of space dominance during a speech at Rice University in 1962, stating that "no nation which expects to be the leader of other nations can expect to stay behind in this race for space". He subsequently managed to win his congressional request to approve billions of dollars allocated to developing the Apollo space programme.

Initially, the Soviet Union had the upper hand. It launched the first base satellite, Sputnik 1, in 1957. This was followed by the first living thing to be sent into space—a dog—in 1957. In 1961 the first man in space orbited the Earth, Russian cosmonaut Yuri Gagarin. The press provided images of all these developments, creating an enthusiastic public who followed the progress of space exploration with an unprecedented interest. In his *Transparency 1, Yuri Gagarin 12 April, 1961*, Tilson captures one of television's most notable records of the first man in space peering out at the cosmos, framed by the now ubiquitous curved limits of the television screen.

The Americans responded in 1969 by being the first to land on the moon, an event that captured the imagination and admiration of people the world over. Despite these triumphs there was a growing awareness that space exploration carried with it a darker side, evident in the expansion of international ballistic missiles and the use of satellites for military reconnaissance on an unprecedented scale.

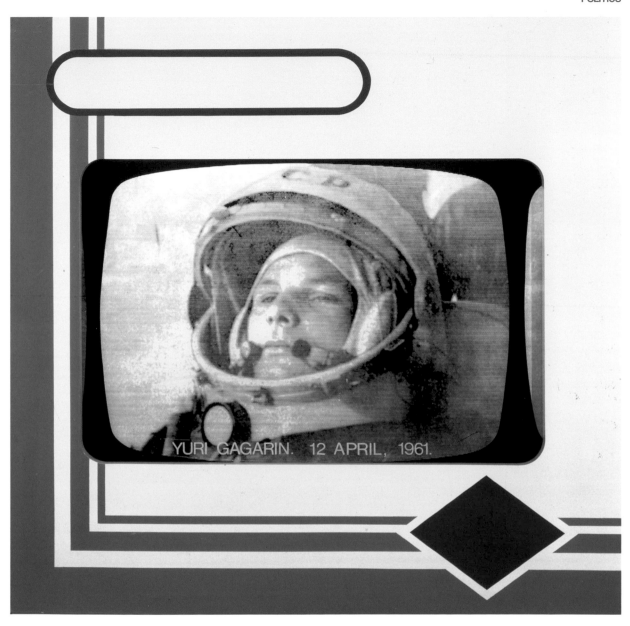

YURI GAGARIN. 12 APRIL, 1961.

Joe Tilson
(b. 1928, London, UK)
Transparency I, Yuri Gagarin 12 April,
1961
121.9 x 121.9 x 5.1 cm
Screenprint and mixed plastic
Tate Gallery, London, UK
© DACS 2007

T

Thinkers Inspiration

Page 16, Ecology, Air, Fire, Earth, Water, 1969–1970, is a tribute to some of the twentieth century thinkers and leaders who had a profound influence on Joe Tilson's political and philosophical outlook. For the most part, they are characteristically 'leftwing', in keeping with the radical student politics of the 1960s. Using his trademark columned structure, Tilson combines printed portraits found in the mass media with wooden geometric shapes, and names of the four elements 'Air, Earth, Fire, and Water'. If we turn our attention to the portraits Tilson chose to include in this screen print it becomes clear which intellectual figures inspired Tilson's aesthetic works. The portraits include Sigmund Freud, the psychoanalyst who looked into the human unconscious as revealed through art, arguing that art was a form of gratification for our innermost desires. Claude Lévi-Strauss, the anthropologist who wrote the semi-autobiographical book Tristes Tropiques, is also represented. Tristes Tropiques remains one of history's most influential anthropological works, turning over notions of so-called 'primitive' peoples by exploring alternative social structures through understanding their rituals and customs. Tilson also chose a portrait of Herbert Marcuse, the philosopher whose book, One-Dimensional Man, 1964, was widely read among the student left of 1960s Europe, and would have been read by many of the artist's contemporaries. Also depicted is the writer Frantz Fanon, who investigated the effect of colonial dominance on cultural identity. Fanon's Black Skin, White Masks describes his experience as a dual-heritaged intellectual living in France, excluded from the establishment because of the colour of his skin, the book provides a critical commentary on race relations and the cost of imperialism. These portraits are set alongside images of Beat writer William Burroughs, Che Guevara, Malcolm X, the writer and inventor Buckminster Fuller, the North Vietnamese leader Ho Chi Minh and Chairman Mao. Taken together, these leaders and thinkers provided the philosophical context in which many Pop artists worked, and the cultural framework through which their work was reviewed.

Joe Tilson
(b. 1928, London, UK)
Page 16, Ecology, Air, Earth, Fire, Water
1969–1970
169 x 169 cm
Screenprint and oil on canvas on wood relief
Collection of the artist
© DACS 2007
Image courtesy of Waddington Galleries,
London, UK

VIETNAM WAR

The Vietnam War set out to forge a unified Vietnam, originating with a conflict between Communist North Vietnam (and its allies the USSR and China) and South Vietnam supported by America, Australia and New Zealand. To many it represented a proxy war; America and Western style democracy versus the USSR and the expansion of Communism. Between 1964 and 1968 the conflict escalated dramatically, and the American government responded by drafting more and more young men to bolster the South Vietnam front. From 1964 onward, around three million US troops were sent overseas.

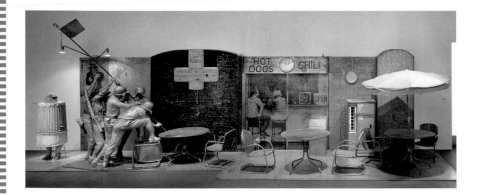

Edward Kienholz
(b. 1927, Fairfield, USA,
d. 1994, Idaho, USA)
The Portable War Memorial
1968
289.6 x 975.4 x 243.8 cm
Plaster casts, tombstone,
blackboard, flag, poster,
restaurant furniture,
photographs, working
Coca-Cola machine, stuffed
dog, wood, metal and fibreglass
Museum Ludwig,
Cologne, Germany
© Estate of Edward Kienholz

The rise in tension led to a terrible loss of life on both sides of the conflict, resulting in over 30,000 American deaths by 1968, along with countless Vietnamese civilian casualties. The South Vietnam side (America included) had little success against the North Vietnamese, as they were unprepared and ill-equipped to deal with the guerrilla tactics employed by the Communist front. Support for the war was plummeting in public opinion as a result of the saturation of media images and stories depicting young soldiers losing their lives in a war that no one seemed to understand. This was the first such international conflict to be broadcast on television, and initially the networks were supportive of the official American position. However, as time passed, independent reports started filtering through, revealing the atrocities perpetrated by the Americans on Vietnamese civilians, and the dramatic amount of American fatalities incurred through disorganised and unprepared military operations. The death toll, by the end of the war, was estimated to be as high as four million. Indeed, casualties were so high that the awarding of Purple Heart medals became commonplace. 'Purple Heart' was adopted in popular culture as the name of a small blue triangular recreational drug prevalent in the 1960s.

While few artists dealt with the subject directly, the Vietnam War inspired many Pop artists. In the installation, *The Portable War Memorial,* 1968, Edward Kienholz depicts American soldiers raising their flag in what seems to be a typical American snack bar, complete with a Coca-Cola machine and hot dogs on the menu. Kienholz specifically alludes to the human cost of war, even in past American military successes, using an image that had become synoymous with the country's triumph —the racing of the American flag at Iwo Jima. Behind the soldiers Kienholz depicts a First World War recruitment poster, and places a blank memorial tablet in the centre, as if to allow the viewer to fill in the details for any conflict of choice. War is both normalised through being represented in a domestic context, and shown for its viscous and essentially inhumane nature through reminders of the destruction it promises. Kienholz seems to suggest that though the tragedy of war has been well documented throughout history, the lessons of the past never seem to be learned, and new tragedies are continuously perpetuated by the powers that be.

Images of Vietnam deeply affected leftwing Britain, initiating widespread protest in association with the Anti-Vietnam Solidarity Campaign, with demonstrations in Grosvenor Place outside of the American embassy in 1967 and 1968, the extensively covered sit-in at the London School of Economics and various demonstrations at several other university campuses across the country.

Tilson makes his leftist allegiances clear, as he borrows the title of this work from the *Vietnam Courier,* a weekly communist journal published in Hanoi and written in English. He includes a photograph of a benign Ho Chi Minh posing with two children and a photograph of a South American, Nambikwara Indian girl, taken from the book *Tristes Tropiques*

Joe Tilson
(b. 1928, London, UK)
*From A-Z Box, V-Vietnam
Courier*, 1969–1970
75 x 50 cm
Screenprint on paper
Tate Gallery, London, UK
© DACS 2007

by Lévi-Strauss. In the text Lévi-Strauss records "that between 1907 and 1930 the epidemics introduced with the arrival of the whites had decimated the Indians". Tilson's use of this gentle image of female grooming alongside the headlines of destruction suggests a lack of respect for alternative social structures and the terrible consequences of imperialism. In his *Kent State*, 1970, Richard Hamilton records an event in the course of several anti-war protests that shocked and horrified liberal thinkers the world over. Demonstrations were organised at Kent and Jackson State Universities to protest against President Nixon's 1970 decision to sanction military incursion into Cambodia in an effort to cut off resources and assistance for the North Vietnam front. The student demonstrators participating in the subsequent protests clashed with the National Guard, who responded by opening fire, killing four protesters and injuring many others. Images of this tragic event were broadcast worldwide, and met with almost universal outrage. Hamilton was deeply affected by the event when he saw it broadcast on television, subsequently choosing to make it the subject of a commissioned screenprint.

This tragic event produced the most powerful images that emerged from the camera, yet I felt a reluctance to use any of them. It was too terrible an incident in American history to submit to arty treatment. Yet there it was in my hand, by chance—I didn't really choose the subject, it offered itself. It seemed right, too, that art could keep the shame in our minds; the wide distribution of a large edition print might be the strongest indictment I could make.[10] – Richard Hamilton

10 Hamilton, Richard, *Collected Words*, London: Thames and Hudson, 1982, pp. 92–94.

The screenprint turned out to be among the most complicated of all the prints he had made up until that point. Generally accustomed to working on editions of less than 100, Hamilton was now embarking on a work that employed 13 different screens for an edition of over 5,000. He worked closely with the printer; taking advantage of his technical knowledge to drive the screenprinting process farther than he had ever done before. For Hamilton, the technical production was integral to the aesthetic idea, and both processes were necessary to communicate the subject of the work. This is an extraordinary analogy of the new science and technology behind the transmission of the image, as it mutated from one medium to another, from film to satellite signal to television picture to photograph, and from one part of the world to another:

> Out of the chemicals into the light another, this time
> random, mesh of coloured particles tells the story.
> The same message is there—the tone of voice is new,
> a different dialect, another syntax; but truly spoken.[11]

Of the actual shooting the artist later wrote:

> The Kent State student depicted, Dean Kahler, was not
> killed. He suffered spinal injuries and is paralysed. The text
> that I originally wrote for the subject avoids any emotion
> of the horrible circumstances of that day in May. It coolly
> describes the passage of information. From the actual
> fact of a young man struck down by the bullets of amateur
> guardsmen to the eventual representation in a print,
> all the transformations of energy, listed remorselessly like
> a modern version of the tale of Paul Revere. It seems
> far more menacing than a sentimental registering of
> personal disgust.[12]

Hamilton's interest lay in the process and distortion of the image by media technologies. This took the underlying theme in his earlier work one step further, that is, the visual languages and technologies behind the visual images in the mass media, their significance in contemporary culture and their possible integration into contemporary art.

11 Hamilton, Richard, *Collected Words*, London: Thames and Hudson, 1982, p. 96.
12 Hamilton, Richard, *Collected Words*, London: Thames and Hudson, 1982, pp. 92–94.

Richard Hamilton
(b. 1922, London, UK)
Kent State, 1970
67.2 x 87.2
Screenprint on paper
Tate Gallery, London, UK
© Richard Hamilton
All Rights Reserved
DACS 2007

CONS

UMER

Tom Wesselmann
Still Life #30, 1963
122 x 167.5 x 10 cm
Oil, enamel and synthetic polymer paint on composition board with
collage of printed advertisements, plastic flowers, refrigerator door,
plastic replicas of 7-Up bottles
The Museum of Modern Art, New York, USA
Gift of Philip Johnson
© DACS, London/VAGA, New York 2007

CONSUMERISM:
POP IN A COKE CULTURE

By the 1950s, the American economy was booming, marking a sharp recovery from the Second World War, and making the USA the richest country in the world. In Britain, the Conservatives were returned to power under the leadership of Winston Churchill. In 1951, his election manifesto, with its emphasis on freedom and abundance, anticipated a new era of increased opportunities where traditional social structures could be challenged. Post-war regeneration bolstered the international economy, creating an overall rise in affluence worldwide. Average earnings in the West increased, the standard of living climbed and ordinary people now expected to own modern luxuries like fridges, televisions, cars and other conveniences that would have been previously reserved for the very wealthy. Many British people were charmed by images coming out of Hollywood, and they aspired to replicate the 'American way of life'. More people were exposed to advertising than ever before through the introduction of commercial television in 1955 and the availability of cheap colour magazines, promising new products and new ways of living. In the 1950s and 60s, the amount and variety of consumer goods available dramatically increased, creating a desire for this merchandise through advertising and media product placement. Consumers were no longer acquiring a commodity, they were buying into a whole lifestyle.

Pop artists were interested in the growth of consumerism and the impact it had on production, advertising and branding. In the 1960s Andy Warhol started to paint images of mass production, like Coke bottles and Campbell's soup cans. His studio, 'the Factory', employed a team of art workers to mass produce prints and posters in a parody of industrial society. Indeed Warhol's production methods mirrored those of other consumer goods being rolled off the factory assembly lines into people's homes at the time. The original Factory was on East 47th Street in New York City, and became a hip hang-out for models, musicians, actors and other arty types. The art workers, known as the 'Warhol Superstars', were an assortment of free-thinkers, models, musicians and drag queens that Warhol employed to make silkscreens, lithographs and act in his films. The Factory was famous for its parties and developed a unique atmosphere of its own, built upon the principles and aesthetic of the new consumer culture.

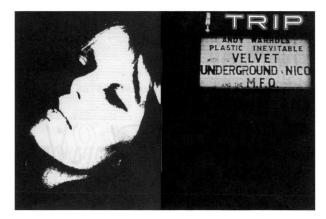

Andy Warhol
(b. 1931, Pittsburgh, USA, d. 1987, USA)
Index Book, 1967
22 x 28.5 cm
Published by Random House, New York, USA, 1967
Wolverhampton Art Gallery, Wolverhampton, UK
© Licensed by The Andy Warhol Foundation
for the Visual Arts Inc/ARS
New York/DACS London 2007
Image courtesy of Wolverhampton Art Gallery, Wolverhampton, UK

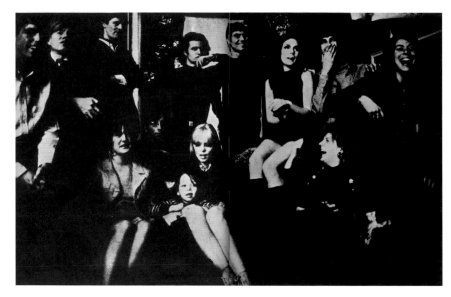

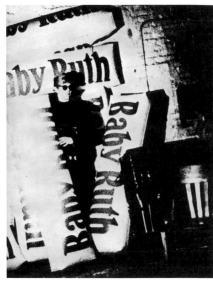

Many artists were interested in the language of advertising and the potential that the new consumer culture offered to artists and graphic designers. But Pop artists were also interested in the visual vocabulary or shorthand used by advertisers and graphic designers to obtain maximum impact. Richard Hamilton's writings reflect the extremely detailed analysis he made of advertisements, in particular, American advertisements for cars and household appliances. The publication of Vance Packard's book *Hidden Persuaders,* in 1957, revealed to many of the younger generation of Pop artists the psychological tactics of motivational marketing—creating an awareness of visual signs and semiotics that some, like Derek Boshier, explored in their paintings. Artists took up the language of advertising in diverse ways—from the expressive sensitivity of Larry Rivers considering the rarefied sources of mundane packaging, to Wesselmann's large still-lifes and interiors, evoking brash billboards.

Derek Boshier explored the sinister side of advertising—the way that consumers were manipulated into buying certain products. For example, in his *Drinka Pinta*, Boshier took an image of Cadbury's chocolate and combined it with the milk marketing board's popular slogan, suggesting that a bar of chocolate is a healthy alternative to a pint of milk, a popular technique used by advertisers to manipulate consumers into purchasing unnecessary products. The figures tip out of the glass, cascade down the canvas, falling into a heap of anonymous victims of advertising's brain-washing tactics. Boshier also produced work based on Pepsi-Cola (*Pepsi Culture*, 1962), where he used the red, white and blue circular logo as a synonym for American consumer culture, and its increasing (almost imperial) dominance in the rest of the Western world.

In the twenty-first century capitalist West, it is hard to fully appreciate the impact of new products, branded with brash logos and tempting packaging, but in the 1950s the impact of this vast increase in choice was profound. Combined with this surge in consumerism was the emergence of a youth culture, resulting from the post-war baby boom and growing economic affluence. These young people were more independent than their parents, and had greater spending power. They were also keen to reconsider traditional ways of living and form their own identity, which is why they were particularly responsive to the new marketing strategies aimed specifically at their demographic.

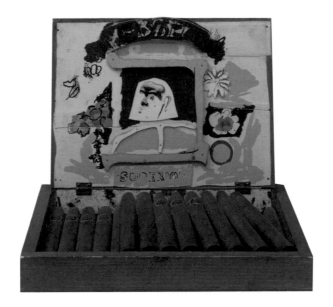

opposite
Andy Warhol
(b. 1931, Pittsburgh, USA,
d. 1987, USA)
Index Book, 1967
22 x 28.5 cm
Published by Random House,
New York, USA, 1967
Wolverhampton Art Gallery,
Wolverhampton, UK
© Licensed by The
Andy Warhol Foundation
for the Visual Arts, Inc/ARS
New York/DACS London 2007
Image courtesy of
Wolverhampton Art Gallery,
Wolverhampton, UK

top
Larry Rivers
(b. 1923, New York, USA,
d. 2002, as Yitzhok
Loi Za Grossberg)
Cigar Box, 1967
33.9 x 40.6 x 33.7 cm (open)
Hinged wood box with
painted, screenprinted,
photolithographed, and
collaged wood, board, canvas,
paper and plexiglas
Published by Multiples, Inc,
New York in an edition of 20
Printer: Chiron Press, New York

bottom
Derek Boshier
(b. 1937, Portsmouth, UK)
Drinka Pinta, 1962
152.5 x 121 cm
Oil on canvas
Royal College of Art,
London, UK
© The artist

ADONIS IN Y FRONTS

Richard Hamilton was an early enthusiast of popular culture as a source of material and inspiration. He was particularly interested in the language of media and advertising. From 1962 to 1963 he worked on a series of four paintings entitled *Towards a Definitive Statement on the Coming Trend in Men's Wear and Accessories* in which he investigated concepts of masculinity and its relation to fashion.

Adonis in Y-Fronts was the third work from this series. Here Hamilton considers the concept of timeless male beauty, combining elements of ideal aesthetics in classical Greek statues with the modern day equivalent, the muscleman. As the basis of the image, he used an advertisement for Potenza Chest Expanders taken from a 1960 *Mr Universe* magazine. Hamilton cropped the head and torso, extended the dimensions of the figure to recreate the classic pose of a Greek sculpture and decorated it with stripes from a cigarette advertisement. The title refers to Y-front underpants, the latest development in men's underwear engineering at the time. It was also a parody of the American pop song *Venus In Blue Jeans* by Jimmy Clanton, which was in the top five of the British hit parade when Hamilton made the work.

Adonis in Y-Fronts was the basis for Hamilton's first screenprint. He worked with printer Chris Prater, who helped him to create an image that involved a complex series of screens and techniques. The resulting work achieved exceptional subtleties of texture with a combination of visual styles: the hard edge colour bands, the precise hand-drawn spring of the chest expander and the photographic transfer of the original advertisement. A few of the prints were mounted on board and fixed with metal rivets, adding an additional, industrial, aesthetic element.

1 Richard Hamilton describing *Towards a Definitive Statement on the Coming Trend in Men's Wear and Accessories* in "Urbane Image", *Living Arts*, no. 2 1963, quoted in Richard Hamilton *Collected Words*, pp. 49–50.

Richard Hamilton
(b. 1922, London, UK)
Adonis In Y-Fronts, 1963
61 x 81.6 cm
Screenprint and collage
on board
Wolverhampton Art Gallery,
Wolverhampton, UK

We live in an era in which the epic is realised. Dream is compounded with action. Poetry is lived by a heroic technology. Any one of a whole range of hard, handsome, mature heroes like Glenn, Toto, Kennedy, Cary Grant, can match the deads of Theseus and look as good, menswear-wise.[1] – Richard Hamilton

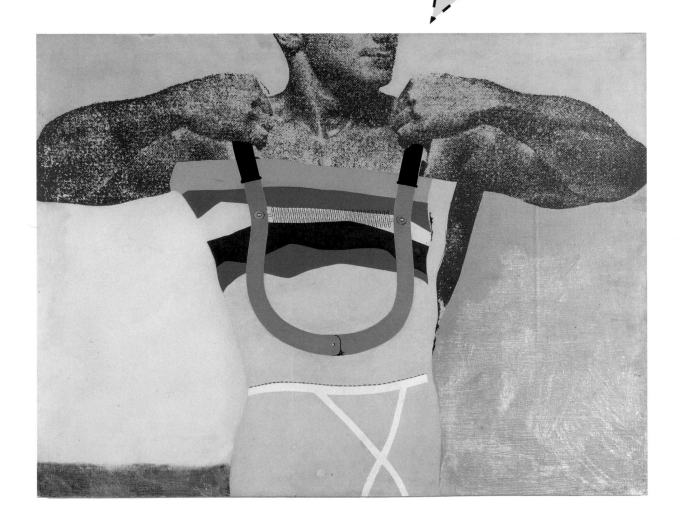

ADVERTISING

Many brands that we take for granted today, first had wide appeal in the 1950s. Products such as Coca-Cola, Nescafe, Oxo cubes, Campbell's Soup and Kellogg's cereals were thoughtfully packaged, temptingly advertised and branded to within an inch of their lives. Most of these goods had their naissance several decades earlier but never before had they been subject to the intense and persistent advertising campaigns that turned them into household names, aided by the now prevalent existence of televisions and radios in homes across the Western world.

The fantasy world of magazine and advertising images was reflected in Joe Tilson's prints. Like Richard Hamilton, he shared an enthusiasm for American popular culture and products projected through the lens of mass media. This interest is reflected in *Cut out and Send*, 1968, which highlights the technicolour world of lush magazine and advertising photography and pays reference to other forms of media, such as early Hollywood films and news footage.

Tilson's interest in the five senses is linked to his examination of human communication, from the most essential physical means to the more psychological techniques adopted by the media. In *Cut out and Send*, the eyes are surrounded by visual media; films, TV footage and newspaper images. The eye itself is a recognisable magazine image. It is glamorous and heavily made-up, typical of women's glossy fashion magazines. Hamilton adds another level of discourse with the 'cut out and send' directive on the work, echoing mail-in advertisements or 'send away for' coupons in newspapers. The contact sheets on the edge of the image are partially ripped, heavily collaged and positioned next to a Kodak colour scale that reflects the newly available photographic technology. On the opposite edge is the dazzling white glare of a rocket launching into space. These images culminate in a celebration of new visual media and the power of contemporary communications to inform and persuade.

Joe Tilson
(b. 1928, London, UK)
Cut out and Send, 1968
98 x 66 cm
Collage screenprint
Wolverhampton Art Gallery,
Wolverhampton, UK
© DACS 2007

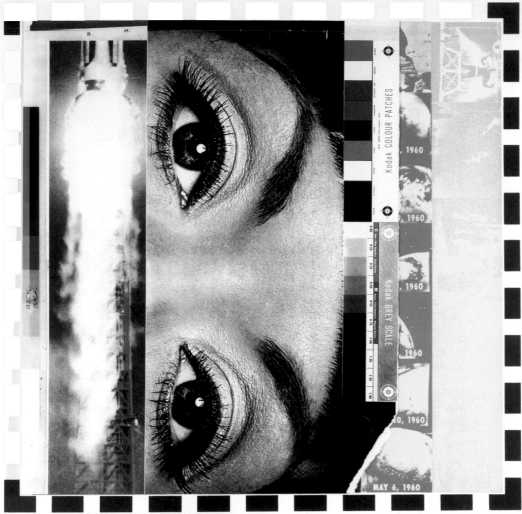

CUT OUT AND SEND

In the *Transparency, The Five Senses* series, each sense (represented by the eye, ear, nose, lip and finger) is screen-printed onto vacuum formed acrylic. Although Tilson had painted a wooden construction dealing with the five senses, in these prints he again chose imagery from glossy magazines as his primary source. The lush colour photography is encased in these new plastic forms, providing a platform to showcase two new aesthetic technologies side by side. Photographic origins are emphasised by being printed onto acetate film and encased in the vacuum-formed plastic to resemble a slide. The same mouth was used in various prints between 1967 and 1969 and was originally photographed by Robert Freeman, another friend and established photographer of the 60s scene. The teeth are given the artificial airbrushed sparkle used in toothpaste advertisements, while the perfectly shaped lips and teeth are slightly open, mysteriously revealing a galaxy of stars in the night's sky. The fantastical nature of the image, coupled with its slide-like appearance, creates a feeling of artificial reality. This artificiality is further heightened by the fact that the transparencies are on a super-large scale, one and a half square metres in total. As Tilson himself wrote in 1964:

Art is a symbolic discourse of which man alone is capable... art is one of the techniques for understanding and dealing with the phenomena presented to our five senses. It gives us a frame of reference for doing this. Man sees not with his eyes, but with his mind, which immediately involves him on many levels at once....

Joe Tilson
(b. 1928, London, UK)
Transparency, The Five Senses: Taste, 1969
147 x 147 x 5 cm
Screenprint on vacuum-formed sheet of perspex
Tate Gallery, London, UK
© DACS 2007

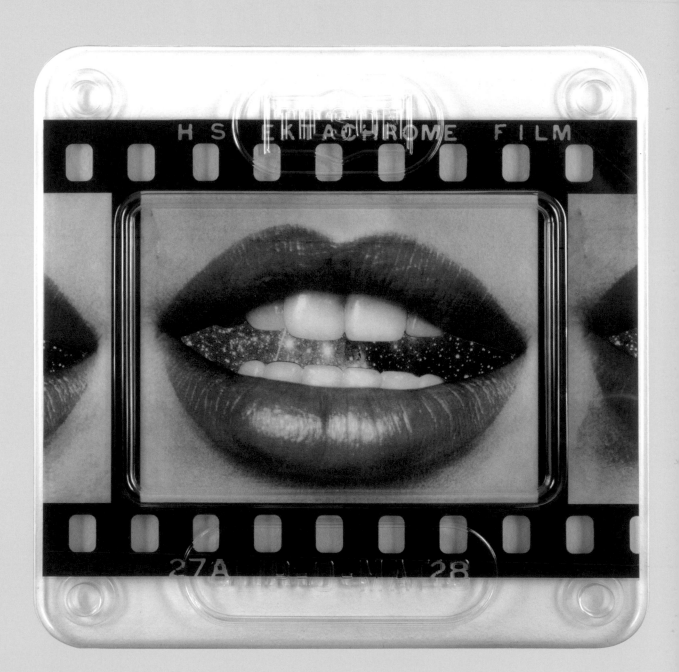

The Automobile

The 1950s were the great age of automobile design in America. Richard Hamilton, Reyner Banham and others in the Independent Group were heavily influenced by aesthetics of car-styling and the volume of car advertising. In a surge of marketing, the US car industry promoted the notion that every household should own at least one car, ideally two to compliment the two-car garages they had built onto their suburban houses. To add to the allure of the product, cars were highly stylised by their manufacturers. The car was not just a status symbol, but also indicative of masculine prowess, sophistication, sex appeal and success. Pop artists teased out these underlying messages, and frequently referenced the three main car manufacturers, General Motors, Ford and Chrysler, in their work. The 'custom car' increased in popularity, a machine modified to reflect the personal taste of the buyer, giving the impression that personality can be expressed through the objects we choose to buy and exhibit. Colin Self used a commercial image of the first customised car as the basis for his print *The Power and the Beauty*, 1968.

Some of the most seductive images in advertising were to be found in car magazines and manuals. Peter Phillips used such images in *Untitled '64*. In earlier paintings, Phillips was interested in using concepts from pinball machines and games boards as a structure for his compositions. However, from 1964 onward he became increasingly interested in arranging elements (still culled from popular media) so that they seemed to float above the background. Although he was interested in the 'contemporary iconography' of cars and customised products, the artist's main focus remained the formal elements of composition. In 1964 Phillips began moving away from more expressive brushstrokes,

Peter Phillips
(b. 1939 Birmingham UK)
Untitled, 1964
85.1 x 57.2 cm
Screenprint
Wolverhampton Art Gallery,
Wolverhampton, UK
© the artist

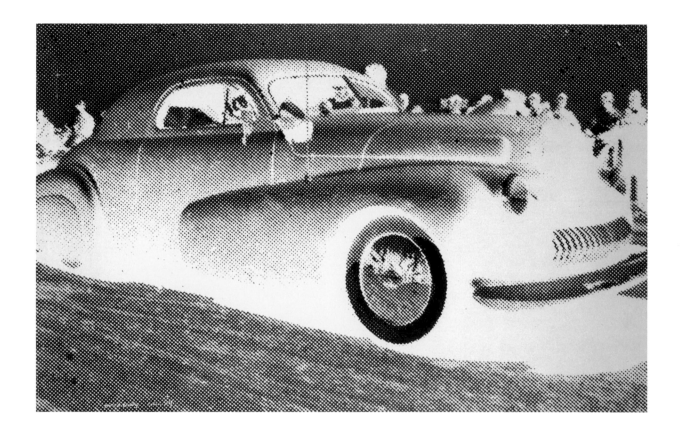

Colin Self
(b. 1941, Norwich, UK)
Unique Car, 1968
68 x 106 cm
Screenprint
Wolverhampton Art Gallery,
Wolverhampton, UK
© DACS 2007

My awareness of machines, advertising and mass communication is not probably in the same sense as an older generation that's been without these factors; I've been conditioned by them and grew up with it all.... – Peter Phillips

experimenting with airbrush and screenprint to create flat blocks of colour. On the surface of this brutally applied pigment, he could arrange random figurative and geometric elements (often ready-made) to create a carefully controlled spatial depth. Having trained in technical draughtsmanship before going to the Royal College of Art, Phillips was able to rely on his skill and appreciation for technical drawings. During his stay in New York from 1964 to 1966 he began working on the *Custom Paintings* series, the title of which referred to customised car paint workshops. Amongst the myriad special car finishes available were car transfers of pin-up models and bold abstract colour stripes.

My awareness of machines, advertising and mass communication is not probably in the same sense as an older generation that's been without these factors; I've been conditioned by them and grew up with it all... and so it's natural to use them without thinking. I'm basically interested in painting and not just a presentation of imagery.[2]

Richard Hamilton
(b. 1922, London, UK)
Hommage à Chrysler Corp, 1957
147.9 x 107.4 x 6.7 cm
Oil, metal foil and collage on wood
Tate Gallery, London, UK
© Richard Hamilton
All Rights Reserved
DACS 2007

2 Phillips, Peter, *The New Generation*, exhibition catalogue, London: Whitechapel Art Gallery, 1964, quoted in *Pop Art*, London: Royal Academy of Arts, 1991 p. 160

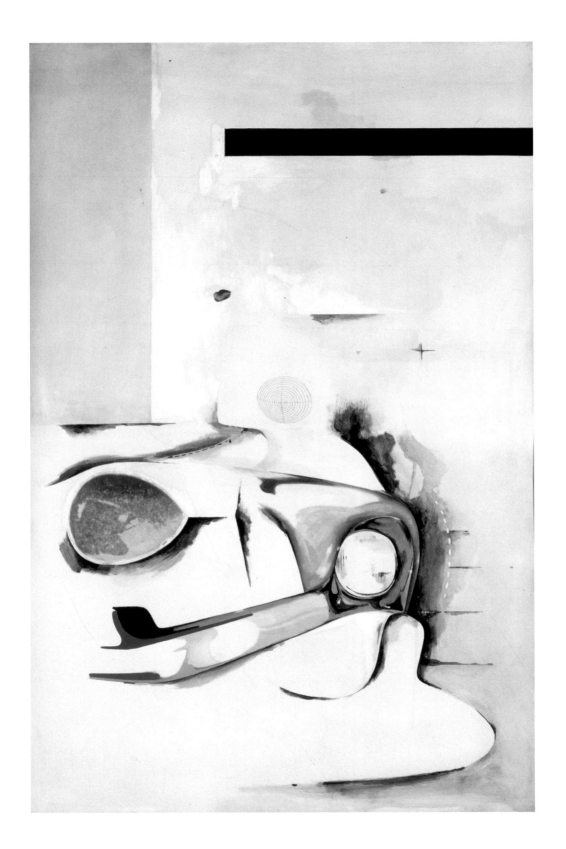

Richard Hamilton used images from car advertising in *Hommage á Chrysler Corp*, 1957. Following his letter to the Smithsons, he sought to apply his list of Pop credentials to create a painting. This took over two and a half years to complete and was the result of detailed research into advertising and Hamilton's particular interest in process and technology. The work was inspired by a number of advertisements, ranging from Chrysler's Plymouth and Imperial, to General Motors and Pontiac. Hamilton wrote: "The main motif, the vehicle, breaks down into an anthology of presentation techniques."[3] He admired the car industry for being "the most prolific image maker", one that absorbed symbols from a great variety of sources and created a stylistic language used by nearly all manufacturers. These symbols ranged from the seductive woman next to the car to the visual devices, the 'flick and flourish', or the adman's shorthand for shine on chrome. It was the relationship between women and consumerism that particularly fascinated Hamilton. The sex appeal prevalent in car advertising was predominantly aimed at male consumers who would subconsciously identify the acquisition of cars with sexual prowess. In advertisements, a female model would lean on the bonnet or caress its shiny surfaces, rendering the car an analogy for the male form. In *Hommage á Chrysler Corp* the female element is only hinted at in the presence of lips, the curve of breast and a vague impression of a feminine shape leaning over the bonnet. Viewers, familiar with the graphic devices of advertisements, would be able to visualise the female presence from this schematic reference. Hamilton's research provided specific sources for the lips and breast. The lips were Voluptua's, an American late night TV presenter, and the breast from an Exquisite Form Bra advertisement, with its unique 'CirclOform' technology.

In *I Love You With My Ford*, 1961, Rosenquist divides the canvas into three sections; a close-up of the grille of a Ford, a sensuous female profile, and a mass of tinned spaghetti. The juxtaposition of images makes the familiar link between cars and sexuality, while at the same time suggesting that both are treated just like any other consumer product. In other paintings, Rosenquist highlights the extremes of car styling at the time— the streamlined shapes, tail fins and so on, evoking speed and echoing features on the latest military aircrafts and space rockets.

3 Hamilton, Richard, *Collected Words*, London: Thames and Hudson, 1982, p. 31.

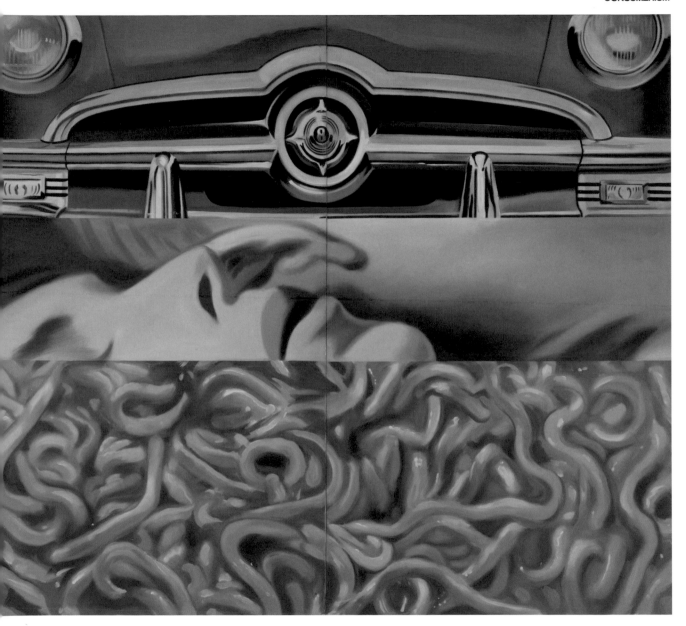

James Rosenquist
(b. 1933, Grand Forks, USA)
I Love You with My Ford, 1961
210 x 237.5 cm
Oil on canvas
The Museum of Modern Art, New York, USA
© DACS, London/VAGA New York 2007
Image courtesy of Moderna, Museet, Stockholm, Sweden

B BILLBOARDS

Richard Smith was a contemporary of Peter Blake and Joe Tilson at the Royal College of Art from 1954 to 1957, and knew Richard Hamilton from the Independent Group. Principally interested in large abstract paintings, during the early 1960s, Smith began to explore the presentation techniques used in advertising and packaging, in particular, the extreme close up and its effect of monumentality. He was particularly influenced by the American billboard painters he had observed in New York during the late 1950s. Between 1962 and 1963 Smith created a number of cigarette packet paintings as well as his first published print, *PM Zoom*, which he made for Hamilton's ICA portfolio.

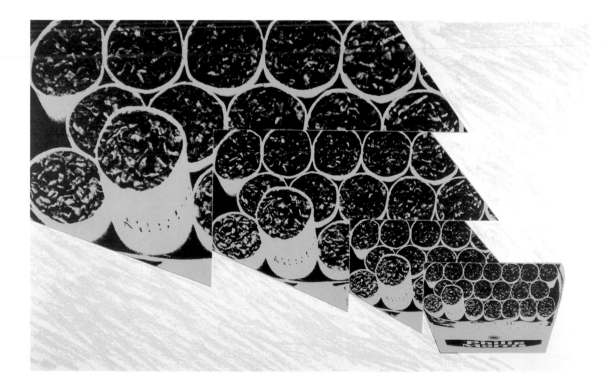

During his two-year stay in New York, Smith created various works that bore the mark of mass media—particularly advertising and packaging—which brought his work well into the Pop arena. Like Hamilton, he was influenced by Marshall McLuhan's book *The Mechanical Bride: The Folklore of Industrial Man*, 1951. McLuhan was a cultural critic who celebrated the impact of the new developments in mass communication and technology on science and art. Smith became interested in visual perception and through his paintings sought to explore some of the mass media techniques used to gain the viewer's attention. He did not realistically reproduce media images, but rather took a more conceptual, abstract approach to the key components of visual perception, including colour, field of vision and picture surface. Barbara Rose, the American art critic, described how McLuhan opened up new possibilities for artists such as Hamilton, Smith and Rauschenberg. The traditional landscape no longer inspired Smith, who instead turned toward the aesthetic of the urban landscape as mediated by the media, where "the soft focus blur of green in ads for mentholated cigarettes metaphorically [equated] cool tobacco with the freshness of a spring landscape".[4]

As Smith succinctly put it: "The communication media are a large part of my landscape. My interest is not in the message so much as in the method."[5] He analysed the photographic and film techniques used in mass media —the use of close-up, multiple frames, the effect of the zoom lens and extreme viewpoints—and they became part of his painterly language.

When he arrived in New York, Smith was excited by the vitality of the city and the extraordinary quality of light beaming from the Times Square billboards, colour magazines and advertising. New cinemascope movies made an even greater impact on the artist's visual interpretations. The Royal College of Art magazine *ARK* was rife with glowing accounts of the sights and sounds of New York City, including the one below from Alan Fletcher, the graphic designer who had been impressed by his visit overseas in 1957.

By day the streets of New York are a kaleidoscope of colour. The dazzling hues of automobiles form constantly changing and brilliant patterns with the rigid design of gridded streets and vertical buildings. The flat areas of pink, blue, chocolate, and red are punctuated with the chequered square of taxis. Meccano-like neon structures rear against the sky, and the garish colours and tinsel of advertisements lie haphazardly across the faces of buildings.

Richard Smith
(b. 1931, Letchworth, UK)
PM Zoom, 1963
76.2 x 48.6 cm
Screenprint
Wolverhampton Art Gallery,
Wolverhampton, UK
© The artist

4 Smith, Richard, *Seven Exhibitions 1961–1975*, exhibition catalogue, London: Tate Gallery, 1975, p. 11.
5 Richard Smith in *Living Arts* No.1, 1963, quoted in *The Sixties Art Scene in London*, London: Barbican Art Gallery, 1993, p. 130.

By night the city is transformed. The skyscrapers blend into the night sky and glittering neons write across a drop of millions of twinkling lights. Many of the signs, seemingly suspended in the blackness above the sidewalk's glare, give a feeling of disbelief as the interweaving shapes and lines grow and then fade away into nothingness. The moving lights of Coca-Cola reflect from a waterfall which cascades down to the bright-lit street and then silently disappears just above the sidewalk without a splash or drop of water....[6]

Smith's work was included with that of American artists at the Green Gallery's first exhibition in 1961. Among the work he exhibited at the Green Gallery were *Panatella*, 1961, *McCalls*, 1960, *Revlon*, 1961, *Chase Manhatten*, 1961, *Billboard*, 1961 and *Somoroff*, 1960. Many of the paintings depicted an extreme close up of a logo, advertisement or packaging, such as the logo of Chase Manhattan bank. They reflected Smith's interest in photography, specifically the photographic techniques used in advertising. Jeans advertising in the 1960s often focused on the detail of the pockets and its stitching and this is something that Smith has chosen to target in *Lee I*, 1961. The scale of the paintings was often physically related to hoardings or cinema screens, which never present objects in actual size.

In 1963 Smith created a series of boxes, beginning by painting brutal outlines, which get progressively larger, projecting outwards emulating a typical series of shots taken by a zoom lens. The title of the painting was decided after the work was completed, as Smith observed, it was "about the size of a piano".[7] The rhythmic black circles, and the edges of the boxes, echo piano keyboards, but also relate closely to his depiction of cigarettes as circular dots in the artist's earlier paintings. *Piano* was the first painting to push past the boundaries of the wall and spill out onto the floor in a groundbreaking use of canvas and space that reflected both the 1960s ethos of breaking traditional barriers, and Smith's personal desire to push his medium beyond its limits.

6 *Ark 19*, 1957 p. 36.
7 *Tate Gallery 1974–1976: Illustrated Catalogue of Acquisitions*,
London: Tate Gallery, 1978.

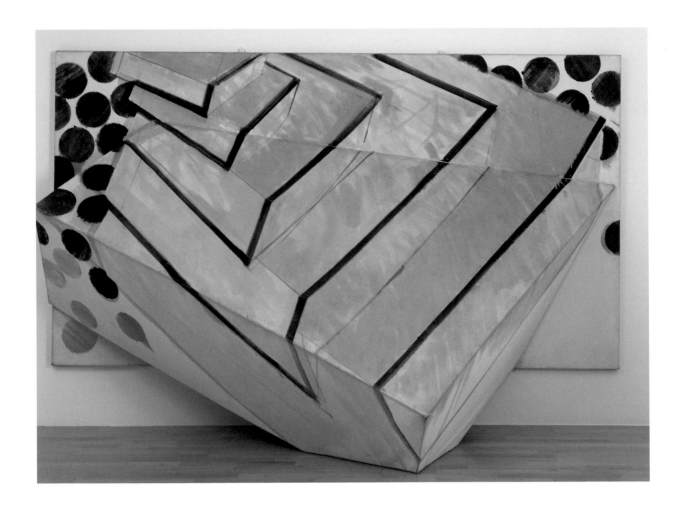

opposite
Richard Smith
(b. 1931, Letchworth, UK)
Lee 1, 1961
48.2 x 45.7 cm
Oil on canvas
Collection of the artist
© The artist
Image courtesy
of Flowers London, UK

Richard Smith
(b. 1931, Letchworth, UK)
Piano, 1963
182.6 x 277.2 x 114 cm
Oil on canvas
Tate Gallery, London, UK
© The artist
Image courtesy of
Tate Gallery, London, UK

BODY BEAUTIFUL

Images of musclemen appear in various Pop artists' work. The legendary muscleman, Charles Atlas, featured in several advertisements for body building equipment and advice. Newspaper images of these adverts appear in many of the collages by several of the Independent Group members, Hamilton, Paolozzi and Nigel Henderson included.

David Hockney was among the artists who were interested in these themes. Hockney graduated from the Royal College of Art in 1962 with a prestigious gold medal, identifying him as an important young talent. His particular focus was on the figure, drawing deeply on his personal concerns and narratives, while exploring new aesthetic directions like graffiti and the autograph.

Although he did not consider himself a Pop artist, Hockney's early work did include visual references to packaging and popular culture. In *Cleanliness is Next to Godliness*, 1965, he uses an image from the slightly homoerotic American magazine *Physique Pictorial*, which he first encountered at the Royal College of Art in London in 1959. This publication provided the inspiration for several of the artist's other works of the period, like *Life Painting for a Diploma*, 1962 and *Domestic Scene and Los Angeles*, 1963. Hockney wrote of the magazine:

> **California in my mind was a sunny land of movie studios and beautiful semi-naked people. My picture of it was admittedly strongly coloured by physique magazines published there.... Also I must admit I'd begun to be interested in America from a sexual point of view; I'd seen American *Physique Pictorial* magazines... they were full of what I thought were very beautiful bodies, American.[8]**

The images in *Life Painting for a Diploma* and *Cleanliness is Next to Godliness* are rare examples of Hockney's direct use of photographic sources, the former in a collage and the latter transferred photographically to the silk screen. Hockney had an affection for life drawing, but the artist complained that there was a shortage of attractive models, particularly of the male variety. He felt so strongly about the matter that he eventually persuaded the college to allow him to organise his own male models.

During his time in New York in the summer of 1961, Hockney sold some etchings to the Museum of Modern Art, enabling him to buy an American suit and bleach his hair blond. In 1964, he visited the publisher of *Physique Pictorial* in Los Angeles and was fascinated by the use of outdoor sets and the recruitment of attractive young men to adorn them. Indeed Hockney was not the only artist to gain inspiration from this arrangement; it also influenced the sensuous poems of one of his favourite writers, CP Cavafy.

David Hockney
(b. 1937, Bradford, UK)
*Cleanliness is Next
to Godliness*, 1964
91.4 x 58.1 cm
Silkscreen
Wolverhampton Art Gallery,
Wolverhampton, UK
© The artist

8 Hockney, David, quoted in *David Hockney: My Early Years*, London: Thames and Hudson, 1976, p. 65.

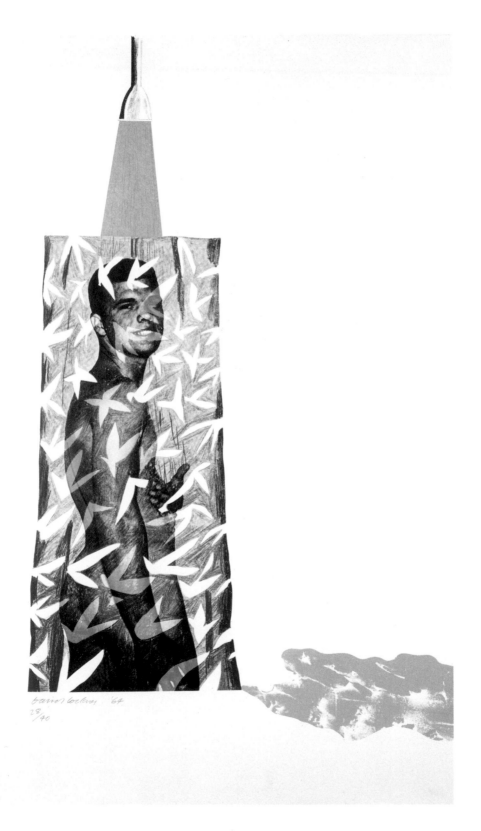

Campbell's Soup

Andy Warhol first made his name with his soup can exhibition, held at the Ferus Gallery, Los Angeles, in 1962. Warhol painted 32 identically-sized soup cans, which the gallery displayed along a narrow shelf, reminiscent of the newly erected supermarkets dotting the nation. When asked why he chose Campbell's Soup, Warhol famously replied: "I used to drink it. I used to have the same lunch every day, for twenty years, I guess, the same thing over and over again."[9]

To generations brought up in the Depression, Campbell's Soup would have seemed a luxury food. Campbell's was in fact a pioneer in convenience food marketing. From its beginning, in 1897, it had maintained the basic label design depicted in Warhol's work, and only altered the packaging to change the name of the soup's flavour. Despite a few minor modifications the product design has remained almost identical today, suggesting a promise of consistent quality throughout the product's life. By the early 1960s, Campbell's had expanded into Europe and Australia, and augmented its expansion with a huge advertising push, placing the image of the Campbell's Soup can on the pages of endless publications, and at the top of many shelves. Warhol emphasises this uniformity, which he exaggerates further with the use of simple, flat, graphic lines. Ironically, Campbell's were quick to take advantage of their notoriety as a Pop icon, with special offers on 'Pop' bowls in one of their 1968 advertising campaigns.

After the first hand-painted series, Warhol turned to silkscreen stencils for both his prints and his paintings, using a commercial printing process to depict consumer products. He identified closely with contemporary consumer culture's emphasis on mass production. Warhol was also very conscious of his Czechoslovakian parentage, and the opportunities America had provided for his immigrant family. He made a direct association between American free enterprise and mass production in his ironic comparison of Communist and Capitalist systems and concluded that both systems made people think alike.

9 Swenson, *What is Pop Art?*, p. 26.

It's happening here all by itself without being under a strict government! So if it's working without trying, why won't it work without being Communist? Everybody looks alike and acts alike, and we're getting more and more that way... I think everybody should be a machine. – Andy Warhol

Andy Warhol
(b. 1931, Pittsburgh, USA, d. 1987)
Campbell's Soup Can, 1969
87.6 x 54 cm
Screenprint
Wolverhampton Art Gallery, Wolverhampton, UK
© Licensed by
The Andy Warhol Foundation for the Visual Arts, Inc/ARS
New York/DACS London 2007

Coca-Cola

Few images in drinks industry advertising were more iconic than the Coca-Cola bottle. During the early 1960s Coca-Cola and Pepsi-Cola dominated 85 per cent of the soft drink market. Competition was fierce for the remaining share of the consumer pool and in 1961 Coke and Pepsi were spending a combined amount of nearly one million dollars on advertising. They were highly protective of their brands—their logos, colours (red and white for Coke and red, White and blue for Pepsi) and catchphrases. It has even been claimed, probably unfairly, that Coca-Cola invented the modern day Santa Claus, decked out in red and white to suit their corporate colours. It is true that he was an important figure in their advertising campaigns. The product came to be synonymous with America—on a par with the Statue of Liberty and the American flag. It is therefore not surprising that an extraordinary number of American artists including Rauschenberg, Johns, Wesselmann, Rosenquist, Segal, Kienholz, Marisol, Ramos, Oldenburg, and Warhol included Coca-Cola or Pepsi-Cola in their work.

Rauschenberg's *Coca-Cola Plan* combines real and fabricated objects. The Coca-Cola bottles, distinctive in their shape and design, are instantly recognisable. Clive Barker cast Coke bottles in aluminum. Warhol made serial images of the bottles, emphasising their iconic shape and logo. In his work, he also appropriated the matchbooks that Pepsi and Coca-Cola had produced in vast quantities and given away in bars, diners and drug stores to promote their product. Warhol marvelled at the equalising effect of modern consumer culture:

> **What's great about this country is that America started the tradition where the richest consumers buy essentially the same things as the poorest. You can be watching TV and see Coca-Cola, and you can know that the President drinks Coke, Liz Taylor drinks Coke, and just think, you can drink Coke, too. A Coke is a Coke and no amount of money can get you a better Coke than the one the bum on the corner is drinking. All the Cokes are the same and all the Cokes are good. Liz Taylor knows it, the President knows it, the bum knows it, and you know it.**[10]

Clive Barker
(b. 1940, Luton, UK)
Three Coke Bottles, 1967
21 x 15 x 15 cm
Polished aluminium
Collection of the artist
© The artist
Image courtesy of
Whitford Fine Art Gallery,
London, UK

It was widely recognised that Coke had come to signify America abroad, and with franchised bottling plants worldwide, the product introduced US production systems, and presented the US as a commercial free enterprise culture.

10 Warhol, Andy, *The Philosophy of Andy Warhol, from A to B and Back Again*, New York: Harcourt Brace Jovanovic, 1975, pp. 100–101.

You can be watching TV and see Coca-Cola, and you can know that the President drinks Coke, Liz Taylor drinks Coke, and just think, you can drink Coke, too. – Andy Warhol

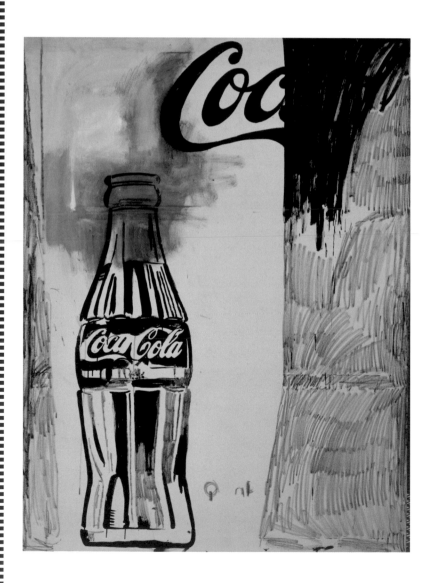

Andy Warhol
(b. 1931, Pittsburgh, USA,
d. 1987)
Coca-Cola [2], 1961
176.5 x 132.7 cm
Casein and crayon on linen
The Andy Warhol Museum,
Pittsburgh, USA
Founding Collection
Contribution The Andy Warhol
Foundation for the Visual
Arts, Inc.
© Licensed by
The Andy Warhol Foundation
for the Visual Arts Inc/ARS
New York/DACS London 2007

Domestic Goddess

In the 1950s, women were regarded as the mainstay of the family unit. A woman must be a loving wife, a caring mother and a diligent housekeeper, whilst maintaining a perfectly groomed, unruffled appearance. There were many books available to provide women with guidelines of deportment, etiquette, and household management. The guide, *In Search of Charm*, was one such example that extolled the virtues of housework:

> **The stretching, bending, kneeling (with tummy drawn in of course), is wonderful exercise, and a wise girl will enjoy it as such. As with any exercise you will find you are breathing more deeply. Therefore, open the windows and air yourself as well as the flat. Any steam around can be wonderful for your complexion- particularly if you are giving full make-up a rest during your housework session and are wearing say, just a moisturiser and a lipstick. Hands can have a rest from nail varnish, and inside those rubber gloves with silk lining (which of course you will be wearing) they can be wallowing in some oil or hand and nail cream.**[11]

At the time there were a growing number of mechanical aids for women in pursuit of the perfect home. Like other consumer products, these were heavily marketed, particularly at younger women anxious to be the perfect wife.

In *$he* Richard Hamilton explored the adman's visual language with particular reference to domestic appliances and, what he categorised as the "woman in the home". He was interested in the use of pose and gesture to convey specific messages as he explained with sample advertisements in *Collected Words*.[12]

11 Mary Young, *In Search of Charm*, 1962, p. 101.
12 Hamilton Richard, *Collected Words*, 1953–1982, p. 36.

In *$he* Hamilton combined a forward-facing upper torso revealing revealing cleavage and an outline of the film star Vikki Dougan's back. The upper torso was airbrushed in cellulose paint, while the lower half was a projecting shallow relief, emphasising the outline, which could also be interpreted as a housewife's apron.

Cadillac-pink RCA Whirlpool refrigerator/freezer, with automatic defrosting and automatic filling of ice-tray functions: major appliance if ever there was one, bring your bright fabrications in homage to her. Heap your gift-wrapped minor miracles... to her command that she remain supremely housewife-mother-cupcake.[13]

Hamilton depicts an appliance in the foreground, an amalgamation of various toaster and hoover images, juxtaposed with a diagram reminiscent of a frequent advertising technique. The lenticular winking eye was a gift to Hamilton from a German friend who thought it a suitable present for an advocate of 'blue jeans philosophy' and adds an element of amusement to the otherwise serious work.[14] By the late 1960s, the feminist movement was growing in strength and, with their fight for full social and economic equality and the right to birth control, they challenged many of the pre-existing attitudes to women's roles. Nonetheless advertisers of household products still primarily targeted women and it would be a long time before the perfect kitchen ceased to be a women-only domain.

Richard Hamilton
(b. 1922, London, UK)
$he, 1958–1961
121.9 x 81.3 cm
Oil, cellulose paint and collage
on wood
Tate Gallery, London, UK
© Richard Hamilton
All Rights Reserved
DACS 2007

13 Hamilton, Richard, "Urbane Image", in *Living Arts*, No. 2, quoted in *Collected Words*, London: Thames and Hudson, 1982, p. 49.
14 Hamilton, Richard, *Collected Words*, London: Thames and Hudson, 1982, p. 38.

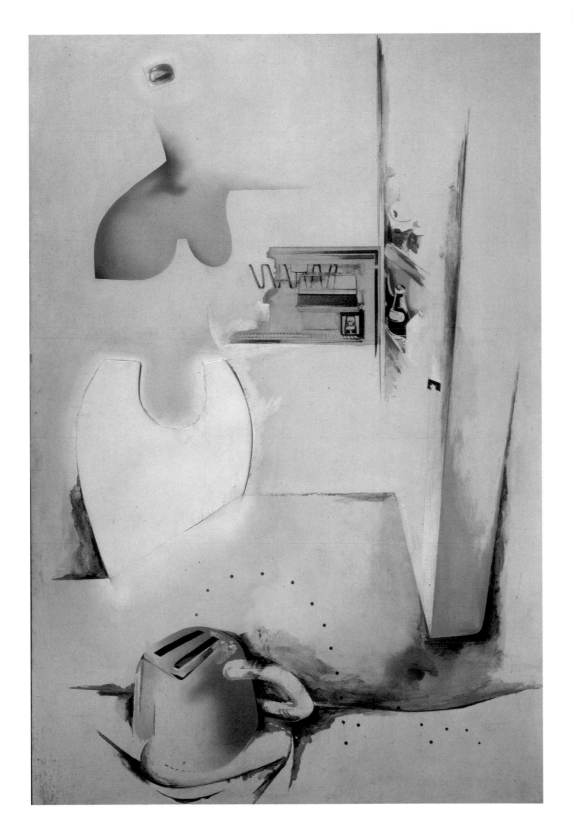

FASHION

In 1964, Andy Warhol created *Brillo Dress* and *Fragile Dress*, both of which were photographed at various Factory parties. A year later the *S&A Green Stamps Shirt* was worn at one of Warhol's exhibition openings. And in 1966 an advertisement appeared for "USA Happening! Tomorrow at A&S. See Andy Warhol Paint A Paper Dress on Nico" at Abraham & Straus a New York department store. At this event Warhol and Gerard Malanga printed 'FRAGILE' on Nico's paper dress while she wore it, while on another dress, they pasted giant yellow bananas (the same motif used for The Velvet Underground and Nico album in 1967) screen-printed in advance by Warhol and his assistants at the Factory. The artist's films and silver clouds were often used as backdrops for fashion shoots for advertisements and magazine features, such as in *Mademoiselle* in 1965. Avant-Garde fashion designers like Betsy Johnson were also included among Warhol's friends, with the artist hosting parties at Johnson's Paraphernalia Boutique, with music provided by The Velvet Underground. Many of Warhol's 'Superstars' became models in their own right and featured in newspaper and magazine articles of the period.

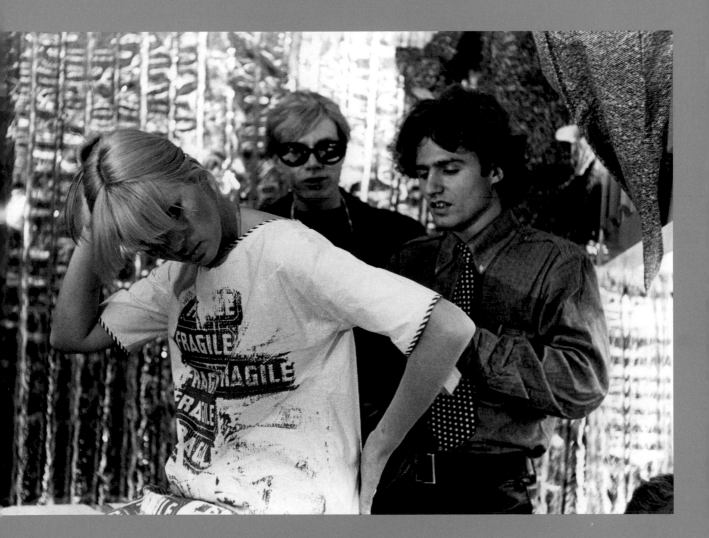

Fred McDarrah
(b. 1926, New York, USA)
Andy Warhol and Gerard Malanga stencilling 'FRAGILE' onto
a paper dress worn by Nico in the A&S Department Store in
Brooklyn, New York, 1965
23.8 x 16.8 cm
Vintage print (on double weight)
Collection of the artist
© The artist

FAST FOOD

It wasn't just American brand names, but also typical American foods that Pop artists chose as their subjects; the most obvious example is the hamburger, as featured in Ramos's *Girl on a Burger*. Fast food was a genuinely democratic product, available to a majority of socio-economic groups, and with the new national and international distribution networks, available almost anywhere in the developed world. The hamburger and the hot dog were the epitome of the pace of urban American life; convenience food to nourish the consumer at the speed of modern living. In the post-war period, successful marketing had led to the success of national chains of restaurants, owned by competing burger brands, White Tower, Burger King, Wendy's and McDonald's. McDonald's was founded in 1954 and within 20 years had become a multi-million dollar concern. Like the major competitors in the soft drink industry, all of the fast food chains were fiercely competitive and supported through extensive advertising campaigns and marketing devices.

Claes Oldenburg made several hamburger sculptures in the 1960s, ranging from painted plaster sculptures such as *Two Cheeseburgers with Everything (Dual Hamburgers)* to the giant fabric *Floor Burger*, 1962. The *Floor Burger* was made to reflect the three-dimensional signboards promoting fast food, referencing exaggerated claims for the biggest burger, the softest bun and the best deal for the buyer.

Claes Oldenburg
(b. 1929, Stockholm, Sweden)
Floor Burger, 1962
132.1 x 213.4 cm
Acrylic on canvas filled
with foam rubber and
cardboard boxes
© Art Gallery of Ontario,
Toronto, Canada
Image courtesy of
The Bridgeman Art Library

CLOSE COVER BEFORE STRIKING

GIVE AWAYS

Manufacturers were forever developing new ways of enticing consumers into buying their products. Advances in technology allowed for seductive packaging, all shiny plastic and beautiful finishes. In *The Five Senses*, Joe Tilson encased the subject of the work (a pair of lips culled from a fashion magazine) in vacuum-formed plastic, referencing the desirable, glamorous consumer products coming out at the time. Many manufacturers hit on the idea of including free 'give aways' within thier products, like plastic toys or collectible cards, a clever gimic that endures to this day. Many of these objects seemed frivolous, even useless, but nonetheless provided a real incentive to buy a particular brand.

Joe Tilson was very fond of the types of ephemeral material found in America. He admired the American abstract painters throughout the 1950s, but it was not until 1965 and 1966 that he actually touched down on American soil when he visited New York. These trips provided the inspiration for several new forms of print; *Rainbow Grill*, 1965, is based on the match book the artist kept as a souvenir of his meeting with abstract painter Barnett Newman. Making the most of the pictorial qualities, Tilson enlarged the New York skyline found on the matchbook, and encased it in a three-dimensional vacuum-formed plastic, reminiscent of a museum display case.

oppopsite
Joe Tilson
(b. 1928, London, UK)
Rainbow Grill, 1965
61 x 60.3 cm
Screenprint and mixed media
on paper
Tate Gallery, London, UK
© DACS 2007

Joe Tilson
(b. 1928, London, UK)
New York Decal 3–4, 1967
90.5 x 101.3 cm
Screenprint and mixed media
on paper
Wolverhampton Art Gallery,
Wolverhampton, UK
© DACS 2007

I was trying to make very strong, unforgettable images using the latest technology and printing and vacuum forming methods... consciously avoiding 'fine art' etching and lithography— making work that strongly represents the time and culture—avoiding nostalgia... Richard Smith, Peter Blake, Derek Boshier and myself were all engaged in making paintings using ideas taken from paper ephemera—enlarged Japanese paper toys, postcards, tickets, air mail letters, newspapers, sweet wrappings, packaging, match boxes, etc, etc.[15]

New York postcards inspired other types of print. In 1967, Tilson produced *New York Decals (1,2,3,4)*, which were again reminiscent of souvenir postcards encased in glassine envelopes to protect them from damage. These four prints were predominantly of New York landmarks like Radio City in the Rockefeller Centre, but were based on illustrations rather than photographic views. Apart from postcards, souvenirs collected by Tilson included an airmail envelope decorated with a view of New York, and free give-away toys from cereal packets, suggesting that these silver plastic trinkets could be sent home to friends as a novelty from New York City.

Many UK artists visited the United States in the early 1960s and would have been affected by the marketing tools employed there. Richard Hamilton was invited to give a lecture during the Duchamp exhibition in Pasadena, California, in 1963. Richard Smith, Allen Jones, Gerald Laing and Peter Phillips spent long periods of time in New York, while Peter Blake and David Hockney favoured Los Angeles.

15 Tilson, Joe, in conversation with David E Brauer, February 1988, quoted in David E Brauer et al., *Pop Art: US/UK. Connections, 1956–1966*, Houston: Menil Collection, 2001.

H HIDDEN PERSUADERS

These depth manipulators are, in their operations beneath the source of American life, starting to acquire a power of persuasion that is becoming a matter of justifiable public scrutiny and concern.[16]

The Hidden Persuaders was the title of a book by Vance Packard first published in 1957. The book investigated the media manipulation of the population in post-war America, particularly the way that advertisers used motivational research and other psychological techniques to induce consumer desire for consumer products. Packard questioned the morality of employing such tactics, particularly because the public was not made aware that they were being subjected to them.

Derek Boshier was particularly fascinated by how the 'American way of life' had infiltrated Britain, indeed many of his works are visual expressions of his fear that America was creeping into English cultural and political life, a fear that finds a resonance with contemporary English culture. Other writers beyond Packard were interested in these themes, like Marshall McLuhan and JK Galbraith, both of whom were popular with British Pop artists. The seminal texts that came out of that tradition exposed the world of media and consumer culture for its self-preserving, manipulative tactics, and investigated the rapid expansion of communication and consumerism.

16 Packard, Vance, *The Hidden Persuaders*, 1960 Cardinal Edition, New York: David McKay Co, 1960, p. 7.

Cereal packets, Pepsi-Cola, and toothpaste are subjects that recur in several of Boshier's paintings. The first toothpaste painting created in 1962 shows men swallowed up by a giant toothpaste tube, from which bright red and white striped toothpaste is being squeezed onto a toothbrush. It seems to comment on the volume of people involved in research, mass production, advertising and marketing in order to produce what—a striped toothpaste? The *Toothpaste Paintings* are closely linked with Boshier's reading of *The Hidden Persuaders*, where Boshier picked up concepts like motivational 'triggers', used by the marketing industry, and given the visual form of guns by the artist. The symbolism he used for the effect of advertisements with its pursuit of mass appeal, was the faceless man, dissolving into nothing or turning into an anonymous jigsaw piece.

In *K's Special*, the cereal packet, with its contents of identikit men and rows of toy aeroplanes, seem to reference the free gifts often included within the packaging itself as an added incentive to buy.

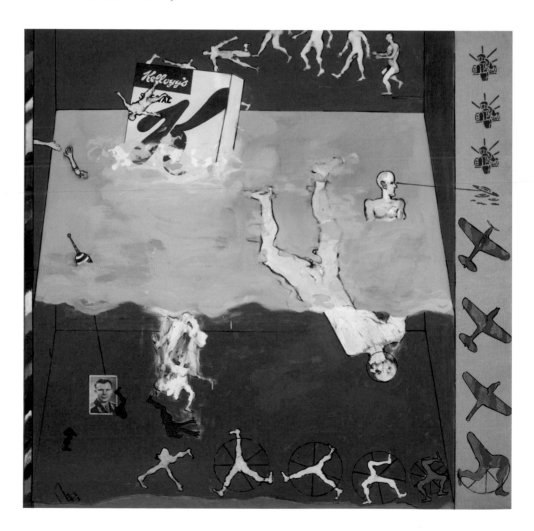

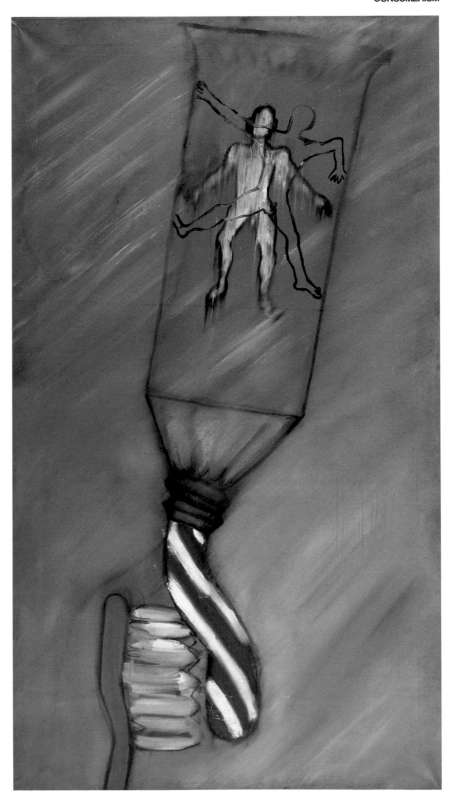

opposite
Derek Boshier
(b. 1937, Portsmouth, UK)
K's Special, 1962
183 x 183 cm
Acrylic on canvas
Private Collection
© The artist
Image courtesy of
The Mayor Gallery, London, UK

Derek Boshier
(b. 1937, Portsmouth, UK)
First Toothpaste, 1962
138 x 77.6 x 3.4 cm (framed)
Oil on canvas
Sheffield Galleries
and Museums Trust,
Sheffield, UK
© The artist
Image courtesy of
The Bridgeman Art Library

S SHOE BOX

The Shoe Box is an extraordinary contribution to Pop Art by Allen Jones. A simple portfolio of traditional black and white lithographs is taken to a new dimension, in subject matter and stylistic treatment. Following a trip to America, Jones began collecting fetish illustrations of the 1940s and 50s and developed a similarly extreme, stylised form of drawing as the basis of his own figurative work. The catalogues, such as those from Fredericks of Hollywood (the American lingerie store famous for selling fetish underwear) provided him with not only a drawing style but also a figurative source book of semi-clad females, in shiny synthetics and stiletto heels.

> **I began to appreciate the vitality of this kind of drawing of the human figure, which had been produced outside the umbrella of fine art. So I started to collect as much of the stuff as I could and began going through mail order catalogues... there was no extraneous line or information.[17]**

17 Jones, Allen, quoted in Marco Livingstone, *Allen Jones Prints*, Munich/New York: Prestel, 1995, p. 19.

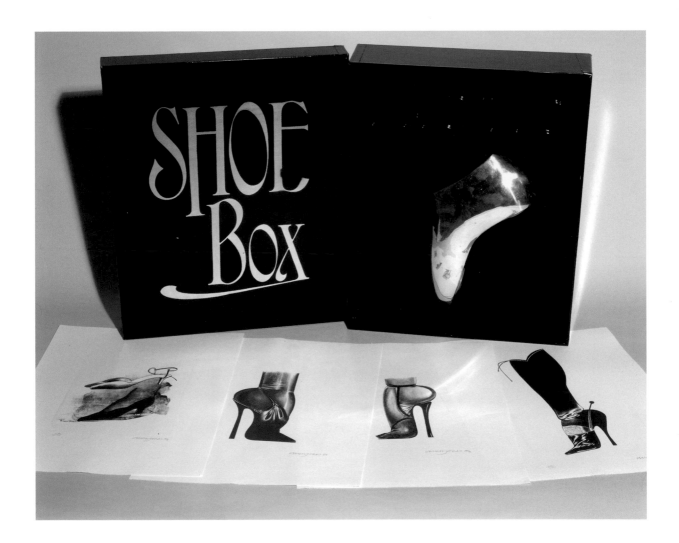

Allen Jones
(b. 1937, Southampton, UK)
Shoe Box, 1968
Various dimensions
Screenprint, lithograph and
letterpress with aluminium
sculpture and coloured Perspex
Wolverhampton Art Gallery,
Wolverhampton, UK,
MGC/V&A Purchase Grant Fund
© The artist

Lithography was an important medium in Allen Jones' artistic practice, and he often felt able to explore ideas in lithography before going on to use them in his paintings. Describing his working practice with reference to this portfolio, Jones states that he only started sketching the day before printing so that he had no pre-conceived ideas of how the print would turn out. In this way the print was not simply a reproduction of a drawing.

The concept for the portfolio came to Jones while he was waiting at a lithography studio and found a shoe size slab of lithographic stone. Petersburg Press then offered him the opportunity to develop the idea into a portfolio, expanding on the theme. Many of the shoes were derived from paintings made in the previous five years, undertaken in an extensive range of drawing techniques. Colour normally dominated Jones's work but here he explored the use of black only and used tone and contrast to add depth and dimension to the seven different lithographs.

Having decided to call the work *Shoe Box*, Allen Jones and Peter Cornwall-Jones, of Petersburg Press, wanted to create a shoe box rather than a traditional portfolio to house the prints. Jones also found the idea of making a sculptural multiple appealing, having found an extraordinarily shaped shoe last at London's theatrical and dance shoe specialist, Anello and Davide. The shoe was cast in aluminum to compliment the shiny black shoe box, the reflective surfaces of the material a reminder of the shine depicted in lithographs. Jones completed the box with a blue perspex lid, bearing the title 'EXOTIC', as a reminder of the illuminated boutique signs in 'red light' districts. The shoe, the artist described as "a kind of Pop Brancusi" referencing the Romanian sculptor renowned for his simple forms. A suitably provocative method of promotion for the *Shoe Box* was then conceived. A double page advertisement in *Art and Artists* appeared in June 1968 designed by Allen Jones, with captions by the critic Christopher Finch. The captions were a parody of advertising jargon and identified the paintings and illustrations from which the image and the style were derived.

The Supermarket

The supermarket was the apogee of affluence and plenty; shelves stacked with a vast amount of over-packaged goods competing for customers' attention. This particularly American phenomenon represented a new era of abundance to a British population still living with the memories of wartime deprivation. Prime Minister Macmillan summed up the general mood when he said "You've never had it so good." The first supermarket, King Kullen, opened its doors in New York during 1930. The novelty of this new shopping experience captured the attention of Pop artists contemplating consumer culture in both America and Britain. Many writers were also influenced by society's changing complexion, like Packard and Arthur Miller. Miller wrote a play called *The Price* in 1968, where he introduced the idea of 'retail therapy', suggesting shopping can condition your mood.

In 1964 the Bianchini Gallery, New York was transformed into the *American Supermarket*, complete with display shelves, refrigerator-style units, neon signs, aisle numbers and price tags. It was marketed using typical commercial promotions like 'Week Long Grand Opening', 'Special Reductions', and freebies of over 1,000 badges. The exhibition had a distinctly nationalistic flavour, emphasised by the use of red, white and blue for the ribbons on 'shop keepers' hats and badges, acknowledging that the first supermarkets were American; it was not until the 1950s that the phenomenon came to Britain. The installation was a great success, with over 3,000 visitors in the first two weeks.

**You've never had it so good.
– Harold Macmillan**

In a disorienting mixture of reality and artifice, a number or art objects were placed alongside real consumer products. Oldenburg contributed realistic sculptures of a jar of pickles, a slice of pie and a candy bar display. Warhol showed his painted wood and screen-printed Brillo Boxes, brown cartons for Campbell's tomato juice and Kellogg's Cornflakes ($350 each).

Wesselmann created a large vacuum-formed turkey: *Still Life No. 45*, 1962. Robert Watts provided chrome fruit and vegetables, multi-coloured wax tomatoes, plaster loaves of bread and black and pastel flocked eggs, starting at two dollars each. Jasper Johns' *Still Life II: Painted Bronze Ale Cans* were lent for one night by the collector Robert Scull. Rosenquist lent the painting *Noxzeme $100,000 Be-Beautiful Contest* while Richard Artschwager contributed *The Turnstile*. There were also real Campbell Soup cans signed by Andy Warhol and selling for $18 each. Paper carrier bags were designed by Warhol and Lichtenstein, and printed with a soup can and a turkey respectively which sold for $12. These artist-designed products, stimulated an interest in making multiples, small, inexpensive mass produced sculptures and works of art. *The American Supermarket* became a site of consumerism, a comment on shopping but also on the art world and the value placed on the unique work authored by the artist and sold through exhibitions in commercial galleries, which endorsed this notion of 'uniqueness' and the skill of the artist.

Although Andy Warhol was well represented in *The American Supermarket* he preferred in his solo exhibitions to keep a single theme per room, following the precedent he had set with his Campbell's Soup paintings in 1962. Whether the images were of consumer products or popular culture heroes like Elvis Presley, by seeing so many identical canvases in close proximity the concept of mass production was unavoidable. In 1964, Warhol exhibited his *Brillo Boxes* at the Stable Gallery, New York. Screen printed canvases had been provocative, but these wooden boxes were screen-printed in enormous numbers in Warhol's studio and were themselves, therefore, a product of mass production.

Andy Warhol
(b. 1931, Pittsburgh, USA,
d. 1987)
Brillo Soap Pads Box, 1964
43.2 x 43.2 x 35.6 cm
Silkscreen ink and house paint
on plywood
The Andy Warhol Museum,
Pittsburgh, USA,
Founding collection
Contribution The Andy Warhol
Foundation for the
Visual Arts, Inc.
© Licensed by The Andy
Warhol Foundation for the
Visual Arts, Inc/ARS
New York/DACS London 2007

WOMEN IN ADVERTISING

By the 1960s, the Western world was becoming more liberal and images that previously would have been considered likely to deprave or corrupt society were now at least tolerated in much of the media. The relaxing of the obscenity laws, the legalisation of contraception, the writings of Alfred Kinsey on human sexuality, and the success of softcore pornography like *Playboy* were all symptomatic of changing attitudes in the twentieth century. In advertising, sex was blatantly used to sell products, most commonly depicting female sexuality in a bid to win male attention. It was within this context that Tom Wesselmann was creating the works that he would come to be most remembered by, his *Great American Nudes*. Wesselmann was conscious of the increasing commodification of the female form, and took up the theme of woman as consumer object in much of his work, typically depicting female bodies alongside various other products commonly seen in advertising and store displays.

Wesselmann's work is in the tradition of the female reclining nude, seen in the work of artists like Matisse and Modigliani, placing the figure in a domestic interior, creating a more intimate feel. In *American Nude no. 27* the figure is spread across the whole canvas, with the bed indicated by a block of blue and white colour, and her body described by just a few semi-abstract lines. Wesselmann does not paint any features onto her face, suggesting an erasure of identity, indeed for the purposes of advertisers she is no more than an object to be pursued and devoured.

Tom Wesselmann
(b. 1931, Cincinnati, USA)
American Nude no. 27, 1962
122 x 91.5 cm
Enamel paint
and collage on panel
© DACS, London/VAGA
New York 2007
Image courtesy of
The Mayor Gallery, London, UK

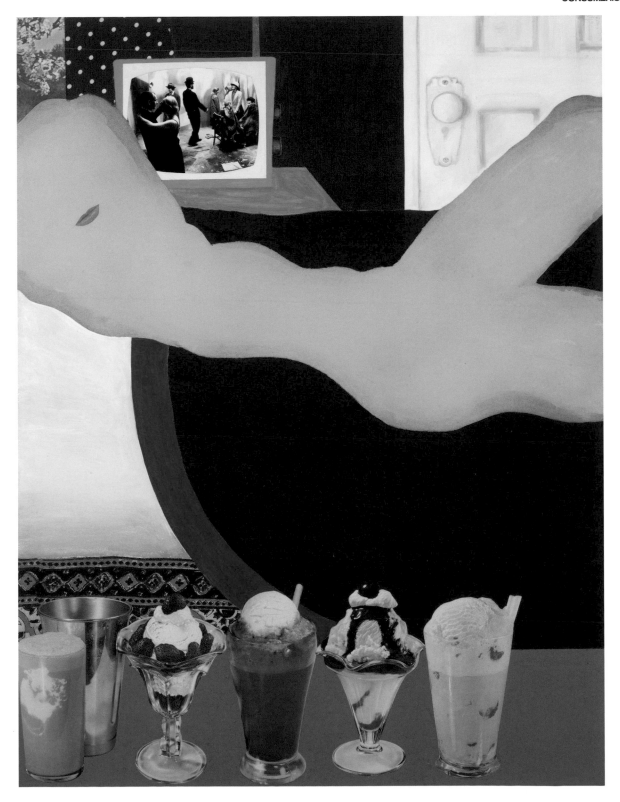

Mel Ramos
(b. 1935, Sacramento, USA)
Girl on a Burger, 1965
77.5 x 61 cm
Photo-lithograph
Wolverhampton Art Gallery,
Wolverhampton, UK
© DACS, London/VAGA
New York 2007

opposite
Mel Ramos
(b. 1935, Sacramento, USA)
Girl on a Bear, 1964
77.5 x 61 cm
Lithograph
Wolverhampton Art Gallery,
Wolverhampton, UK
© DACS, London/VAGA
New York 2007

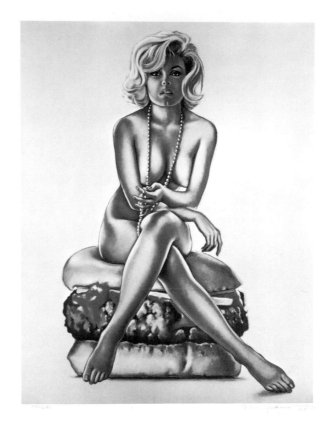

Californian artist Mel Ramos criticised the blatant use of women in advertising. After graduating from the Sacramento State College with a masters in fine art, he began a prolific period of painting comic book heroes and heroines. Then he turned his attention to producing what was eventually to become his trademark style, images of idealised women draped over consumer products in an attack on the advertising industry and their comodification of women. Unlike other artists working with this theme, he did not directly imitate advertisements, but used centrefold pin-ups from *Playboy* magazine. These airbrushed female nudes were posed around a life size consumer product, including a Coca-Cola bottle, in *Lola Cola*, 1972, a ketchup bottle in *Hunt for the Best*, 1965, and a hamburger in *Girl on a Burger*, 1965. Ramos also represented women leaning against animals as a crude reference to the brute maleness often used to sell tyres, cars and other mechanical wares. Of Ramos' work, Robert Rosenblum wrote "He cast a new light on this tradition by showing us how familiar was the American mix of sex and advertising, linking as he often did in the 1960s, American brand names—Kellogg's, Firestone, Lucky Strike, Del Monte, Kraft—with an anthology of sexy girls who hawk their wares."[19]

19 Rosenblum, Robert, *Mel Ramos: Pop Art Images*, Cologne: Taschen, 1997, p. 18.

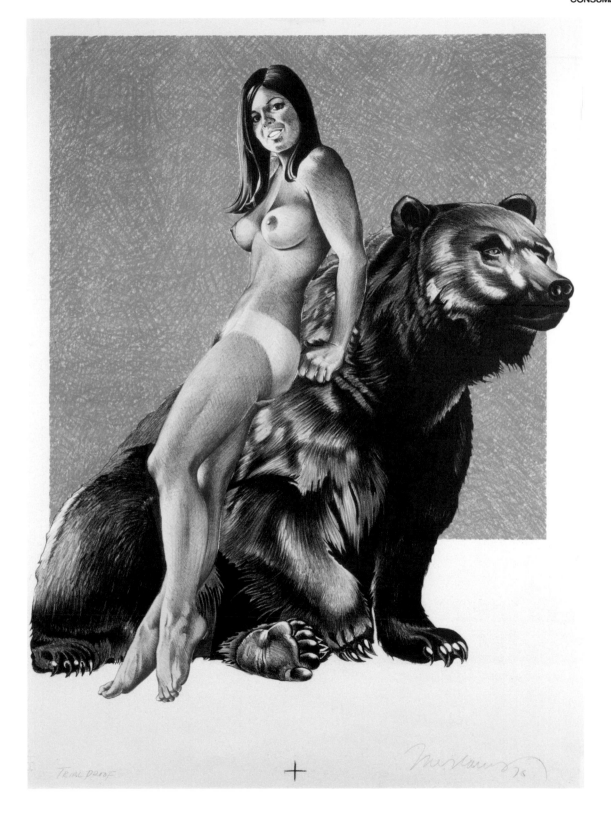

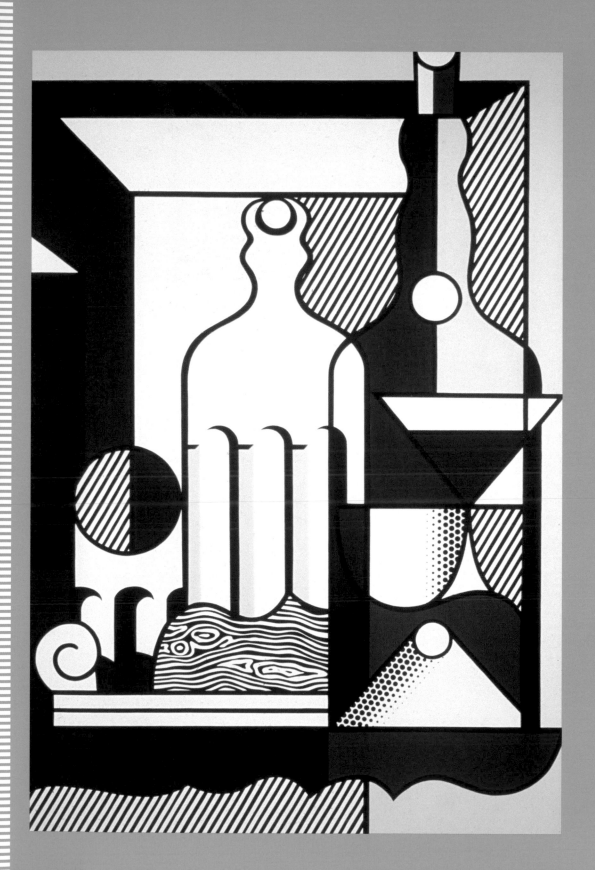

TIMELINE

INDEX

ACKNOWLEDGEMENTS

TIMELINE

POLITICAL AND SOCIAL HISTORY

1956 • Nasar nationalises the Suez Canal, Britain retaliates and is defeated. For many this marks the end of British Imperial power.
• Calder Hall, the first large-scale British nuclear power station opened by HM Queen Elizabeth II.
• Jack Cohen opens first Tesco supermarket, in Essex, modelled on American consumer stores.

1957 • Britain tests its first hydrogen bomb.
• The Soviet Union launches Sputnik 1, the first artificial satellite to orbit the earth, and a month later Sputnik 2, carrying the first dog into space.

1958 • The Campaign for Nuclear Disarmament (CND) established.
• Notting Hill race riots shocked the British public.

1959 • Campbell's Soup company, established 1869, opening a new plant in King's Lynn, Norfolk.

1960 • National Service abolished.
• Harold Macmillan speaks of 'wind of change' prior to independence in Africa.
• John F Kennedy elected the 35th President of the United States of America.
• The contraceptive pill becomes available in Britain and ushers in greater sexual freedom in the decade of peace and love.

1961 • Yuri Gagarin, a soviet cosmonaut, becomes the first man in space.

1962 • The Cuban Missile Crisis known as the 'October Crisis' in Cuba and the 'Caribbean Crisis' by the Russians, threatens to bring about nuclear war.
• Consecration of the new Coventry Cathedral to stand alongside the ruins of the historic bombed cathedral.

1963 • President Kennedy assassinated in Dallas.
• Kim Philby, one of four Oxbridge educated spies including Blunt, Burgess and Maclean, well connected in English society, defects to the USSR.
• Christine Keeler, a prostitute to the wealthy and well-connected, numbers a soviet agent and MP John Profumo among her clients and Profumo is forced to resign.

1964 • Death Penalty abolished in the UK
• Harold Wilson wins the election in the UK after 13 years of conservative rule.
• *The Sun* newspaper launched.

1965 • Civil rights protestors in Selma Alabama attacked by police resulting in the death of Jimmie Lee Jackson.
• Cigarette advertising is banned on British TV.
• Malcolm X assassinated in New York.

CULTURE

• Commercial TV launched in 1955.
• Mary Quant celebrates the first year of trading at Bazaar, a boutique in the King's Road selling her designs for young people at reasonable prices.
• *This is Tomorrow* exhibition opens at the Whitechapel Art Gallery, London.

• The first boutique store is opened on Carnaby Street.
• The first edition of Jack Kerouac's *On the Road* goes on sale.

• Households with TVs outnumber those with radios for the first time.
• *Blue Peter* gets British children recycling consumer products using sticky back plastic toilet rolls and washing up bottles to make fab items.

• *Some Like it Hot* released, starring Marilyn Monroe, whose first film appearance was in 1947, as Sugar Kane.

• Claes Oldenburg's *The Store* opens at the Judson Memorial Church, New York.
• Penguin's victory in The Lady Chatterley Trial overturns moral prudishness in UK publishing.

• The 'Ken' doll is introduced.
• The Beatles first perform at the 'Cavern Club' in Liverpool.

• Marilyn Monroe commits suicide.
• Andy Warhol produces his silkscreen *Marilyn Three Times*, and his work *Campbell's Soup Cans*.
• Ken Kesey's *One Flew Over the Cuckoo's Nest* is published.

• Sindy dolls introduced, a more down to earth version of the rival American doll, Barbie.
• *Dr Who* begins his travels through time and space in the policebox tardis and his enemies, the daleks, frighten children behind sofas on Saturday evenings.

• Barbara Hulanacki opens the first Biba boutique and Terence Conran launches the first Habitat store.

• *The Sound of Music*, starring Julie Andrews, is released.
• Bob Dylan plays Newport folk festival and is booed for playing an electric set.
• The Velvet Underground form.

1966 • Mao Tse Tung launches the Cultural Revolution in China.
• The England football team win the World Cup.

• Radio One, the first legal pop radio station, takes to the air with DJ Tony Blackburn.

1967 • Homosexuality and abortion are legalised in the UK.
• The Marine Broadcasting Offences Act outlaws support for offshore broadcasting.
• Britain signs Outer Space Treaty.

• *Bonnie and Clyde*, directed by Arthur Penn, is released
• *The Graduate*, directed by Mike Nichols, is released.
• The Beatles release their *Sgt. Pepper's Lonely Hearts Club Band* album.

1968 • Anti-Vietnam demonstrations in London.
• Fay Sislin becomes the first black woman police officer in England.
• Martin Luther King Jr assassinated.
• Enoch Powell, delivers the Rivers of Blood speech in Smethwick, Birmingham calling for the repatriation of immigrants.

• Stanley Kubrick's *2001: A Space Odyssey* is released.
• *The Night of the Living Dead* is released.
• Johnny Cash records *Live at Folsom Prison*.
• Marcel Duchamp and John Cage play chess at Ryerson Polytechnic, Toronto.

1969 • The Open University is established opening up further education to a wider public.
• Neil Armstrong takes one large step for mankind on the moon.
• Concorde, designed by the French and English, makes maiden flight.

• The Theatres Act ends censorship in the theatre.
• Woodstock happens in the small rural town of Bethel, New York.
• *Easy Rider* is released.
• Judy Garland dies, aged 47.

1970 • Four student anti-Vietnam protesters shot at Kent State University, USA.

• Robert Altman's *M*A*S*H* is released.
• Cult leader Charles Manson releases an album entitled 'Lies' in order to try and finance his court defense.

1971 • Stanley Kubrick releases *A Clockwork Orange* based on his views about the Cold War.

• Vivienne Westwood and Malcolm McLaren open a shop in the King's Road in London marking the beginning of punk.

1972 • 'Bloody Sunday'—13 people killed in protest against internment in Northern Ireland.
• President Idi Amin of Uganda expels 40,000 Asians.

• *Cosmopolitan* magazine, with a male nude pin up in the second edition of 450,000 copies, sells out in two days—striking a blow for sexual equality.

1973 • America pulls out of Vietnam.

• Pablo Picasso dies.
• Cult British film *The Wicker Man* is released.

1974 • Death of General Franco.
• President Nixon resigns over Watergate scandal.

• Sears Tower in Chicago, Illinois, is completed.
• Talking Heads, Blondie and the Ramones form.

1975 • Sex Discrimination Act passed.
• To mark the end of the Vietnam war Oxford students at Wadham College rename a quadrangle Ho Chi Minh Quad.
• The end of the Vietnam War with North Vietnamese entering Saigon.
• Saigon the capital of South Vietnam renamed Ho Chi Minh City.

• Sidney Lumet's *Dog Day Afternoon*, based on events of a Brooklyn Bank Robbery in 1972, starring Al Pacino, is released.
• Steven Spielberg's *Jaws* is released.
• Charlie Chaplin is knighted by HM Queen Elizabeth II.
• NBC airs the first episode of *Saturday Night Live*.

1976 • Apple Computer Company is formed by Steve Jobs and Steve Wozniak.
• North and South Vietnam unite to form the Socialist Republic of Vietnam.

• Sex Pistols release the record *Anarchy in the UK*.
• Martin Scorsese's *Taxi Driver* is released.
• Throbbing Gristle, Generation X and The Damned form in London.

1977 • First case of AIDS diagnosed in the US.

• Elvis Presley is found dead in his home in Graceland.

1978 • The People's Republic of China lifts a ban on the works of Charles Dickens, William Shakespeare and Aristotle.

• *Dallas* premieres on CBS.
• *Superman: The Movie*, starring Christopher Reeve, is released.

1979 • Margaret Thatcher elected the first woman Prime Minister of the UK.

• *Quadrophenia* and *Monty Python's Life of Brian* released in cinemas.

INDEX

ACKNOWLEDGEMENTS

Set in the centre of a millennium City, Wolverhampton Art Gallery boasts an extensive public collection of over 10,000 artworks and objects spanning from the Georgian and Victorian periods through to works by twentieth century and contemporary artists. Established in 1884 the collection grew with continued support from the South Kensington Museum and major bequests and gifts. The 1960s saw the appointment of the first professional curator and with this the brave decision in the early 70s to start collecting Pop Art. With a firm contemporary collecting policy devised, the 1970s heralded an exciting era of amassing a body of modern art that reflected the political, social and cultural landscape of modern Britain.

The diverse collection continued to grow in the 1980s and 90s with recognition and support for the contemporary art collection from the Arts Council and Contemporary Arts Society to assist with new purchases. In 2007, a multi-million pound building extension opened, doubling the size of the art gallery's main exhibition area. Two large triangular galleries now provide ample space to display national touring exhibitions, international artists and provide a permanent home for the gallery's much loved Pop Art collection.

Collecting contemporary art has always been controversial but at the same time it is an investment for the future. When Roy Lichtenstein's *Purist Painting with Bottles* was acquired for the collection in 1975 it seemed like a phenomenal amount to spend on a single artwork and yet nowadays its price tag would make it beyond the means of a small regional gallery like Wolverhampton. It is thanks to the foresight and courage of previous curators that Wolverhampton Arts and Museums Service has amassed a collection of Pop Art to be proud of, a collection that can be used and enjoyed by future generations of gallery visitors.

We would like to thank all the lenders of works to the exhibition and all the institutions and individuals who have been so helpful in supplying images for use in this book. Also, thanks to Michelle Bonson and Sarah Mayhew for their administrative support, and to Emma Gibson for her inspired artworking.

The Pop Book is part of a project to re-display the Pop art collection in the gallery's new extension, designed by architects Niall Phillips and funded through The Heritage Lottery Fund, Advantage West Midlands and Wolverhampton City Council. The extension opens in March 2007 with the display of the Pop collection and accompanying book being funded by Museums, Libraries and Archives through Renaissance in the Regions.

© 2007 Black Dog Publishing Limited, the artists and authors
All rights reserved

Contributors: Julia Bigham, William McBean, Corinne Miller
and Marguerite Nugent

Editor: Nadine Käthe Monem
Assistant Editor: Blanche Craig

Designer: Emilia López
Assistant Designer: Matt Pull

Black Dog Publishing Limited
Unit 4.4 Tea Building
56 Shoreditch High Street
London
E1 6JJ

Tel: +44 (0)20 7613 1922
Fax: +44 (0)20 7613 1944
Email: info@blackdogonline.com

www.blackdogonline.com

All opinions expressed within this publication are those of the authors
and not necessarily of the publisher.

British Library Cataloguing-in-Publication Data.

A CIP record for this book is available from the British Library.

ISBN 10: 1-904772-69-2
ISBN 13: 978-1-904772-69-9

Printed in Turkey by Ofset Yapimevi.

Black Dog Publishing is an environmentally responsible company.
Pop Art Book is printed on Fedrigoni SYMBOL Freelife Satin, an
environmentally-friendly ECF woodfree paper with a high content of
selected pre-consumer recycled material from well managed forests.

architecture art design
fashion history photography
theory and things

black dog publishing

www.blackdogonline.com

RENAISSANCE
WEST MIDLANDS

wolverhampton art gallery

Wolverhampton
City Council

MLA
MUSEUMS LIBRARIES ARCHIVES
COUNCIL